DYNAMIC WRINKLES AND DRAPERY

BY BURNE HOGARTH

WATSON-GUPTILL PUBLICATIONS/NEW YORK

Edited by Carl Rosen
Designed by Bob Fillie, Graphiti Graphics
Graphic production by Ellen Greene and Hector Campbell

Published in 1995 in the United States by Watson-Guptill Publications,
a division of BPI Communications, Inc.,
1515 Broadway, New York, NY 10036

Library of Congress Cataloging-in-Publication Data
Hogarth, Burne.
 Dynamic wrinkles and drapery: solutions for drawing the clothed
figure / Burne Hogarth.—Pb. ed.
 p. cm.
 Includes index.
 ISBN 0-8230-1587-4
 1. Drapery in art. 2. Human figure in art. 3. Drawing Technique. I. Title.
NC775.H64 1995
743'.5—dc20 9136840
 CIP

Manufactured in Malaysia

Paperback edition, first printing 1995

4 5 6 7 8 9 10 / 03 02 01 00 99 98

DYNAMIC WRINKLES AND DRAPERY

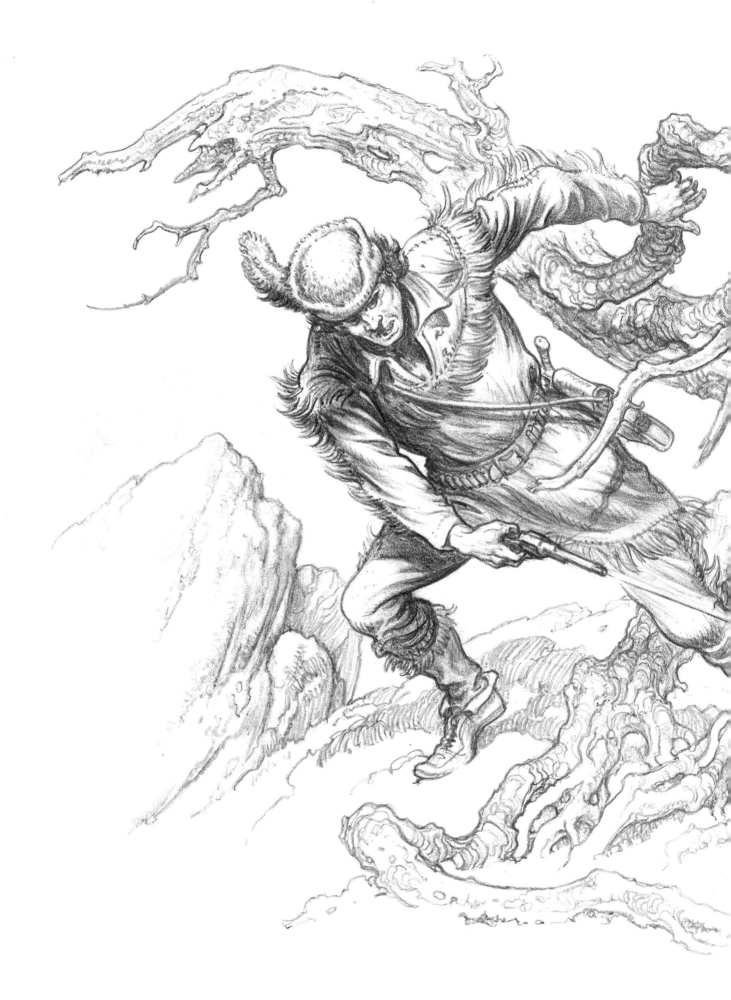

This book is dedicated to my good friends:
Maurice Horn, a distinguished, seminal historian
of the comic narrative idiom and the graphic novel;
Richard Pryor, of Collector's Press, and his family,
Joanna and John, for their warmth, devotion, and
steadfast appreciation of the Ninth Art of our time;
Jack Iversen, one of the "old-timers" of the
animation form, for his idealism, energy, and
unflagging grit in pursuing and building his
Viking dream.

ACKNOWLEDGMENTS

In the course of preparing this book, I incurred a debt of gratitude first and foremost to Mary Suffudy, Executive Editor of Watson-Guptill, for her unreserved enthusiasm for and encouragement of this project when hope for it seemed to have waned; to her wise guidance and the judgment of Carl Rosen in the editorial area and details of production; and to Bob Fillie for his masterly projection of the "look" and design of this book.

Special mention must be accorded to the unnamed and unrecorded specialists, designers, and illustrators of current and recent vintage in modes of fashion—indeed, to fashion artists of earlier eras and the scattered records of a more remote and distant historical past of attire and dress in many lands and diverse cultures—some found in obscure print media, some in painting and sculpture reproductions, going back to early classical times.

Much of this background reference matter I have deliberately reworked and scrambled (like military uniforms, for example) so that no specific geographic, national, ethnic, or political provenance can be attached or inferred. My sole objective is the strict adherence to solving the problems of wrinkles and folds. Other than that, I do not choose to make claims of original insight; and my deep thanks go to those image makers whose work unwittingly served the narrow compass of my needs.

CONTENTS

PREFACE

In the course of a truly remarkable career spanning some sixty-odd years, Burne Hogarth has worn many hats in the worlds of art, art education, and art publishing. Although he was from the beginning a popular success, critical acclaim was a long time coming. Thankfully, he has now taken his place among the important artists of the twentieth century.

Burne is most famous for his internationally syndicated Sunday color page *Tarzan* (1937-1950) but is probably most revered for his contributions to art education. Through his books on drawing and his hands-on teaching, he has touched the lives of countless thousands of art students. I truly believe that he is one of the most influential figures in art education today.

Burne has published five books on drawing, beginning with *Dynamic Anatomy* in 1958. These books are the definitive studies of five aspects of drawing. This book, Burne's sixth, may well be the most unique and information-packed of them all. Begun as a study of the clothed figure and the dynamic properties of drapery, the project expanded to create a vocabulary and terminology with which to address the clothed figure in art education. This did not exist and was not generally perceived as being needed. The clothed figure was a chance encounter in most art school study programs. Historically, the emphasis in drawing was on the nude. This may well be a result of the lack of terminology and vocabulary with which to address the clothed figure.

The project expanded further to deal with characterization, especially by means of gesture.

The people in these drawings are unique individuals; personalities reflecting all the varied aspects of contemporary society. As a matter of fact, this book may be the best visual record of contemporary society to date.

In the late fifties, I was just starting out on a career in illustration and was teaching my first class at the School of Visual Arts in New York. I had graduated from Art Center College of Design the previous year, and although I had experienced immediate success as an illustrator, I was far from sure of myself in the role of teacher. Burne Hogarth was teaching in a classroom next to me and I couldn't help but overhear most of his lectures. Hogarth has an awesome energy level and is not a quiet man. He illustrated his lectures with giant anatomical drawings done on the spot from memory in an extraordinary and unique style of his own invention. I had never seen anyone so clearly define the human form before. Needless to say, I learned a great deal about teaching from this experience and I believe that Burne's commitment and enthusiasm inspired me to take up a second career in education which continues to this day.

When I returned to California many years later to chair the illustration department at Art Center, the main thing that I felt was missing was Burne Hogarth. Burne was such a confirmed New Yorker, it never occurred to me that I could lure him to California. Happily, sometimes things work out. Burne did move to California and did join our faculty. He is a constant source of inspiration to the department and I feel honored to have been asked to write this preface.

PHILIP HAYS
Chairman, Illustration Department
Art Center College of Design, Pasadena

INTRODUCTION

This book is essentially a study of the problems and solutions related to drawing the clothed human figure. I propose to deal with the integral facts, details, and systems of wrinkles and drapery as influenced by the movement and activity of the human form.

One of the ironies of art education is that while a great deal of attention is given to drawing and painting the figure, **figure** in this context refers only to the nude or unclothed form. Indeed, from the very beginning of the learning process, the well-held axiom is that basic art study proceeds unquestionably from the representation of the unclothed human form. That tacit principle is the norm in private studios and group classes, as well as in large art schools and colleges. If one can draw the nude figure, doors are automatically open for further study, the ability to draw nudes being perceived as the foundation for all other developing art skills. In subsequent study, drawing the nude figure is also a constant preoccupation. It is the central rationale and confirming activity for advanced and master classes.

As a matter of course, in classes devoted to painting, illustration, and fashion study, clothed figures are presented. The figures are dressed in a variety of costumes and styles of this year and yesteryear. And surely, an instructor might occasionally provide some salient information on folds and drapery, but such instruction is sporadic. In the average pattern of study, very little attention is given to the systematic understanding of the **clothed figure**, because there are no requirements in the curriculum to propagate such a disciplined program.

The irony is that in reality artwork depicting clothed figures is far more common than work showing nude figures. By merely making an across-the-board scan of the art in various media, one will observe that the overwhelming proportion use the clothed figure. With this oversight in the education of artists in mind, we hope to fill the gap by revealing the secrets of wrinkles and drapery.

It is my contention that such a vital and instrumental subject as **wrinkles and drapery**—the analytical and kinetic factors of the clothed figure—must be seen as integral to figure drawing. The subject must be construed as the basic support stage of the nude form. The stress-related anatomical features of change, mobility, and action are best shown through the interactive, sequential stage of figure drawing that I describe in *Dynamic Wrinkles and Drapery*.

Wrinkles and drapery are not independent, exclusive agencies of form. The divisions of wrinkles and folds in clothing worn on the body should be conceived as a part of a coherent system of movement and response. From this premise, any garment can be regarded as a new skin, a looser, variable cover that augments the nude substructure, but is responsive to the underlying foundation below.

This book explains how and why wrinkles act the way they do, focusing on the kinetic forces of tension and thrust, the resistance factors of friction and traction areas, and the counterforces of retention and anchor points. Nine major systems of wrinkles and drapery are discussed in detail, and these systems are shown as they affect a variety of textural materials and weaves, responding to bulk, density, stiffness, and resilience.

After scrutinizing the basic interactions of wrinkles and drapery and the nude form, we move to the pursuit of problem solving in drawing the clothed figure. This involves understanding the clothed figure in terms of such individual, behavioral, and socially oriented distinctions as personality, age, sex, and status. Work and job-related attire can help the artist to define social guise and demeanor. These conditions all affect both the movements of the body and the movements of the clothing on the body, hence the patterns of wrinkles.

It is my hope that within the narrow limits of a book, we present sufficient information to excite interest and inspire awareness and understanding of the nature of wrinkles and folds.

Now, let's get on with our work.

BURNE HOGARTH

UNDERSTANDING KINETIC FORCES

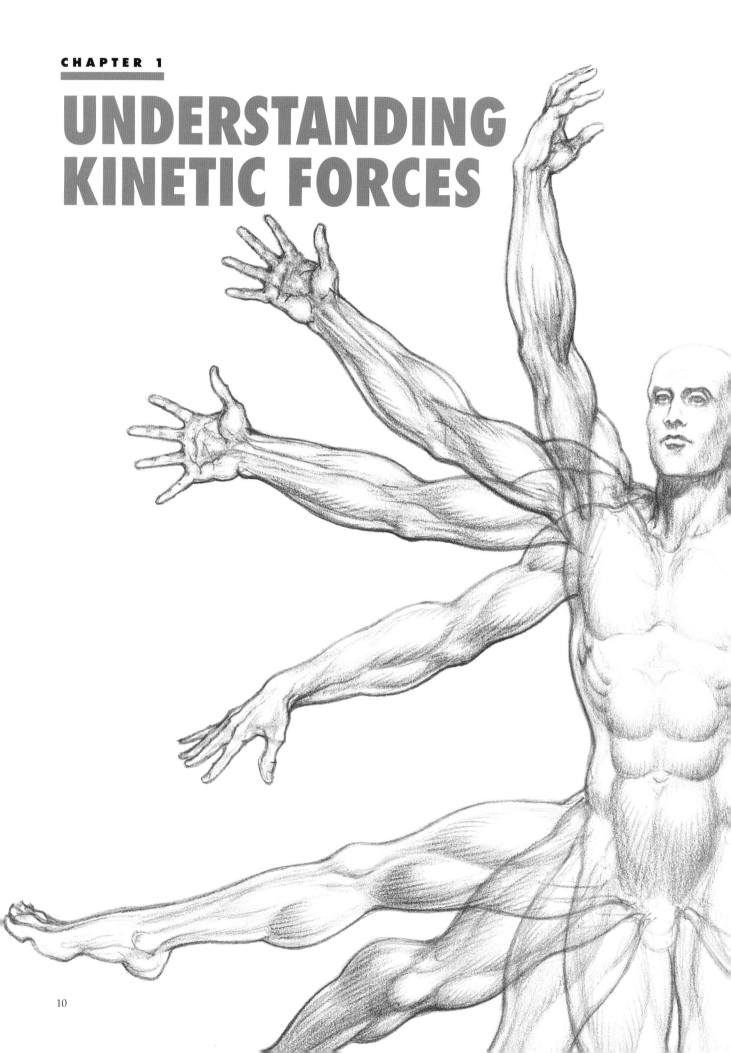

The innate forces and stresses that arise in the human body are revealed in the folds and creases of clothes. In order to understand wrinkles and drapery in context of a wide variety of wearing apparel, it is necessary first to understand specific kinetic forces themselves. **Kinetic forces**, which are tied to the motion of a figure in opposition to other natural forces, such as gravity, generate the stresses from which wrinkles and folds develop. This combination of forces acts on the various weaves and textures of dress, creating in effect another form of skin, loose and free-acting as our real skin. This artificial overlay, however, can act with a diversity not available to the tightly bound flesh.

The casual observer would conclude that the body is capable of producing an unlimited number of possible movements. Closer inspection, however, would show that the apparently different kinds of actions can be simplified into four fundamental types of movement. These **basic actions of the body** forms are: extending, bending, twisting, and rotating.

When the four basic actions of the body act on clothes and garments, which obviously have their own weight, shape, and texture, a broader interaction takes place with the external forces of gravity, weather, and random events. This combination of forces give rise to categorical systems of wrinkles and folds. These systems are discussed in detail later; for now, let's take a closer look at the four basic actions of the body.

1. Extending. The extension of forms, or the straightening and stretching of the body parts, can be seen when the figure is in an erect, elevated posture. The head, neck, and torso are said to be extended when they are straightened; the legs and feet when straightened taut; and the arms, hands, and fingers when stiffly stretched out.

2. Bending. The bending of forms in the flexing or closing of parts can be seen in the compression inward of the head to chest; the compression of the rib cage toward the pelvis (at various angles); the backward bending of the legs and the forward flexing of the arms; and the closing and clenching of hands and fingers, feet and toes.

3. Twisting. The torque and twist of forms can be seen in the left and right turning of the head; the twisting or wrenching of the chest against the pelvis; the corkscrewing of the legs in the hip socket and the spiraling of the arms in the shoulder cup; and the turning and wrenching of the wrists and ankles, fingers and toes, in small twists.

4. Rotating. The rotation of forms can be seen in the wide gyration of the outstretched arm from its pivot in the shoulder; the wide rotary whirls of the leg from its pinion in the hip; the upward circular swirls of the head, combined with neck forms; the wheeling around of the pelvis and the leg base of the torso in large, windmilling curves; and the wheeling and winding rotation of hands, and the reeling rotation of dangling feet.

These gross motions of the body's members, in combination with each other and external forces, create a remarkable sequence of wrinkle systems in the coverings and garments that we choose to inhabit.

In the figures that follow, look for the broad differences in the movements of forms in terms of the four basic actions of the body.

11

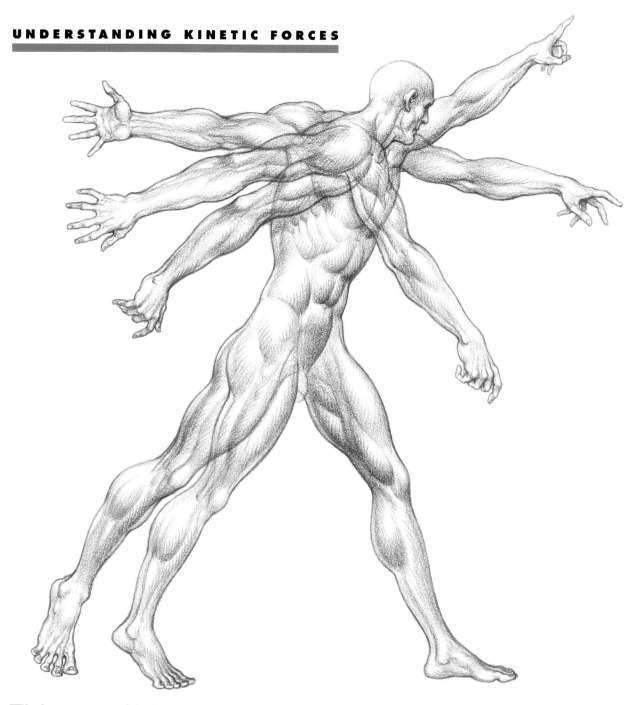

The basic actions of the body mobilize the forces of tension and thrust, which in turn energize wrinkles. Wrinkles are an expressive indication of the force of actions. The actions performed by this male figure are excessively strained and contrived. This is done to show the expressive value of wrinkles in proportion to the straightness of the members in **extension**.

The fully extended arms stretch outward to their limits, giving the viewer a feeling for the strain and sweep of the figure. Similarly, the extended legs convey the feel of forward motion, as they move through the sequence of step, pace, stride, march, and advance. Note the upward extension of the head and body, which lifts high along with the legs in projection and the arms in elevation. As you observe these extensions of the figure, try to identify with each of the drawings and feel your way through the movements.

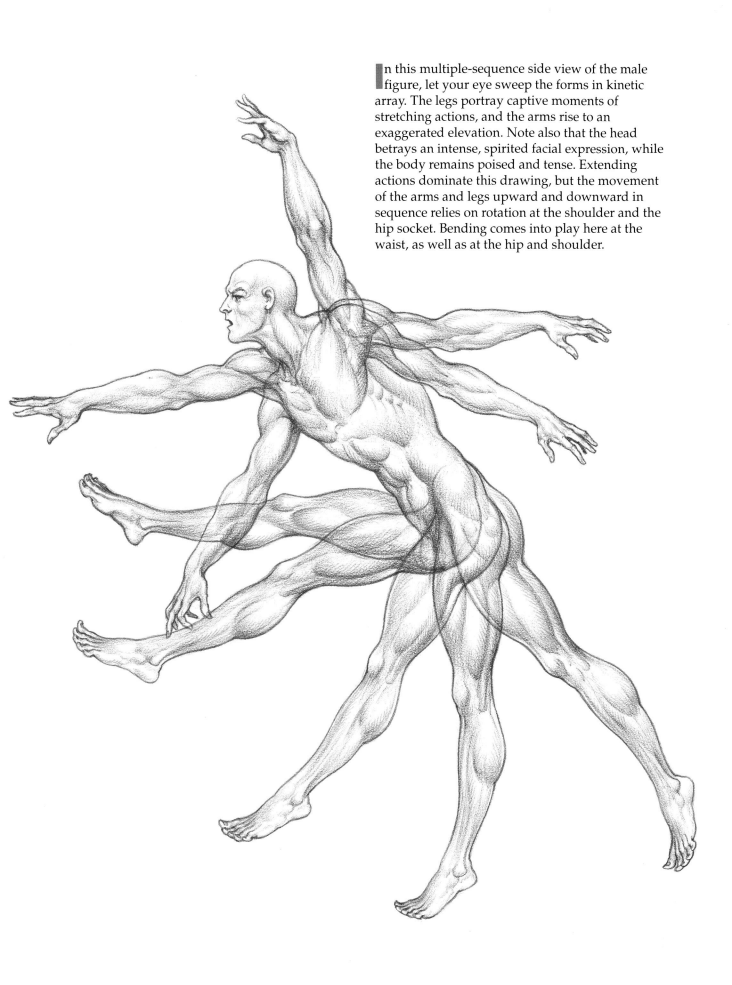

In this multiple-sequence side view of the male figure, let your eye sweep the forms in kinetic array. The legs portray captive moments of stretching actions, and the arms rise to an exaggerated elevation. Note also that the head betrays an intense, spirited facial expression, while the body remains poised and tense. Extending actions dominate this drawing, but the movement of the arms and legs upward and downward in sequence relies on rotation at the shoulder and the hip socket. Bending comes into play here at the waist, as well as at the hip and shoulder.

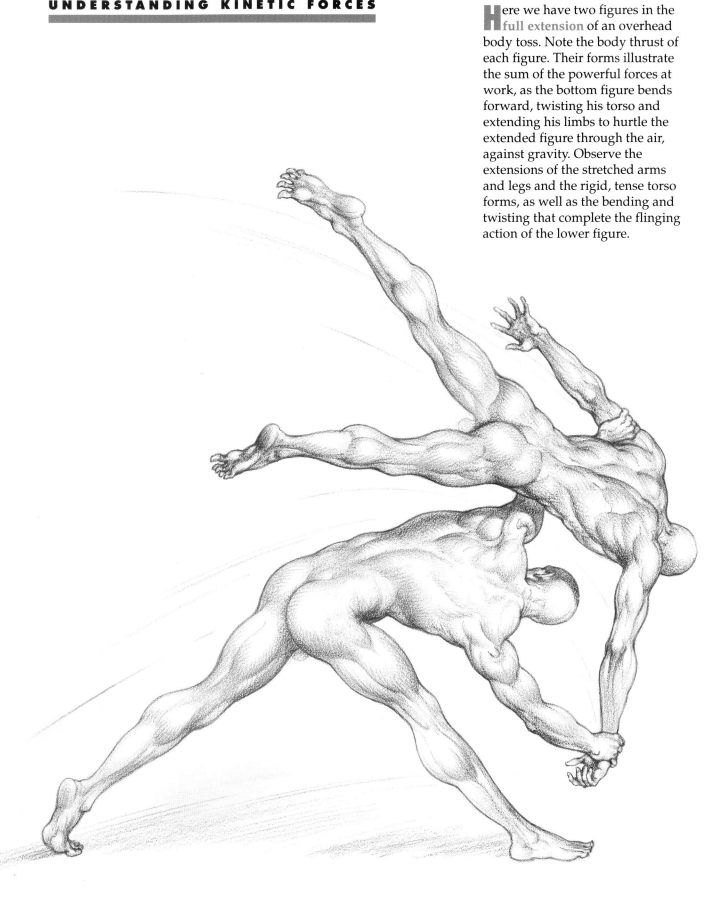

Here we have two figures in the **full extension** of an overhead body toss. Note the body thrust of each figure. Their forms illustrate the sum of the powerful forces at work, as the bottom figure bends forward, twisting his torso and extending his limbs to hurtle the extended figure through the air, against gravity. Observe the extensions of the stretched arms and legs and the rigid, tense torso forms, as well as the bending and twisting that complete the flinging action of the lower figure.

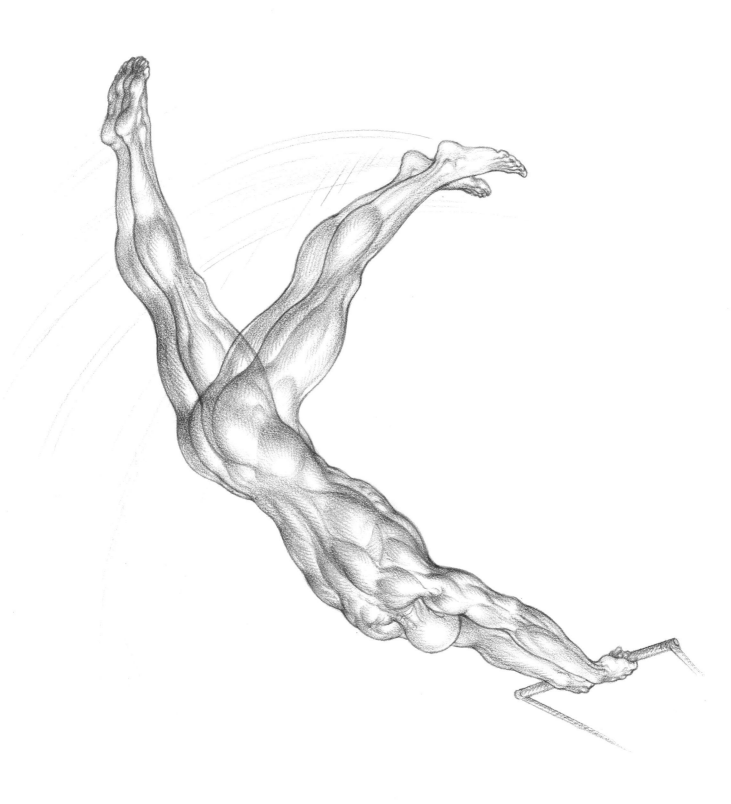

Observe the two-phase flying figure of this trapeze performer: Every form is in extension—stretched, tense, and elongated to convey the flying outward swings. The figure bends at the hips and arcs his legs above his head with slingshot acceleration to complete the flight. Now imagine the extended swirling folds that would follow the speed lines behind the body if this figure wore clothes!

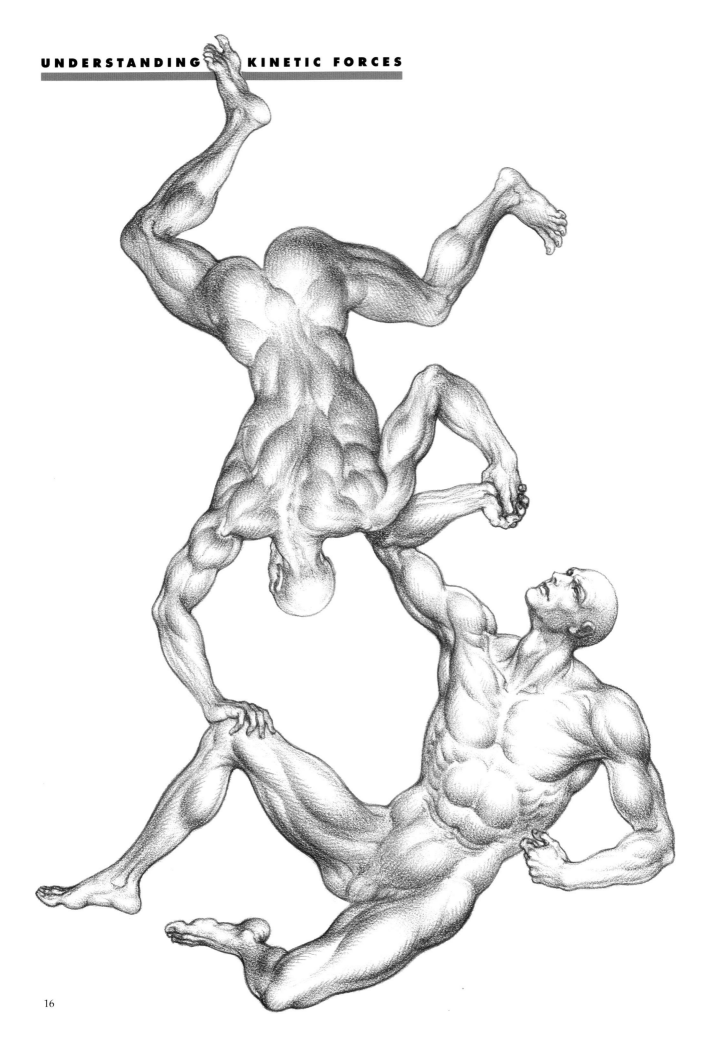

ook closely at the two male athletic figures (opposite) locked in **dynamic balance**: Virtually all parts of the body that can express some aspect of a sideways bend do so. Note the tipping and compression of the two torsos; both also exhibit torque or twisting. Now follow the bending of each head—both tip away from the axial change in the hips. (When we examine these bend motions in the clothed figure in later chapters, a remarkable rhythmic system will prevail in the wrinkles.)

irtually every body form in the athletic figures below expresses some aspect of flexion, compression, and bend. Note the inward convergence and contraction of upper and lower arms, hands and fingers, and the closure and compression of upper and lower legs. The central image of the two torsos present opposing bends: The lower torso is developing a depressed frontal concavity, while the upper is forced into a backward arched convexity. The same bending movement occurs in the two heads: The lower head is moving forward, the upper is projected backward.

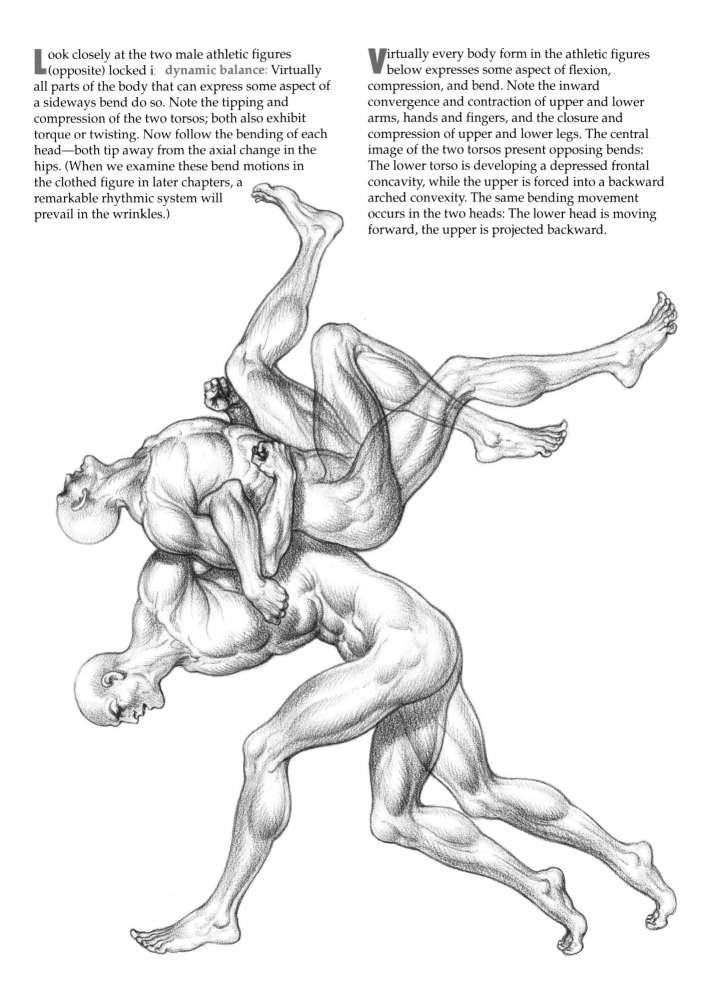

17

This back view of a dancing female figure shows a multiple-sequence change of bending actions in the arms and legs. The hands show a series of actions including finger bends and wrist rotations. The torso develops a deep back bend, as it compresses and twists. The legs alternate between extending and bending actions.

Again, the distinctive female form compels a unique system of wrinkles in clothing. Imagine this figure covered in lightweight swirling gowns and skirts, creating undulant, loosely flowing forms.

This multiple-sequence figure presents the extending actions of parts of the body. Jogging, striding, vaulting, and leaping are shown in kinetic leg movements. The upraised arms convey a sense of upward motion, while the torso and head describe twisting actions that convey a sense of elevation and grace.

We'll see that there are marked differences in the clothed forms of the female and male figures because of the structural differences between the sexes. This consequently influences wrinkle systems and forms of drapery.

Wrinkle systems in clothes, generated by the four basic actions of the body in conjunction with external forces, originate from areas of retention called **anchor points**. These points describe the places where clothes cling to or hold to the body. In the male figures shown here, anchor points are found in seams, as well as in tight places throughout the body, such as the armpits, the collar, the inner elbow and knee creases, the midwaist cinch, the pubic underbody midline, the crotch seam, the side groin creases, and the rear, deep buttock curves. In later chapters, we see these anchor points working to define wrinkle origins.

The anchor points of wrinkle systems in the clothing of the female figures shown here work the same as those of the male figures. Clothing designed for men is often adapted for use as women's wear, so the male figure's anchor points are often interchangeable with those of the female figure.

For distinct women's styles, the anchor points resolve down to simpler systems of wrinkle origins. For example, where the dress or skirt formation of clothing dominates, the direct anchor points for clothes can be seen at the collar, shoulders, armpits, and elbows, as well as at the waistline. The only difference from male anchor points is in the emphasis on particular points.

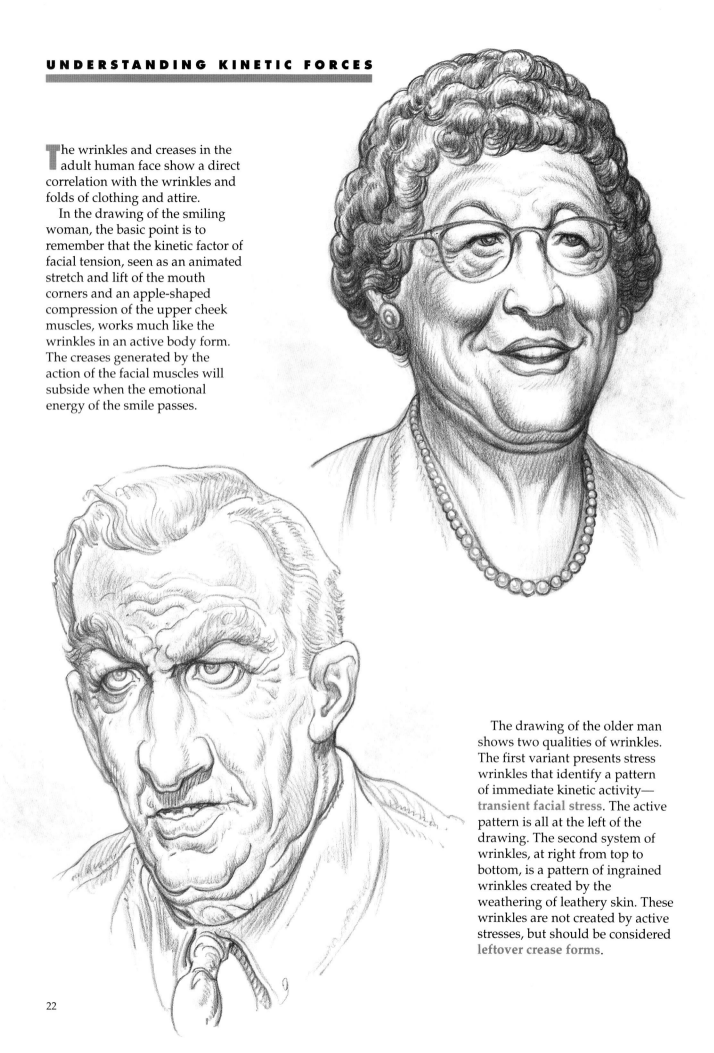

The wrinkles and creases in the adult human face show a direct correlation with the wrinkles and folds of clothing and attire.

In the drawing of the smiling woman, the basic point is to remember that the kinetic factor of facial tension, seen as an animated stretch and lift of the mouth corners and an apple-shaped compression of the upper cheek muscles, works much like the wrinkles in an active body form. The creases generated by the action of the facial muscles will subside when the emotional energy of the smile passes.

The drawing of the older man shows two qualities of wrinkles. The first variant presents stress wrinkles that identify a pattern of immediate kinetic activity—transient facial stress. The active pattern is all at the left of the drawing. The second system of wrinkles, at right from top to bottom, is a pattern of ingrained wrinkles created by the weathering of leathery skin. These wrinkles are not created by active stresses, but should be considered leftover crease forms.

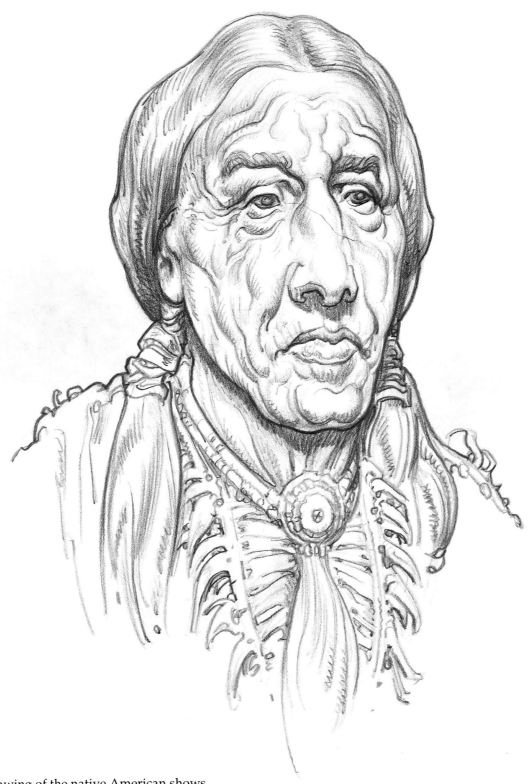

The drawing of the native American shows
wrinkles derived from the aging process. The face
shows wrinkles that will not yield in passivity. Here
we see the exemplary complex of past action folds
and creases, much like the patterns of weaves and
garments. In fact, similar motifs are observable in
durable textures where kinetic stress forces interact
with external forces, such as weather and time.

DIRECT THRUST WRINKLES

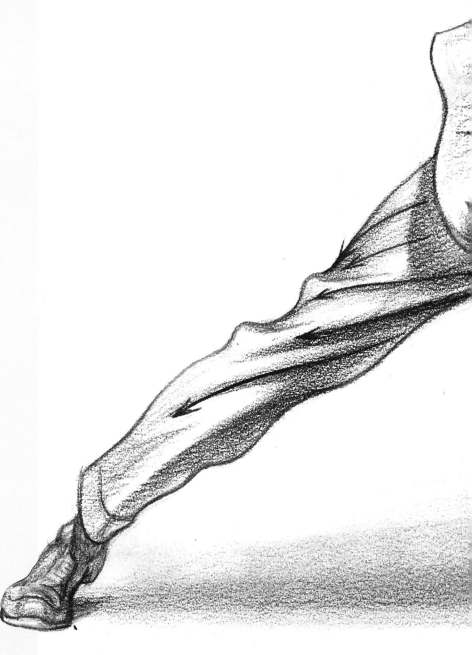

The direct thrusts of body members acting on a variety of clothing types are responsible for the greatest amount of wrinkle patterns. When the members of the body extend outward from the anchor points, the thrust or **pulling action** creates direct thrust wrinkles. These wrinkles radiate along the lines of force. They are also among the most common of wrinkle patterns, and they can be observed in garments acted on by the direct thrusts generated by walking, stretching, and a number of other activities, often involving the arms and legs.

Direct thrust wrinkles, however, do not usually result in the most interesting of wrinkle patterns. I urge you to keep an open mind on this point, since, in the final event, **you** are the judge of what is best and beautiful, and you prove it by making personal choices of forms. There is no higher law.

If you can define the sites of the forces of tension, the pattern of the wrinkles will follow. Study this figure lunging against a door. Note the anchor points: armpit, midline crotch, and a mere coat button (at the waist). This button is central to the radial wrinkles of the torso. The outward thrusts emanating from the armpit appear as long, spiral stretch curves on the arm sleeve and on the coat underneath (see arrows). Now see the two sets of wrinkles that start at the midline crotch anchor. The long arrows trace the path of the forces influencing wrinkles on the figure's pant leg at left, and the foreshortened curved arrows show those at right.

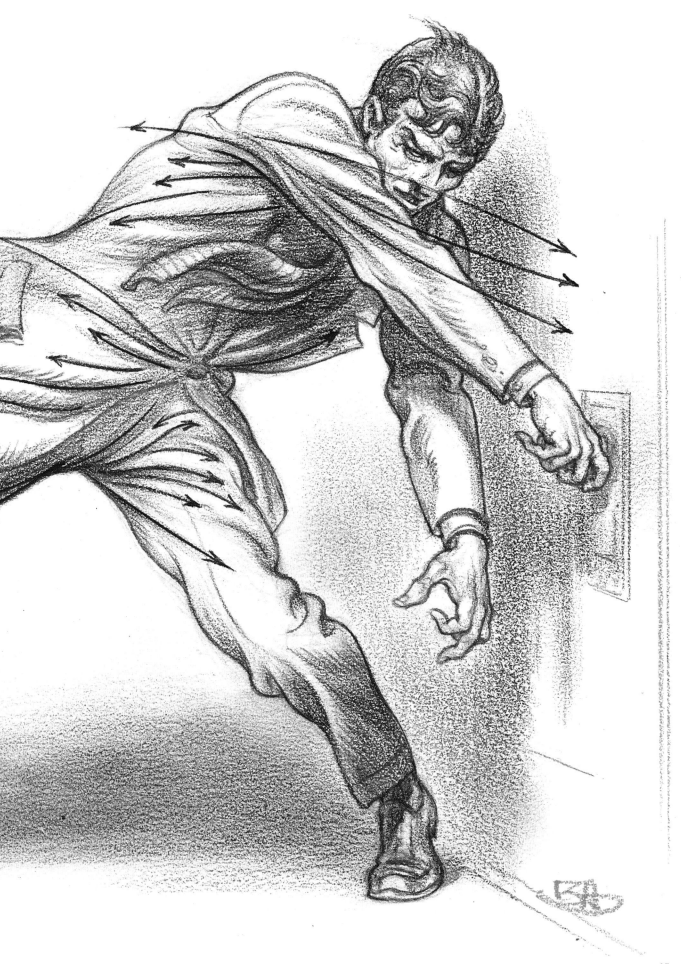

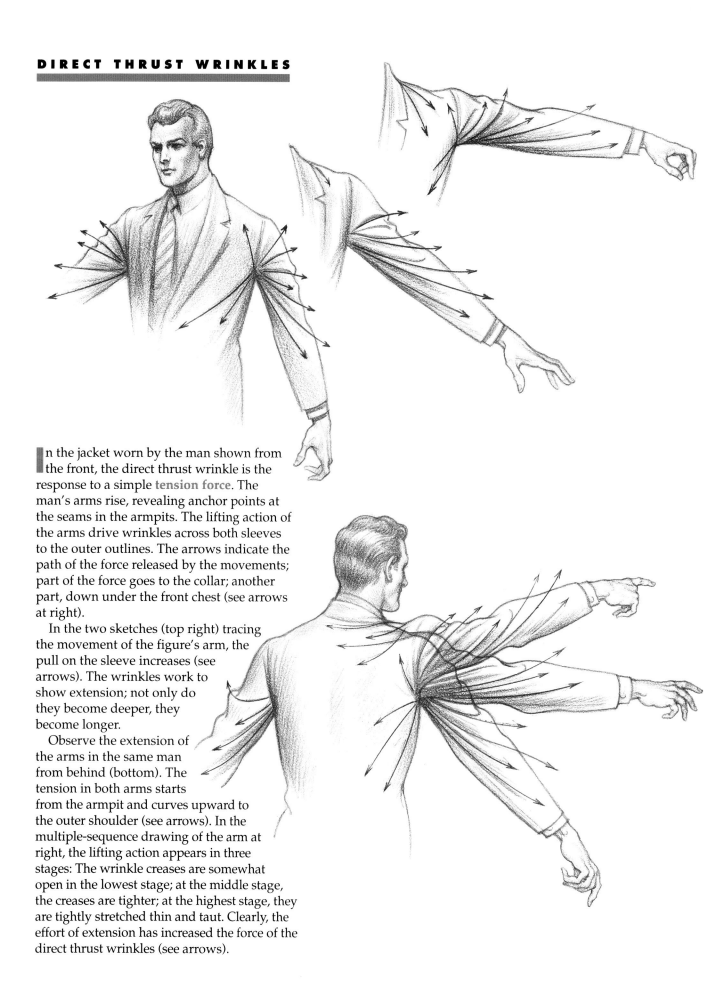

In the jacket worn by the man shown from the front, the direct thrust wrinkle is the response to a simple **tension force**. The man's arms rise, revealing anchor points at the seams in the armpits. The lifting action of the arms drive wrinkles across both sleeves to the outer outlines. The arrows indicate the path of the force released by the movements; part of the force goes to the collar; another part, down under the front chest (see arrows at right).

In the two sketches (top right) tracing the movement of the figure's arm, the pull on the sleeve increases (see arrows). The wrinkles work to show extension; not only do they become deeper, they become longer.

Observe the extension of the arms in the same man from behind (bottom). The tension in both arms starts from the armpit and curves upward to the outer shoulder (see arrows). In the multiple-sequence drawing of the arm at right, the lifting action appears in three stages: The wrinkle creases are somewhat open in the lowest stage; at the middle stage, the creases are tighter; at the highest stage, they are tightly stretched thin and taut. Clearly, the effort of extension has increased the force of the direct thrust wrinkles (see arrows).

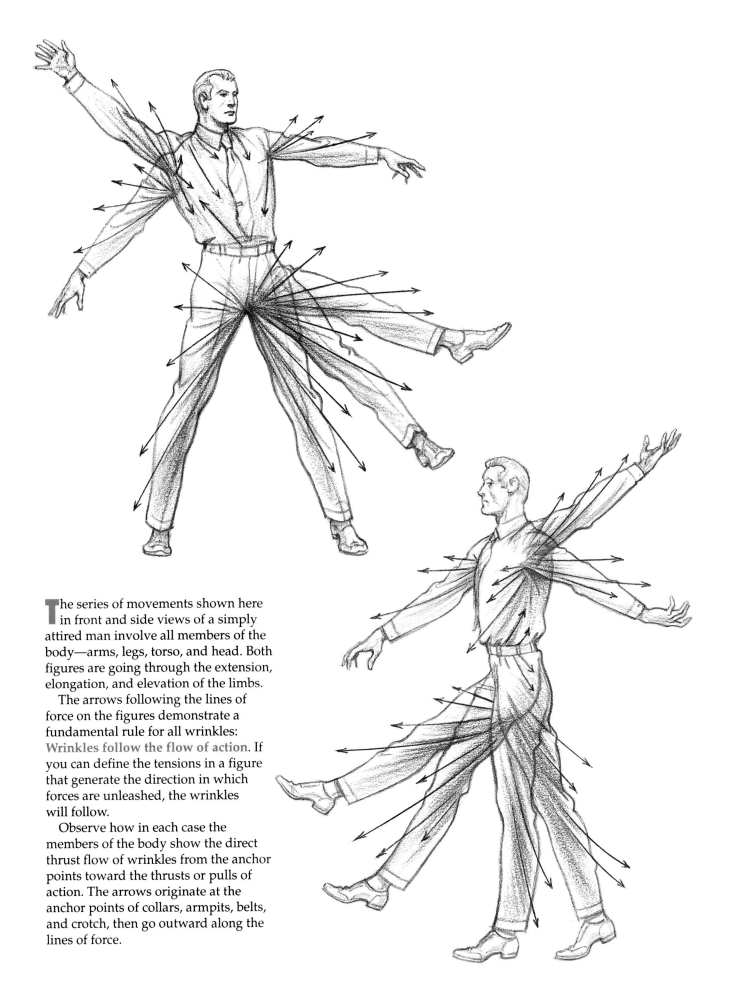

The series of movements shown here in front and side views of a simply attired man involve all members of the body—arms, legs, torso, and head. Both figures are going through the extension, elongation, and elevation of the limbs.

The arrows following the lines of force on the figures demonstrate a fundamental rule for all wrinkles: Wrinkles follow the flow of action. If you can define the tensions in a figure that generate the direction in which forces are unleashed, the wrinkles will follow.

Observe how in each case the members of the body show the direct thrust flow of wrinkles from the anchor points toward the thrusts or pulls of action. The arrows originate at the anchor points of collars, armpits, belts, and crotch, then go outward along the lines of force.

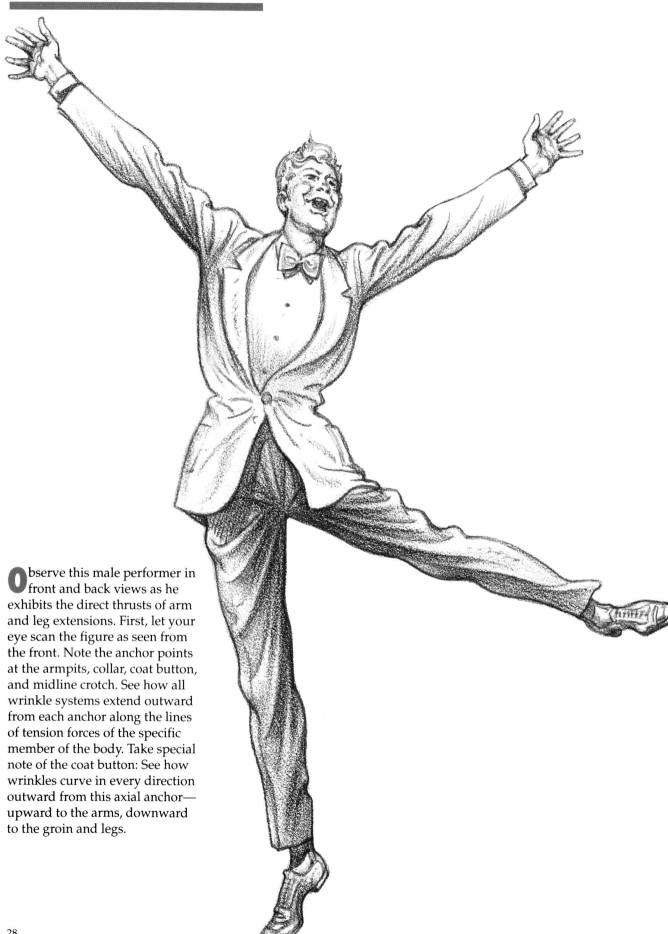

Observe this male performer in front and back views as he exhibits the direct thrusts of arm and leg extensions. First, let your eye scan the figure as seen from the front. Note the anchor points at the armpits, collar, coat button, and midline crotch. See how all wrinkle systems extend outward from each anchor along the lines of tension forces of the specific member of the body. Take special note of the coat button: See how wrinkles curve in every direction outward from this axial anchor—upward to the arms, downward to the groin and legs.

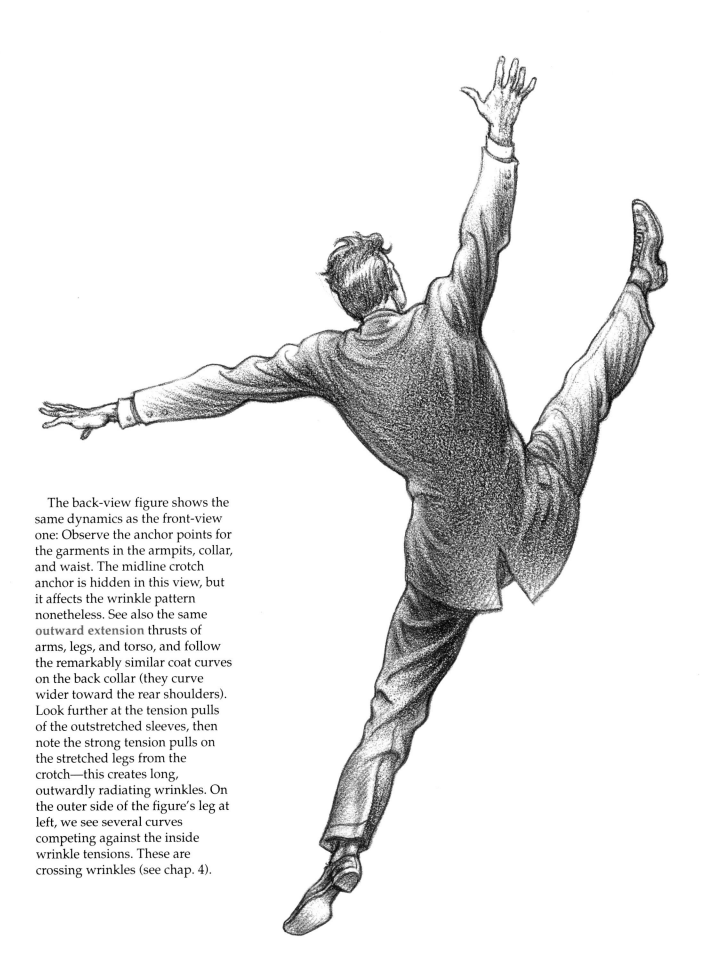

The back-view figure shows the same dynamics as the front-view one: Observe the anchor points for the garments in the armpits, collar, and waist. The midline crotch anchor is hidden in this view, but it affects the wrinkle pattern nonetheless. See also the same **outward extension** thrusts of arms, legs, and torso, and follow the remarkably similar coat curves on the back collar (they curve wider toward the rear shoulders). Look further at the tension pulls of the outstretched sleeves, then note the strong tension pulls on the stretched legs from the crotch—this creates long, outwardly radiating wrinkles. On the outer side of the figure's leg at left, we see several curves competing against the inside wrinkle tensions. These are crossing wrinkles (see chap. 4).

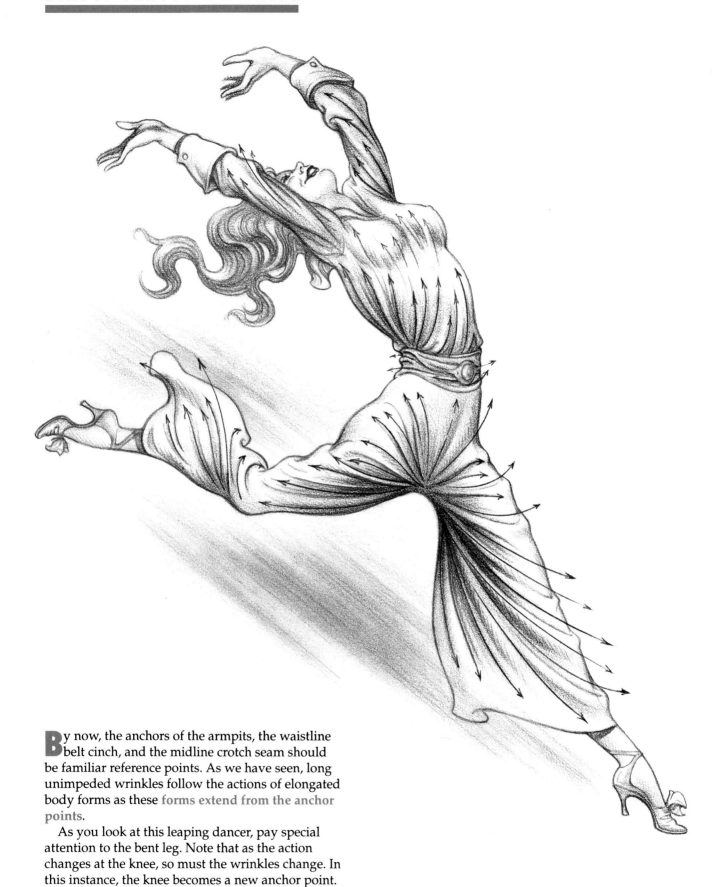

By now, the anchors of the armpits, the waistline belt cinch, and the midline crotch seam should be familiar reference points. As we have seen, long unimpeded wrinkles follow the actions of elongated body forms as these forms extend from the anchor points.

As you look at this leaping dancer, pay special attention to the bent leg. Note that as the action changes at the knee, so must the wrinkles change. In this instance, the knee becomes a new anchor point.

In this multiple-sequence figure depicting extreme arm and leg extensions, the logic of wrinkles as they follow the **flow of action** is very clear. Check the anchor points: armpits, collar, coat button at the waist, midline crotch seam.

Observe the subtle rotation of hands, arms, legs, and feet. Study the feet in detail. Note that the shoes, at center, tend to turn inward, and when the leg is fully extended, the shoes turn outward. See also how the wrinkles are influenced by the position of the shoes in each stage of the drawing.

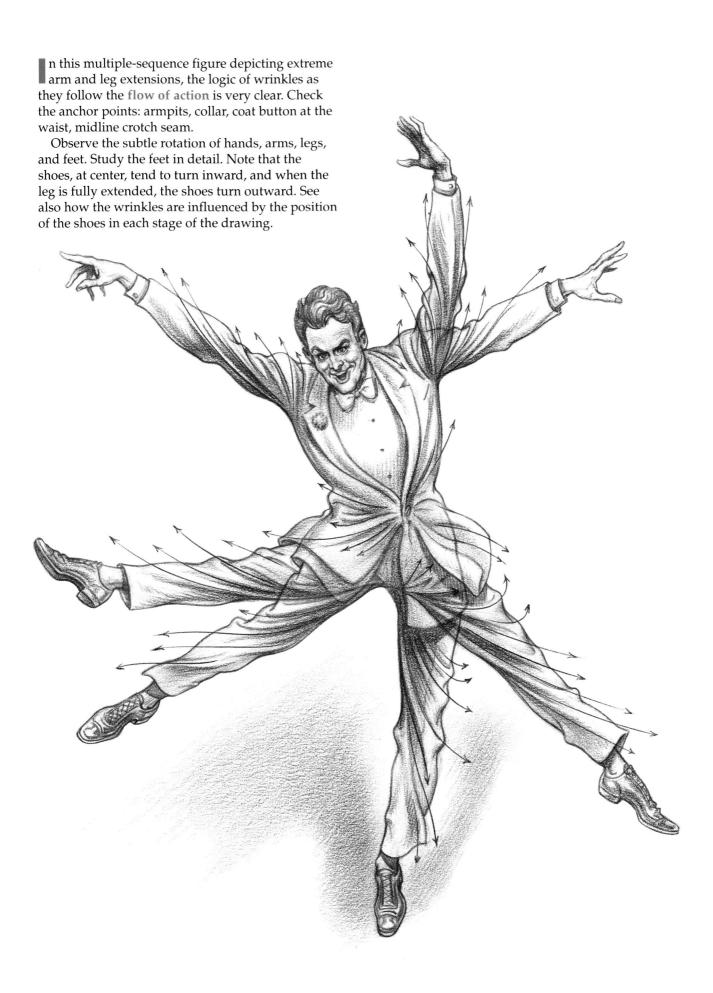

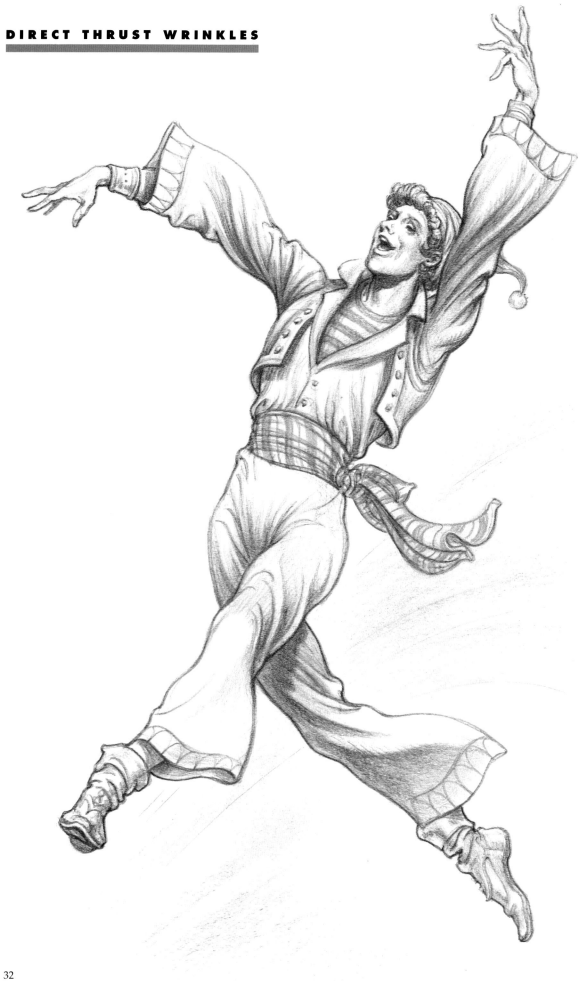

A conditional rule of wrinkles and folds is: **Loose material** tends to wind, curve, and spiral in active, free forms. Look carefully at the extended members of this leaping dancer. They display long, direct thrust wrinkles. Again we have foreshortening of forms, notably in the advancing leg at left, with wrinkles going into spiral curves. Note the loose, wide sleeves and trousers, and see also the free-flowing sash; virtually every garment here moves with spiral wrinkles.

It should be clear by now that the direct thrust wrinkle system is easily predictable. As long members stretch and move, in whatever direction, we can anticipate their course and pattern. As we see in this drawing, the **thrust force lines** always extend outward from the body along the arms and legs.

An important subtlety to note when looking at this drawing is that our viewpoint is angled toward the left rear of the man in the tilted seat. The forms look somewhat foreshortened and elliptically curved. The rule is that the more the forms recede, or become foreshortened, the more curved the wrinkles become.

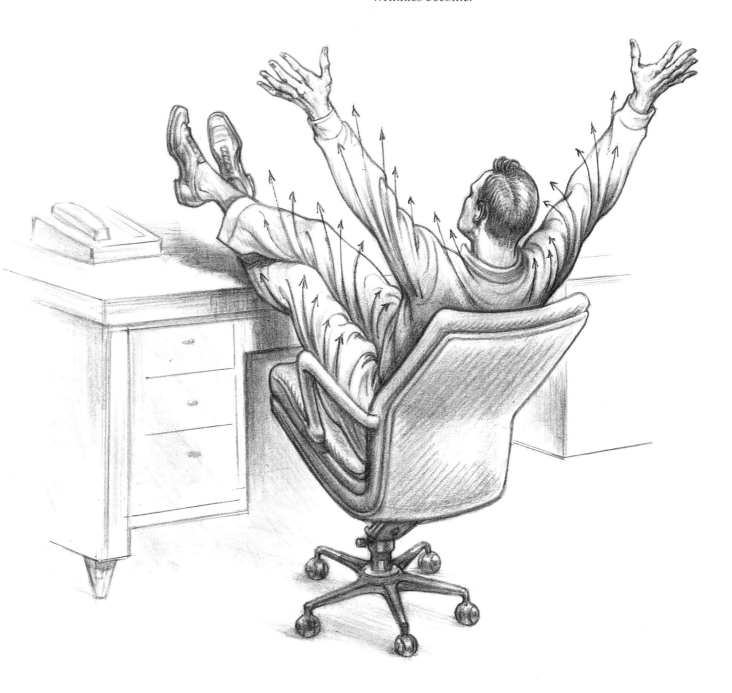

DIRECT THRUST WRINKLES

Two clowns give us a playful look at long direct thrust wrinkles in loose material and foreshortened forms. The trouser legs of both figures show kinetic tensions in long spiral wrinkles extending from crotch anchor points to the ankles (see arrows). The more closely fit sleeves express tightly wound curls (see arrows). Note the **foreshortening** of the arms caused by perspective.

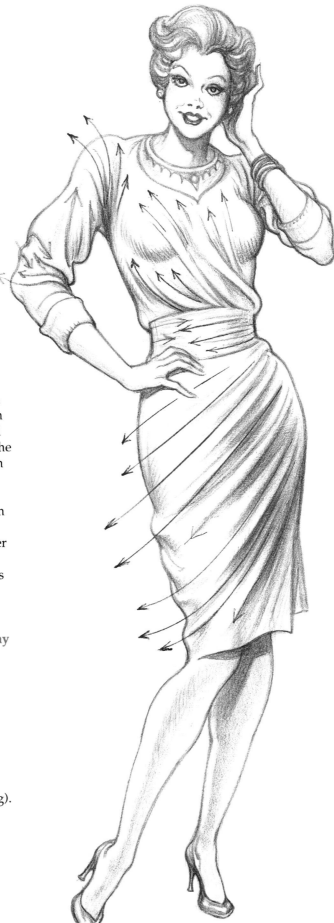

et's look at a female figure in a close-fitting skirt and blouse in order to examine two-directional direct thrust wrinkles. Observe the rising angular folds moving from the belt cinch toward the higher shoulder (see arrows). Also note the figure's high hip at right from which wrinkle forces move angularly down toward the lower thigh at left and the knee (see arrows). These two force patterns are carried through the entire figural stance.

The close-fitting outfit immediately gives **rhythmic sway** to the figure, involving the head attitude, the uplifted shoulder (which generates pull folds that act to reveal the breast thrusts), and the tight waistband tilted downward (which permits the arm and hand at left to support the rise of the right hip, from which curved wrinkles flow toward the leftward knee and leg).

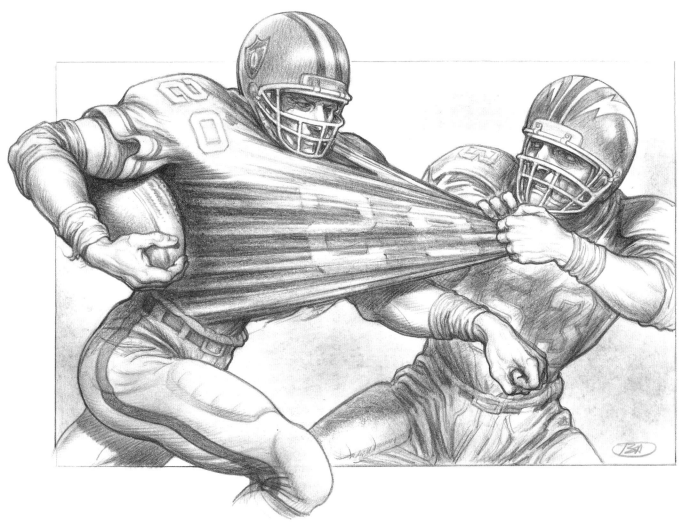

There are times when external events produce extension wrinkles of an unusual kind: In a football scrimmage, a player grabs the jersey of the ball carrier and holds tight. This sets the main anchor point off the body of the ball carrier. The hand of the player becomes the anchor, acting like a hook, catch or snag. The body of the ball carrier creates the thrust away from the anchor point. The result of these actions is an unusual cluster of extension wrinkles that radiate toward the ball carrier.

Let's put forward another rule: For a set of wrinkles, the tight and narrow sequence defines the anchor point; the wider set radiating away from the anchor point defines the direction of the thrust, as well as the location of the action of tension forces.

Here is a dancer in an unusual costume from Greco-Roman times. It is interesting to note the figure's hand gripping, at right, the garment. It acts as a displaced anchor off the body.

The handhold creates a wide set of extension wrinkles that fan out across the figure. Observe a second set of wrinkles across the length of the arm at right. Taut extension wrinkles also cover the shoulder at right and appear on the head, face, and arm at left, as well as down the back lower leg. A final set of swag and drag folds pull across the floor at left.

These wrinkles look complicated, but they follow the simple system of direct thrusts pulling away from anchor points. The thinner wrinkles are generated at the anchor points (see the hand at right and the one at left clutching by the neck). The loose drape behind the figure is covered with drag wrinkles created by the unattached anchor of the floor. The tension forces act to create direct thrust wrinkles that spread across the length of the figure, away from the anchor points.

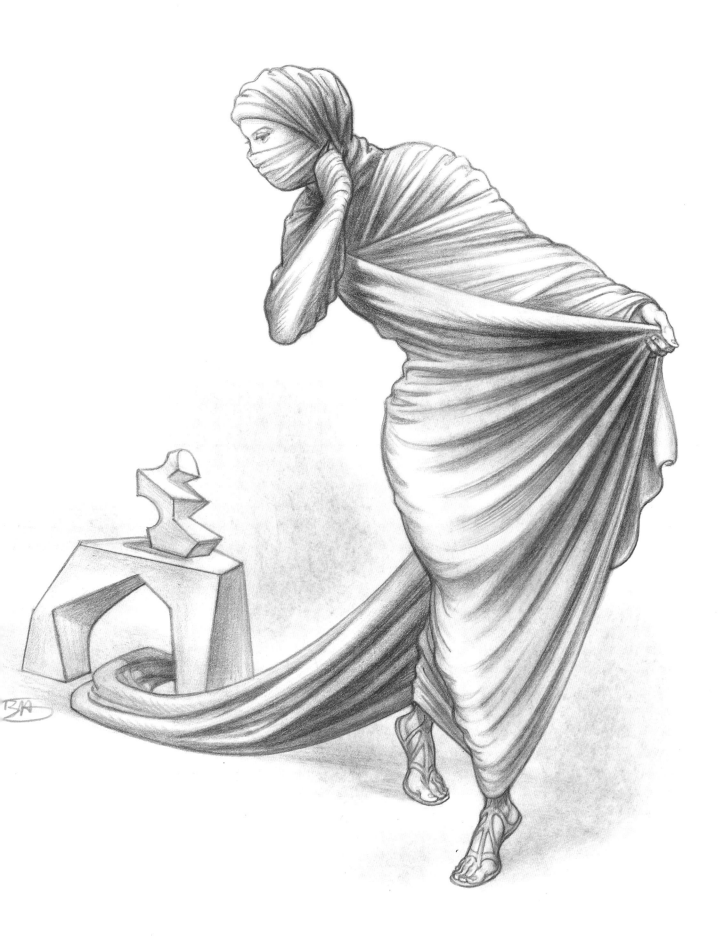

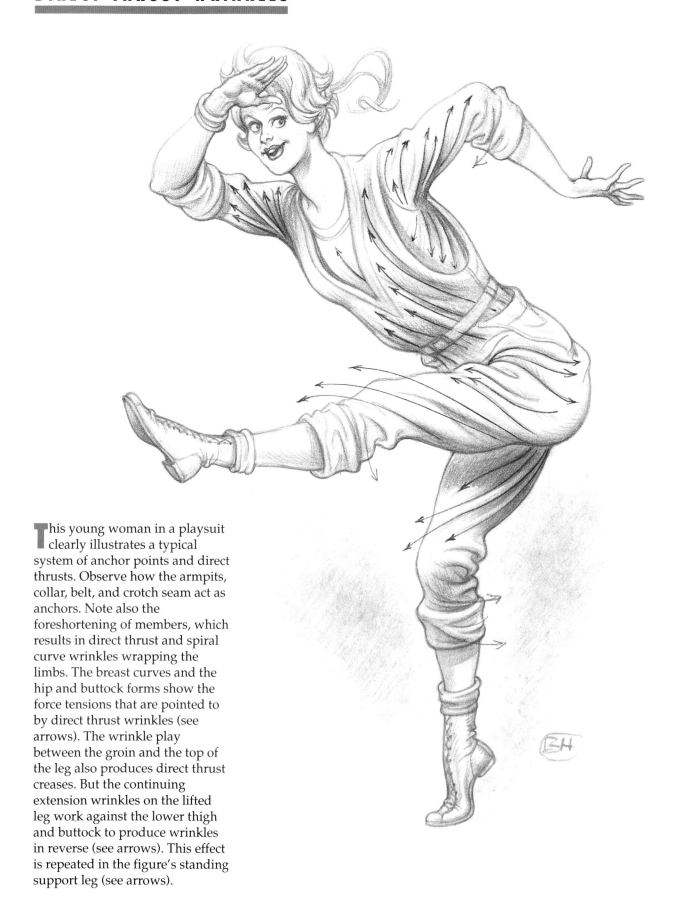

This young woman in a playsuit clearly illustrates a typical system of anchor points and direct thrusts. Observe how the armpits, collar, belt, and crotch seam act as anchors. Note also the foreshortening of members, which results in direct thrust and spiral curve wrinkles wrapping the limbs. The breast curves and the hip and buttock forms show the force tensions that are pointed to by direct thrust wrinkles (see arrows). The wrinkle play between the groin and the top of the leg also produces direct thrust creases. But the continuing extension wrinkles on the lifted leg work against the lower thigh and buttock to produce wrinkles in reverse (see arrows). This effect is repeated in the figure's standing support leg (see arrows).

Here we have two swordsmen in combat. From the foreground, the attacker's extended right sword arm creates extension wrinkles on the forward sleeve; the action creases spread backward across the tunic, chest, and hips; the waistline sash intervenes, but the backward movement continues in the braided cord as it swings out and back; the force moves down the long wrinkles of the extended leg. A long line of angular tension runs through the entire form of the figure. This angular force is reasserted in the background figure; it presses up his leg at left, his tilted body, and his uplifted arms. Both figures show taut extensions on raised leftward arms; the rightward bent legs of each figure produce forward and backward bend wrinkles (see chap. 3).

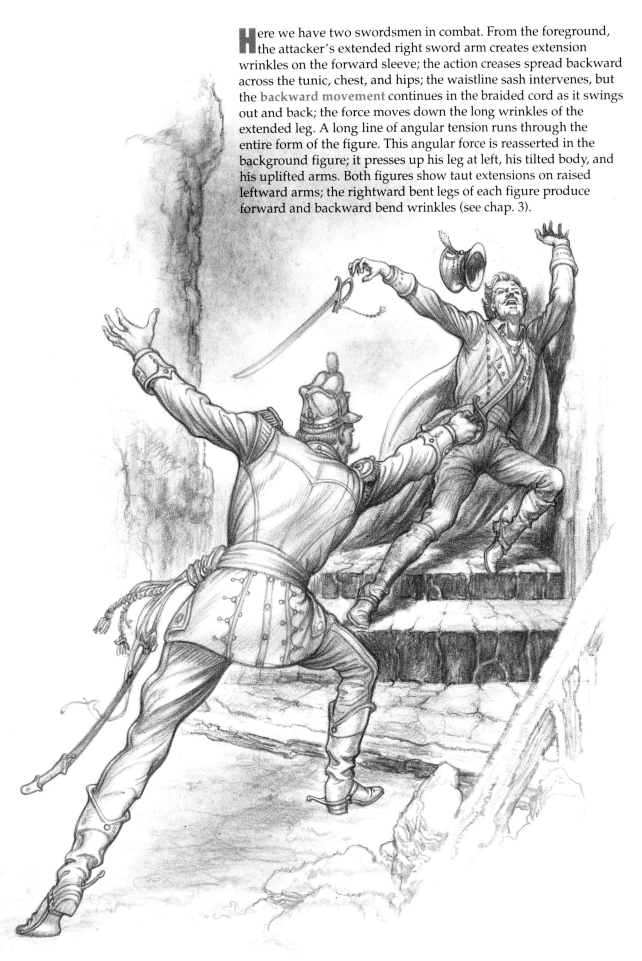

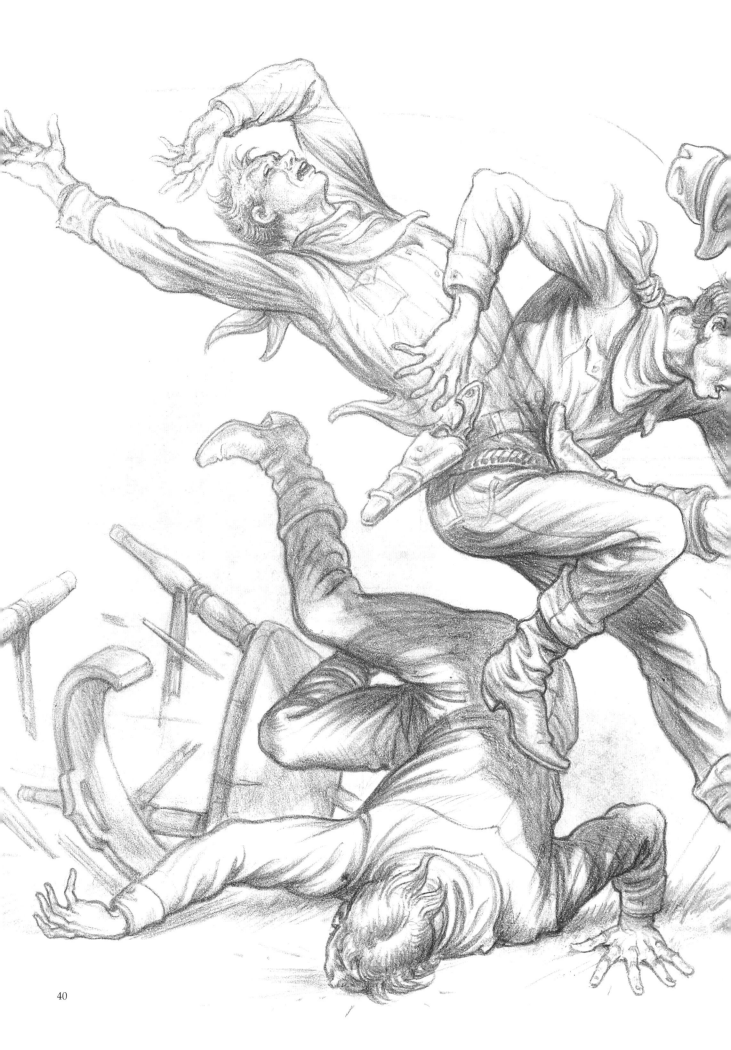

CHAPTER 3

BEND WRINKLES

Bend wrinkles, which are clearly direct thrust wrinkles, occur when arms and legs are bent at the elbows and knees. They form short backward and forward patterns. These **two-way bend patterns** are usually seen to best advantage in clothing when the arms and legs are given full exposition in design and situation.

A good example of such a situation is this fracas, which has erupted at the Hound Dog Saloon. Here we see two-way-thrust bend wrinkles, as well as full-thrust long extension wrinkles. Let's review the **long extension forms** in this drawing. The man at right has lashed out with a straight-leg kick at the belly of his opponent. Wrinkles on the extended leg of the attacking figure start from the deep crotch anchor, which sends a series of close thrust creases coursing across the thigh and across the lower leg to the boot.

Three other extension patterns can be seen on the double-phase figure in the center of the drawing. Note that the wrinkles formed on the extended arm and leg of the forward-bending version of the figure, and the outstretched arm on the version of the body that is lurching backward, all bear a similar dynamic pattern to the attacker's kicking leg. Each series of wrinkles emanates from a seam anchor, armpit or crotch, and each sequence of extension wrinkles flows down the length of the arm or leg, without interruption.

Now, let's return to our main concern of the moment—bend wrinkles. There are ten examples of bend-wrinkle patterns in this drawing. Six arm bends and four leg bends are included. Examine these examples carefully, and then think about the following basic principles that apply to bend wrinkles.

1. At the point of an elbow or knee bend, clothing gets tight, and a bony elbow or knee projection can be seen through the cloth.

2. Squeezed compression folds occur in the bend areas of the elbows and knees. Observe your own knee or elbow in a mirror.

3. Every bent-form system has both an outward and an inward pattern; the median point is the elbow or knee. The result is a two-form angularity—a thrust and a reverse. As you look at this drawing, remember that **wrinkles always follow the actions of forms**.

Bend wrinkles are a type of the direct thrust wrinkle, as they respond to the direct forces of outward arm and leg movements. The difference is that bend wrinkles form only when the extended members of the body bend at the elbows and knees, producing short, two-way (backward and forward) thrust patterns.

In these two examples of bend wrinkles, the trousers go forward with the upper legs and backward with the lower legs. The two-way wrinkles produced are reactions to a thrust force pushing at the knees (see large arrows), which are the midway points on the legs. The lower leg wrinkles tend to go backward from the knee (see arrows). The upper leg wrinkles go forward to the knee (see arrows). Note how these wrinkles move toward the front from under the buttock and the thigh.

As we move upward to the belly and groin, we see a set of curved creases erupting outward to the rear in both figures. This is the result of the strong leg thrust.

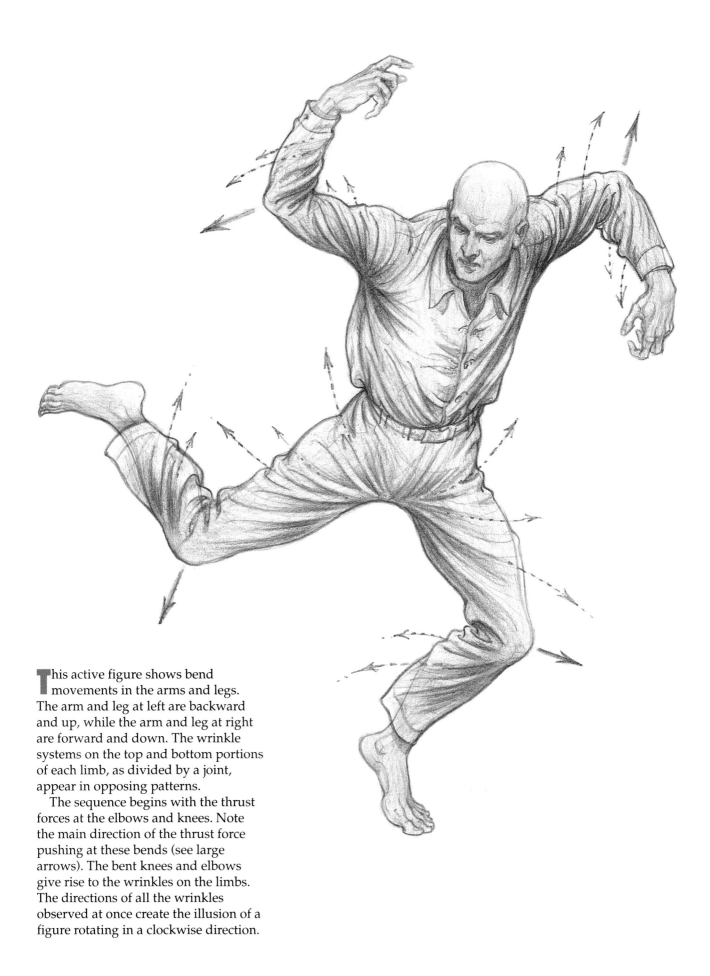

This active figure shows bend movements in the arms and legs. The arm and leg at left are backward and up, while the arm and leg at right are forward and down. The wrinkle systems on the top and bottom portions of each limb, as divided by a joint, appear in opposing patterns.

The sequence begins with the thrust forces at the elbows and knees. Note the main direction of the thrust force pushing at these bends (see large arrows). The bent knees and elbows give rise to the wrinkles on the limbs. The directions of all the wrinkles observed at once create the illusion of a figure rotating in a clockwise direction.

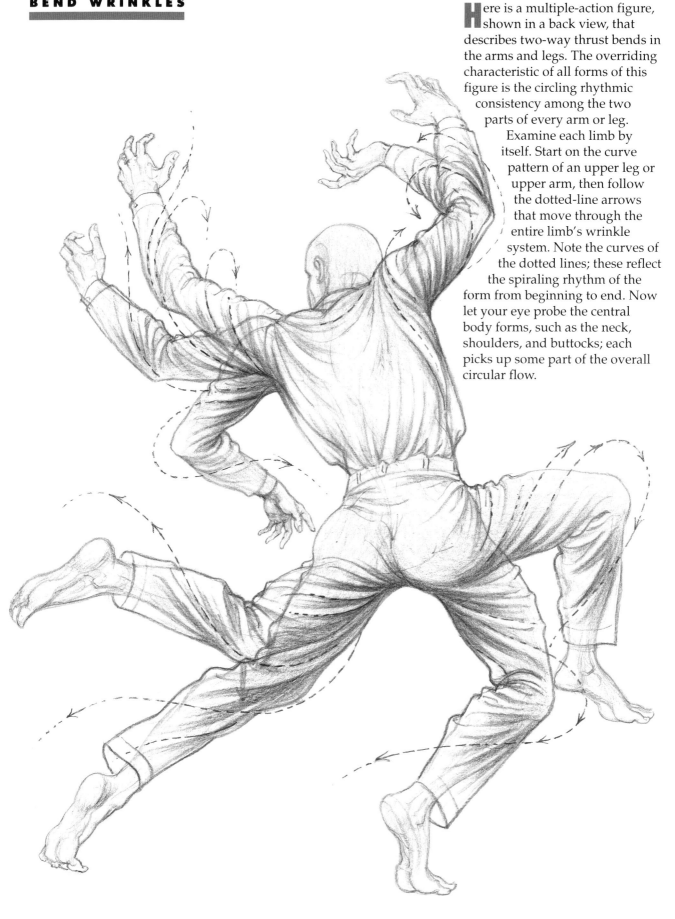

Here is a multiple-action figure, shown in a back view, that describes two-way thrust bends in the arms and legs. The overriding characteristic of all forms of this figure is the circling rhythmic consistency among the two parts of every arm or leg. Examine each limb by itself. Start on the curve pattern of an upper leg or upper arm, then follow the dotted-line arrows that move through the entire limb's wrinkle system. Note the curves of the dotted lines; these reflect the spiraling rhythm of the form from beginning to end. Now let your eye probe the central body forms, such as the neck, shoulders, and buttocks; each picks up some part of the overall circular flow.

The playful sport of piggyback provides an excellent opportunity to illustrate two-way bend actions in which the arms and legs produce a double system of curve and spiral wrinkles on their upper and lower portions.

The outward push of elbows and knees creates a midpoint breach. This starts the reverse activity of an inward contrary stress, whereby long wrinkles divide in half on the inside of the limbs. The midpoint breach compresses the inner elbow bend and back knee bend areas. In each of the figures, the dotted-line arrows show the forward and reverse flow of action, with the elbow or knee in the middle of the position change.

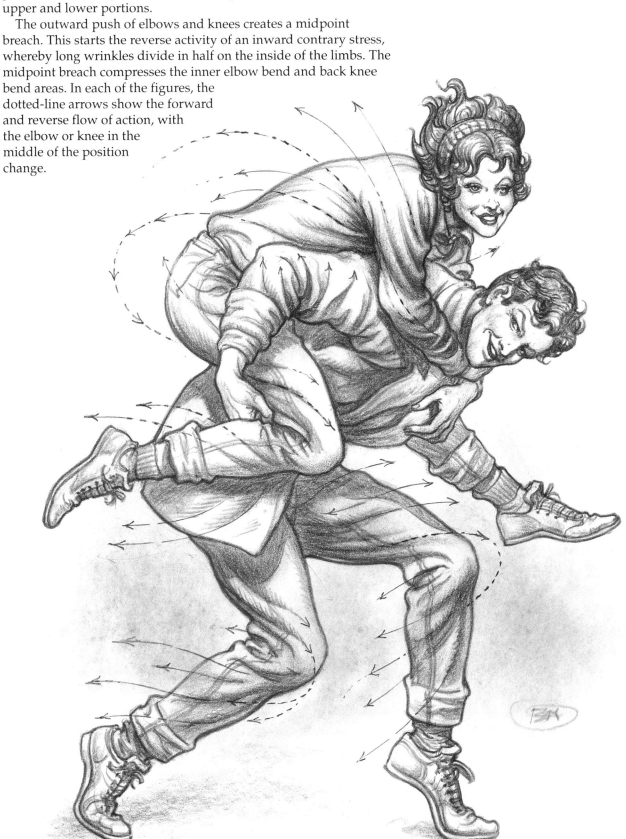

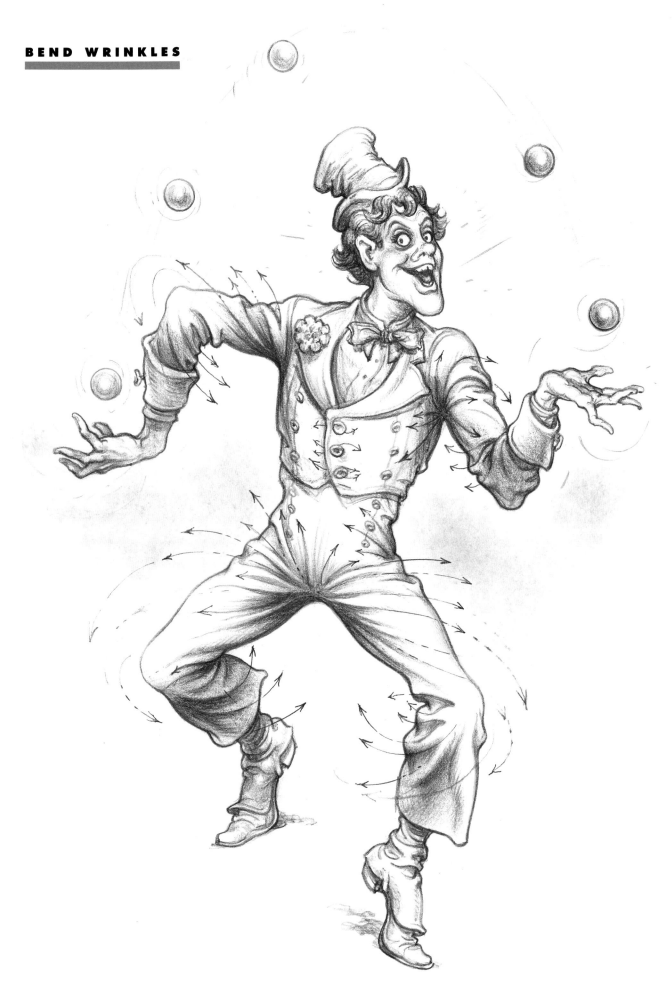

One of the most engaging qualities of two-way bend wrinkles is the tendency to develop a systematic pattern of flow, as in, for example, the arms from shoulders to wrists and the legs from the groin and crotch to the ankles.

In this juggler's stance, bend actions in the arms and legs create the predictable spiraling pattern (see arrows). The spirals spill outward invisibly onto the upper forms; reversing, they move down to connect on lower forms.

The midpoint sectors, the inner elbow and the back knee bend areas, show the tight compression creases. These blend and fuse the forces centrally, which then separate again into diverse actions.

A dress will wrinkle quite differently from pants and jackets, which tend to have short, two-way bend wrinkles. Observe this female figure in a silken gown of neoclassical attire. Long drape folds start from her shoulder at left (and inclined head), moving downward to produce an introductory ensemble of rhythmic flow tensions.

The folds wind up the arm, circling the breast and shoulder at right, then swinging down to the exposed elbow and forward knee; here, the flow reverses on the thigh and both knees in a swift downward cascade angling toward the rear. The course of leftward folds, like a curling wave, lifts, breaking right, swirling around the extended ankle, and spilling like a surging stream in a graceful sweep and drift—coiling in final closure around the water jar.

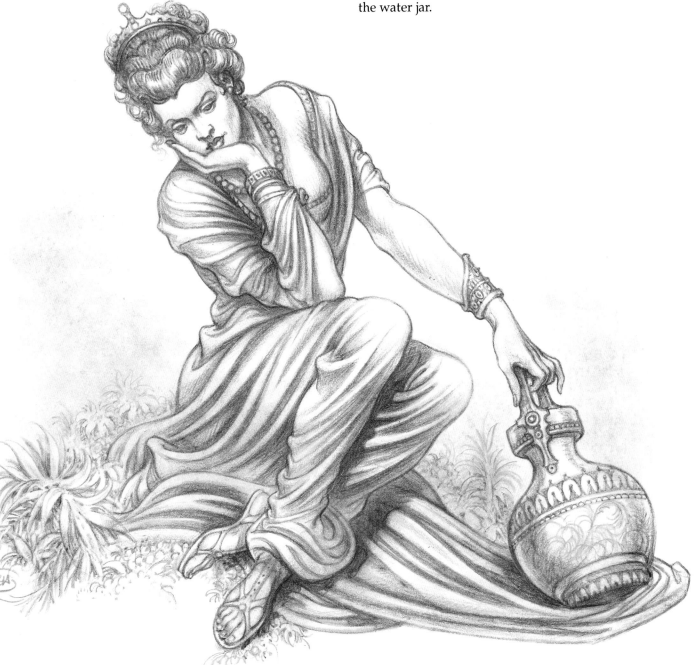

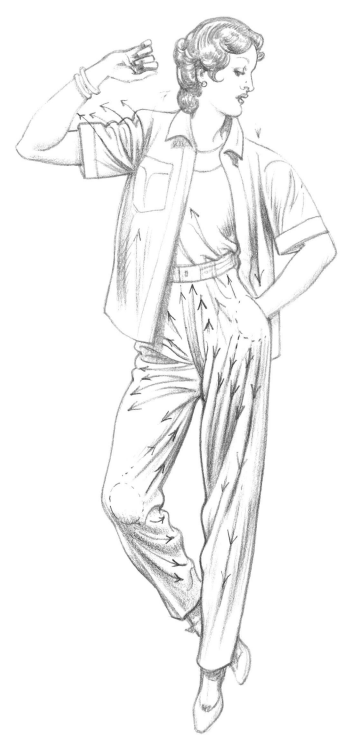

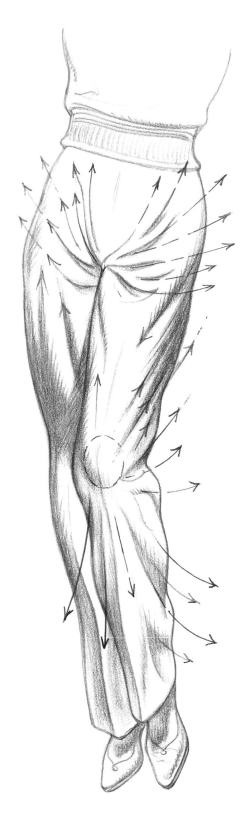

Let's look at two interesting examples of radial wrinkles. First, observe the full female figure in a leisure suit (above). Her bent leg at left (see oval) shows the typical two-way thrust; the upper leg creases forward, and the lower creases backward (see arrows). The leg at right is straight with a high hip support. Note the hand bulge in the pocket (see oval). This gives stress force to the entire straight leg, causing all wrinkles to move downward in a remarkable cascade of **straight folds**.

Next, look at the drawing of a woman's legs and lower torso (left). Radial wrinkles around the abdomen start from the crotch stress area. The knee thrust at right (see oval) initiates the radial wrinkle forces in all directions on the leg.

Let's compare two varieties of bend wrinkles seen in the clothing of the dancer and the drummer.

The typically masculine garb of the drummer, shirt sleeves and trousers, cover separate arms and legs. These clothes present a clearcut example of two-way thrust wrinkles in the upper and lower portions of the limbs. As the drummer's figure at left shows, the outer leg bend, with the knee forward, produces tight tension wrinkles from the seat to the knee. The reverse action, moving from knee to ankle, creates tension forces to the rear in a series of tight creases. Note the inward squeeze of the shoe at the ankle.

The drummer's taut body and arms have a direct forward thrust through the belly and chest that is carried up to the arms and hands. The wrinkle sweep created by this action becomes one system of **ascending movement**.

The dancing figure's skirt shows two-way bend wrinkles of a different sort. The overall skirt covering the upper legs does not allow the hidden inner wrinkle forces to appear on each leg. The tension forces are clear only at the outer sides of the skirt. The inner pull is an **irregular sequence** of stress across the figure's front thigh at right to the recessive tension of the back leg at left. Note how the excess agitated material flies out at the rear right; and the more so at the backward left where the skirt is more active and voluminous. Observe the tightly covered forms on the stretched bodice of the sweater.

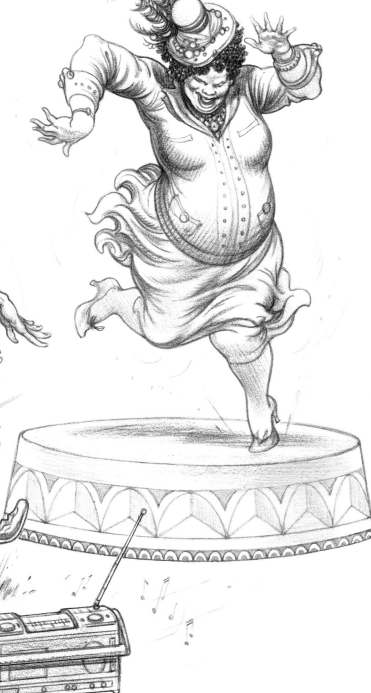

One important version of two-way bend wrinkles are radial wrinkles, which become visible only when a thrust force acts on a foreshortened frontal bend, as in the example where the bent knee projects straight out to the viewer. The oval on the front knee at right represents the thrust area that releases a pressure pattern of radiating wrinkles like spokes from an axle (see arrows). The wrinkles tend to flow outward in the loose trouser cloth, especially on the lower leg area, from knee to ankle.

Note that radial wrinkles as a group also tend to appear from the anchor points where arms and legs emerge. Observe how the radial wrinkles emerge from the figure's armpits (see arrows), flowing across the chest, shoulder, and arms. This wrinkle system also develops at the crotch of the trousers; wrinkles flow radially two ways up the groin and outward onto both thighs. From there, the wrinkles swing downward across the lower legs, especially on the figure's straight leg at left.

The radial wrinkle pattern of the bent knee repeats exactly on the bent elbows of the arms, as they project backward from a foreshortened space. The elbow (like the knee) is a central stress point that forces loose sleeve material to flow around outward and downward in a radial sequence of wrinkles.

Let's look at the woman for examples of stress points that create radial wrinkles. In a three-quarter rear view we see her arms in bend positions. The elbows project toward us, creating the illusion of foreshortening. The dotted ovals show the backward thrust of the elbows. Flowing curved wrinkles move outward radially from the elbows and turn inward to the wrist. The flexible skirt reveals the outward buttock pressure, and from this area we can again observe large wrinkles flowing around and downward on the striding leg.

Now locate the various elements at work in the man's sleeve (top right box). See the elbow shown with a dotted oval and the arrows given as guides for the radial wrinkle system. To the left, back and shoulder wrinkles emerge from under the armpit anchor.

An interesting radial wrinkle system emerges from the belt across the middle of the bottom figure at right. The armpit anchor initiates wrinkles in all directions. Wrinkles curl upward from the chest. The groin squeeze causes wrinkles to radiate downward to the left and right like wheelspokes. Look at the thigh and knee, where the knee front (see oval) shows the forward pressure of the leg. Below, the inside knee bend creates a cramped radial wrinkle system on the rear lower leg.

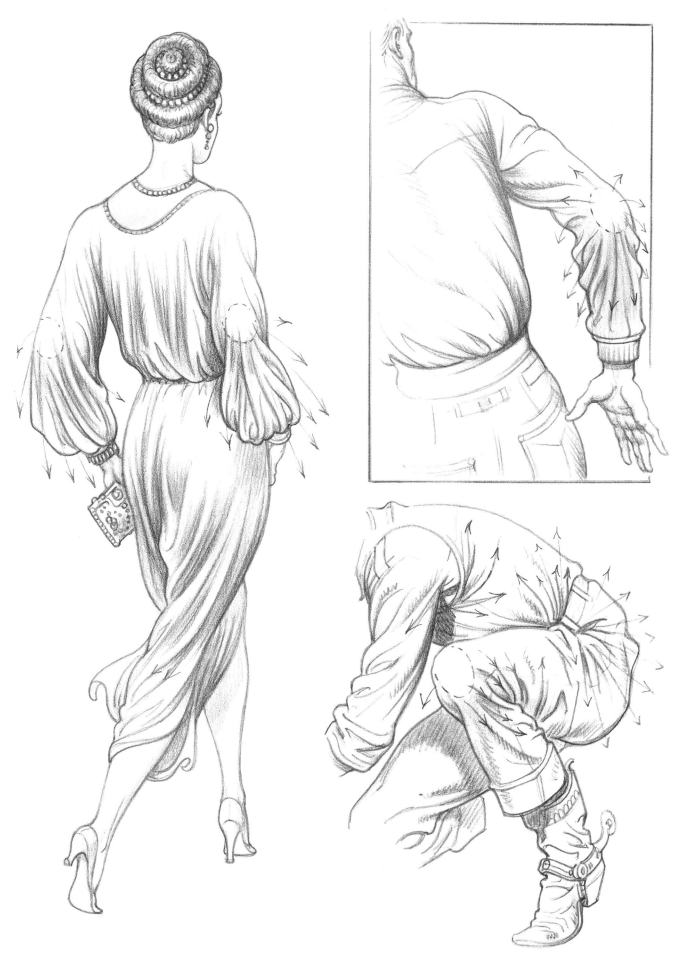

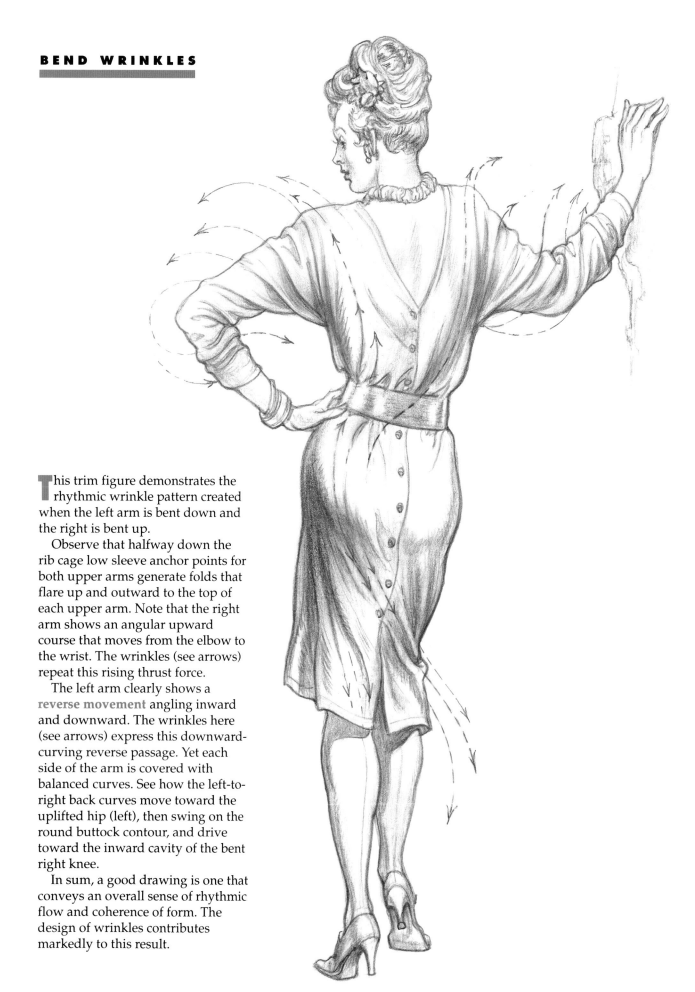

This trim figure demonstrates the rhythmic wrinkle pattern created when the left arm is bent down and the right is bent up.

Observe that halfway down the rib cage low sleeve anchor points for both upper arms generate folds that flare up and outward to the top of each upper arm. Note that the right arm shows an angular upward course that moves from the elbow to the wrist. The wrinkles (see arrows) repeat this rising thrust force.

The left arm clearly shows a **reverse movement** angling inward and downward. The wrinkles here (see arrows) express this downward-curving reverse passage. Yet each side of the arm is covered with balanced curves. See how the left-to-right back curves move toward the uplifted hip (left), then swing on the round buttock contour, and drive toward the inward cavity of the bent right knee.

In sum, a good drawing is one that conveys an overall sense of rhythmic flow and coherence of form. The design of wrinkles contributes markedly to this result.

This three-quarter side view presents a kneeling female figure attired in denim pants and bulky outerwear jacket. The **forward thrust** of the figure's bent knees in tight pants produces predictably smooth, flattened surfaces on the top thighs and knees of both legs. At the crotch-seam anchor points, diverging wrinkles are sent up to the groin and around the lower belly.

At midtorso, the tightness of the jacket waistband and pants create horizontal compression forces. The wrinkles on the inner leg at right come from the low inside crotch seam; but the outside wrinkles of the leg at left are formed in response to the stress

force at the buttock, and the forward stress on the leg sends wrinkles driving to the knee. On the lower sections of the legs, tight shin wrinkles flow backward from the knee and circle up and around the calf areas, ending at the cuffs.

Ordinarily, sleeve wrinkles are both numerous and curved. This figure's bulky sleeves, however, create relatively few wrinkles that are thick and angular. Also note that the armpit anchors are lowered into the sides of the jacket, where the seams tend to diverge, and wrinkles slip down to the waistband area. Small wrinkles are thus limited to the area around the waistband.

The soft-weave sweatsuit this young woman is wearing permits coursing wrinkles to easily enfold the body forms. The downwardly bent knee causes a group of **curving wrinkles** to move from the outer hip at left to the knee. The leg bend forces a reverse thrust into the back knee area, causing creases and underleg folds that move toward the elastic ankle band in the lower rear leg. Now, higher on the straightened leg at right, two small, relaxed wrinkles curve inward, revealing a rising contour of the thigh, which descends gently behind the active thrust of the bent knee.

The sway of the figure's hip at right generates a wave of ripple folds moving up toward the shoulder at left. This is the key to the rhythmic design of the figure: a curve that engages the wrinkles flowing up from the legs, rising inward toward the sleeves and up to the smiling face.

The sleeves themselves have no anchor other than their connection at the side torso, just above the waist. This excess creates a large winglike undersleeve that subsides into a droop, or swag form, which is created by the force of gravity.

These drawings of a cowgirl challenged by a bronc present a complex of **direct thrust** wrinkles and **bend** wrinkles. First, let's look at the large drawing at right. The woman is being lifted high out of the saddle. Her extended arm at right holds the reins, producing a sequence of long, direct thrust wrinkles that curve inward and follow the direction of thrust from shoulder to wrist.

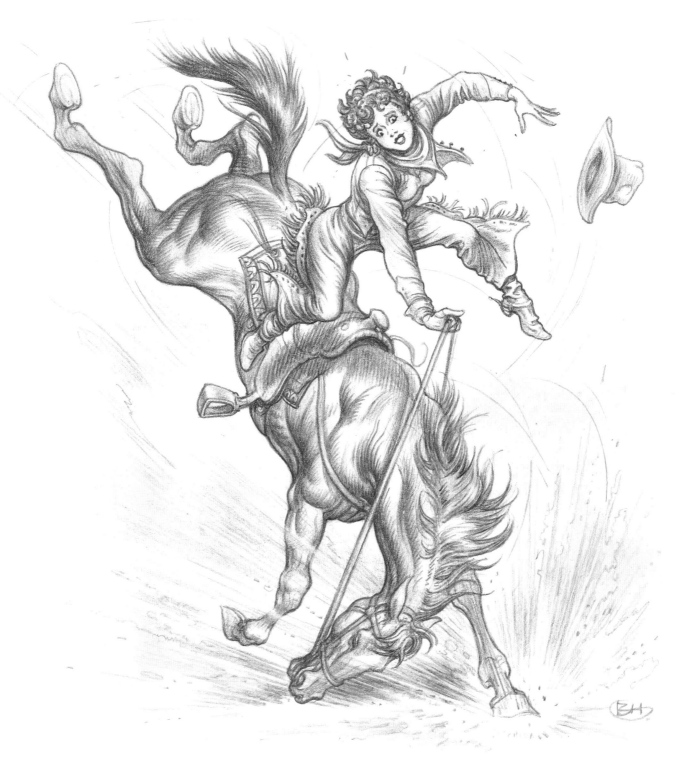

All other body forms are bent, creating short, two-way thrusts. The foreshortened legs are covered with spiraling wrinkles. Wrinkles in the upper portion of the cowgirl's chaps are created by the stress curves of the buttocks and outer leg acting on the inner thigh at right, while stress wrinkles on the inner thigh at left emerge from anchor points at the crotch seam and groin. The two lower legs move backward from the projecting knees, releasing a back-spiraling wrinkle flow from the knees to the boots. The side flaps of the fringed chaps fly backward as the tossed figure begins to plunge downward.

The small inset figure at left is a back-view version of the larger drawing. The wrinkle systems here tend to repeat those seen in the larger drawing. For example, observe the long, direct thrust wrinkles on the straight arm, and the shorter, two-way thrust wrinkles on the bent members. From this view, however, the bend wrinkles reverse direction. They begin to swing frontward, moving over the calf curves to the ankles.

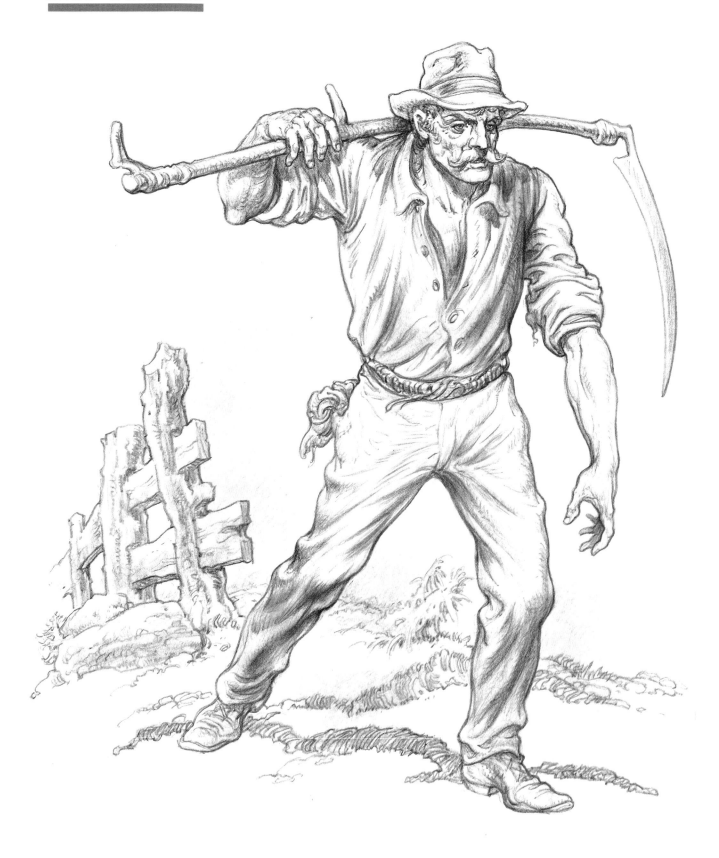

The legs of this farmer show aspects of bend wrinkles in two ways: His leg at right is clearly bent, but the leg at left is in an ambiguous position. Let's look a little closer and compare both legs in detail.

There's no doubt that the leg at right is bent. The knee juts forward and is outlined by the cloth; wrinkles emerge from the crotch seam and travel down toward the inner thigh and up the groin. Also note the crease behind the knee bend; it creates a downward flow of wrinkles from knee to ankle at the back of the leg. In sum, the rules of the two-way thrust are in effect.

The leg at left, however, is apparently shown from the front, creating the **impression of extension**. Note, however, that the knee bulge is given some emphasis, although it is not enhanced. The rear knee crease appears as a depression between side wrinkles above and below the knee. On the thigh, a group of folds sweep from the crotch seam to the outer leg; at this midpoint, the knee intervenes and wrinkles continue to the outside of the lower leg. Observe the shaded tone on the lower leg at left. It is there to enhance perspective, creating the illusion of depth. This illusion is used to show that the leg is not really straight, but is bent slightly backward.

The basic elements of both direct and two-way thrust wrinkles can be seen in this example of a frontiersman encountering a rattler. The frontiersman has an extended member—the pistol arm—that is a perfect example of the direct thrust wrinkle pattern. This pattern is repeated in buckskin garments of the leaning body and the outstretched leg.

The more complicated bend wrinkle system, created by the two-way thrust, can be seen on the figure's bent leg at left and bent arm at right. Each of these forms show the **midpoint force tension**, one at the knee, the other at the elbow. These midpoints initiate the angular reversal of forms that create the compression creases in the inner-elbow sleeve break and the back knee bend. Also, two-way thrust wrinkles radiate across the thigh and down the calf.

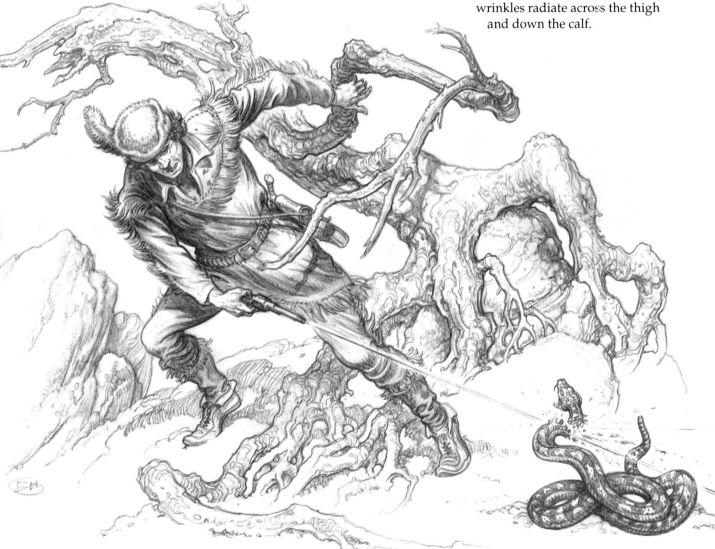

CHAPTER 4

CROSSING WRINKLES

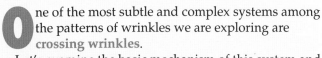

One of the most subtle and complex systems among the patterns of wrinkles we are exploring are **crossing wrinkles**.

Let's examine the basic mechanism of this system and describe the crossing pattern in simple terms: Put your hands together palms open; now, lace your fingers together in an alternating, dove-tailing arrangement. This weaving together of the fingers (*interdigitation*) is the basic model for the crossing wrinkle pattern. Another way to see this is to imagine the pattern a pair of skis leave in the snow. This **zigzag network** is something like a herringbone design, and it is the basic pattern used in drawing crossing wrinkles.

Crossing wrinkles generally occur in loose or open material on active body forms. The tension that creates crossing wrinkles comes from the intersection of two competing wrinkle patterns that meet while traveling in opposite directions—an example is seen in the stresses on a pant leg that come from the pull of the two sides of a thigh. The tension forces emanating from the left and right outlines of the leg, going toward each other and alternating inward, generate the classic crossing wrinkle.

The critical juncture in the formation of crossing wrinkles comes when the patterns moving away from two stress points move toward each other. In the moment when a collision seems possible, the leading edges of the wrinkle patterns tend to avoid direct impact and simply swerve around the potential meeting point. They then veer away from direct contact, creating the crossing wrinkle's signature zigzag pattern.

The crossed legs of this sailor getting positioned to paint the hull of a freighter give us a chance to study two different sets of crossing wrinkles. When one leg crosses over another, **friction drag forces** act on the trousers.

As the top leg slides across the lower, note the upward drag force working through the top leg from ankle to knee to crotch on the underplane of the trouser. Note also the minor wrinkles alternating with the major wrinkles of the leg, including those on the turned-up cuff. Conversely, the bottom leg shows a downward friction drag: As the top leg slides over it, the bottom trouser is pulled down, rubbing against the top trouser as it is being pulled up. Observe how two contrary drag forces affect both legs: The upper becomes high and tight; the bottom, low and loose.

The loose blouse on the man reacts to the slight upward rotation of the body and the direct upward and frontal thrusts of the arms. These are fairly simple, single direction tensions, except for those at the waistline, where the loose material goes into crossing wrinkles. Throughout the figure, the rolled-up cuffs of sleeves and trousers give us the zigzag patterns of the crossing wrinkle.

Look for conflicting tension forces in the drawing of the male frontal figure. Observe how wrinkles from outside and inside the figure's straight leg at left move toward the center of the leg (see arrows). Note how the thigh area of the figure's bent leg at right shows stress forces of alternating directions heading inward to the knee bulge.

The two wrinkle sources acting on each leg are not equal in force because the figure is moving with greater emphasis on a particular side of a body form. This force factor produces stronger, deeper wrinkles from one of the two sources, like those on the outside of the figure's leg at left. In general, one of the two cross-stresses that create crossing wrinkles is dominant and points out the area of greatest activity. To distinguish between the results of the two stresses, which form crossing wrinkles, we refer to long side wrinkles as the result of the **major force**, and short side wrinkles as the result of the **minor force**.

Once we understand major force wrinkles, the minor and lesser folds of the crossing wrinkle system are easy to distinguish and to work through with assurance.

In the drawing of the woman on the phone, note the action of the upper torso and the leftward arm. These forms move in an upward swing from left to right. Now look at the major wrinkles, which emphasize and reinforce this direction on the shoulder and the body under the arm. Take note of the minor wrinkles crossing from the opposite side (right to left). Lower on the figure, the hips and legs are in a force thrust position that moves the body from left to right.

Each leg shows decisive strong folds originating from the left. These are the **major wrinkles**. Once you have observed these, note the shorter minor wrinkles, which come in from the right side.

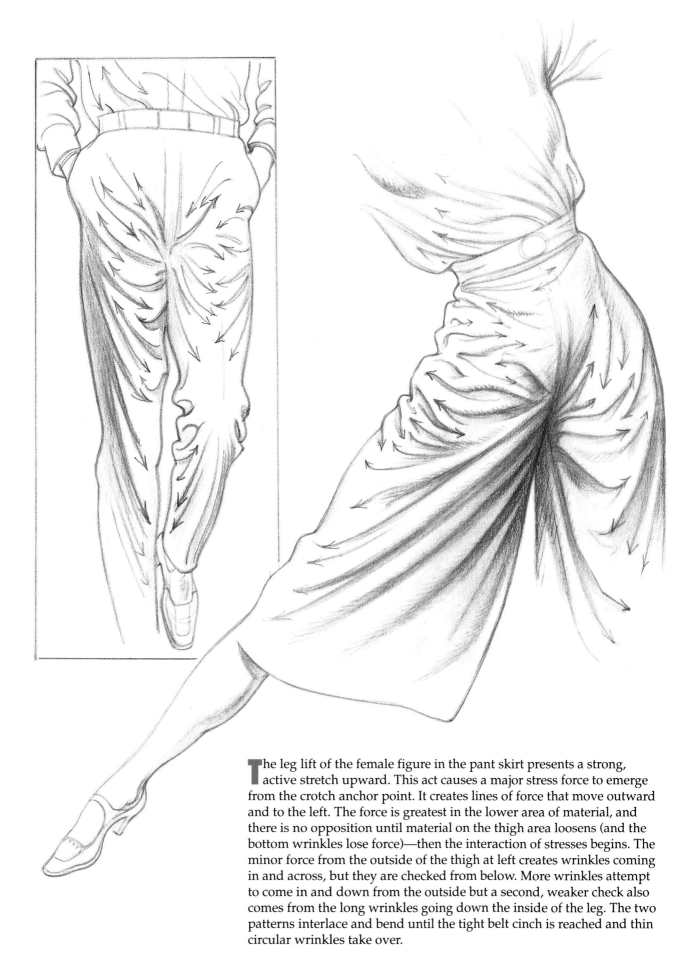

The leg lift of the female figure in the pant skirt presents a strong, active stretch upward. This act causes a major stress force to emerge from the crotch anchor point. It creates lines of force that move outward and to the left. The force is greatest in the lower area of material, and there is no opposition until material on the thigh area loosens (and the bottom wrinkles lose force)—then the interaction of stresses begins. The minor force from the outside of the thigh at left creates wrinkles coming in and across, but they are checked from below. More wrinkles attempt to come in and down from the outside but a second, weaker check also comes from the long wrinkles going down the inside of the leg. The two patterns interlace and bend until the tight belt cinch is reached and thin circular wrinkles take over.

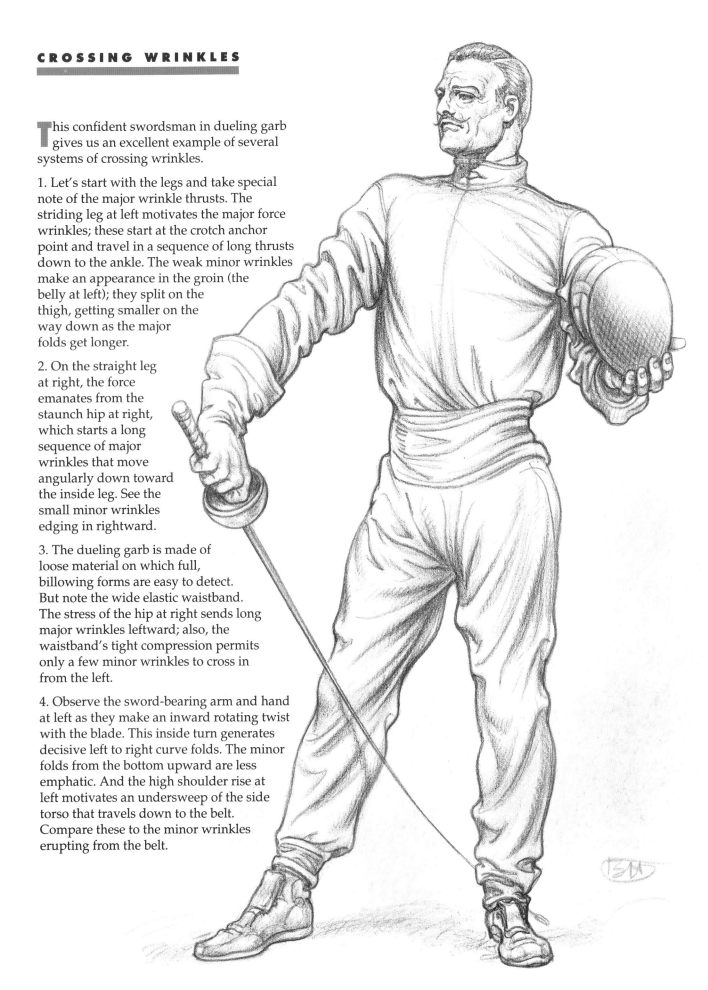

This confident swordsman in dueling garb gives us an excellent example of several systems of crossing wrinkles.

1. Let's start with the legs and take special note of the major wrinkle thrusts. The striding leg at left motivates the major force wrinkles; these start at the crotch anchor point and travel in a sequence of long thrusts down to the ankle. The weak minor wrinkles make an appearance in the groin (the belly at left); they split on the thigh, getting smaller on the way down as the major folds get longer.

2. On the straight leg at right, the force emanates from the staunch hip at right, which starts a long sequence of major wrinkles that move angularly down toward the inside leg. See the small minor wrinkles edging in rightward.

3. The dueling garb is made of loose material on which full, billowing forms are easy to detect. But note the wide elastic waistband. The stress of the hip at right sends long major wrinkles leftward; also, the waistband's tight compression permits only a few minor wrinkles to cross in from the left.

4. Observe the sword-bearing arm and hand at left as they make an inward rotating twist with the blade. This inside turn generates decisive left to right curve folds. The minor folds from the bottom upward are less emphatic. And the high shoulder rise at left motivates an undersweep of the side torso that travels down to the belt. Compare these to the minor wrinkles erupting from the belt.

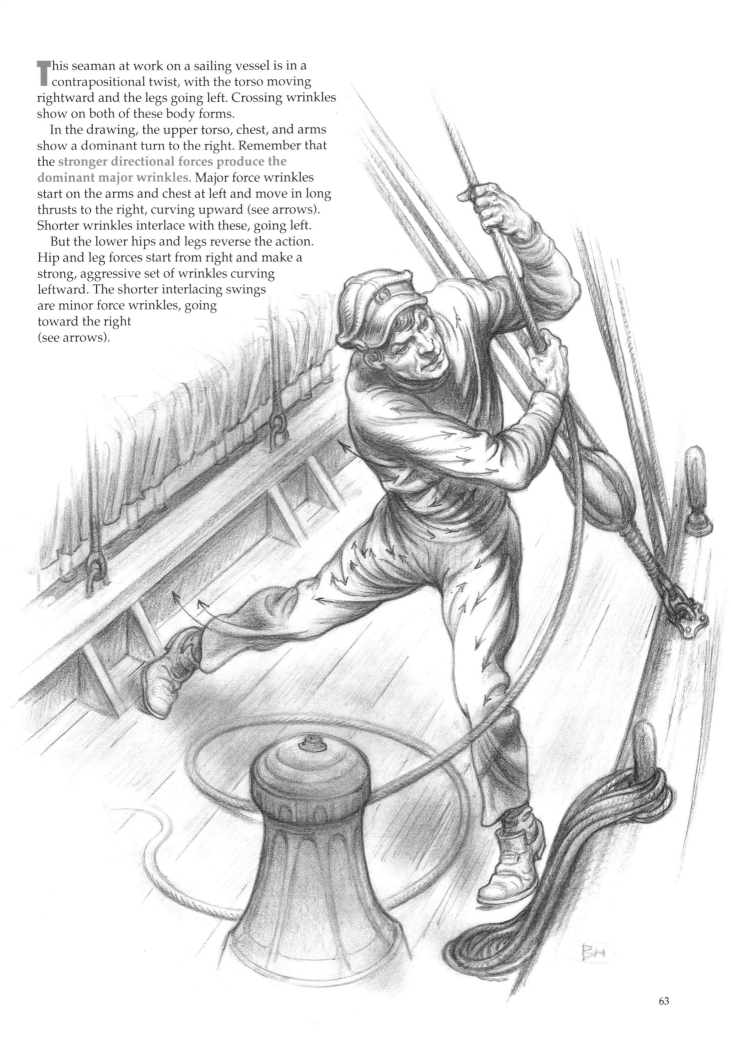

This seaman at work on a sailing vessel is in a contrapositional twist, with the torso moving rightward and the legs going left. Crossing wrinkles show on both of these body forms.

In the drawing, the upper torso, chest, and arms show a dominant turn to the right. Remember that the **stronger directional forces produce the dominant major wrinkles.** Major force wrinkles start on the arms and chest at left and move in long thrusts to the right, curving upward (see arrows). Shorter wrinkles interlace with these, going left.

But the lower hips and legs reverse the action. Hip and leg forces start from right and make a strong, aggressive set of wrinkles curving leftward. The shorter interlacing swings are minor force wrinkles, going toward the right (see arrows).

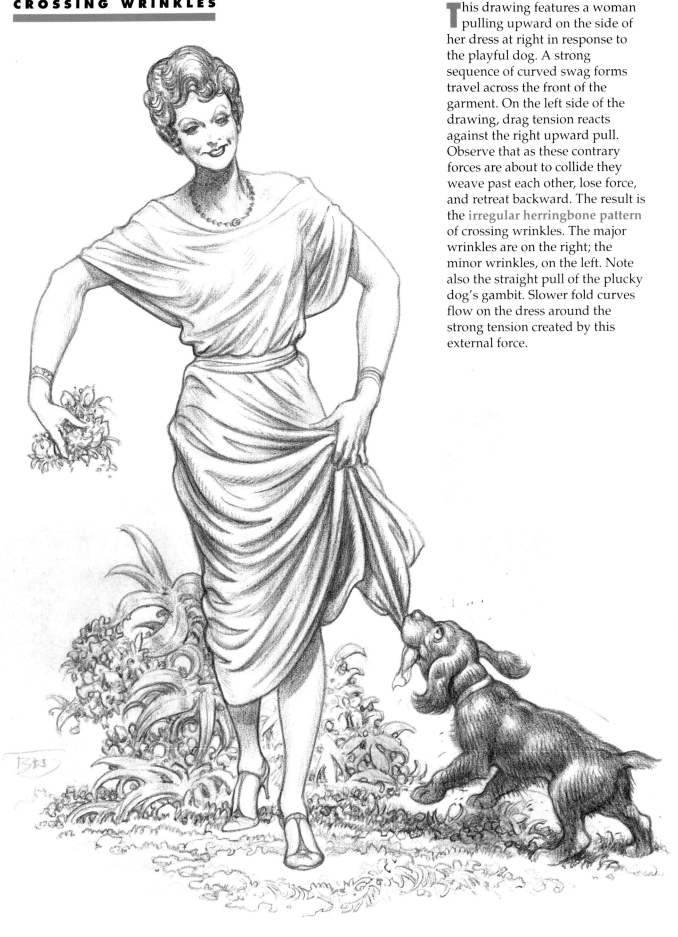

This drawing features a woman pulling upward on the side of her dress at right in response to the playful dog. A strong sequence of curved swag forms travel across the front of the garment. On the left side of the drawing, drag tension reacts against the right upward pull. Observe that as these contrary forces are about to collide they weave past each other, lose force, and retreat backward. The result is the irregular herringbone pattern of crossing wrinkles. The major wrinkles are on the right; the minor wrinkles, on the left. Note also the straight pull of the plucky dog's gambit. Slower fold curves flow on the dress around the strong tension created by this external force.

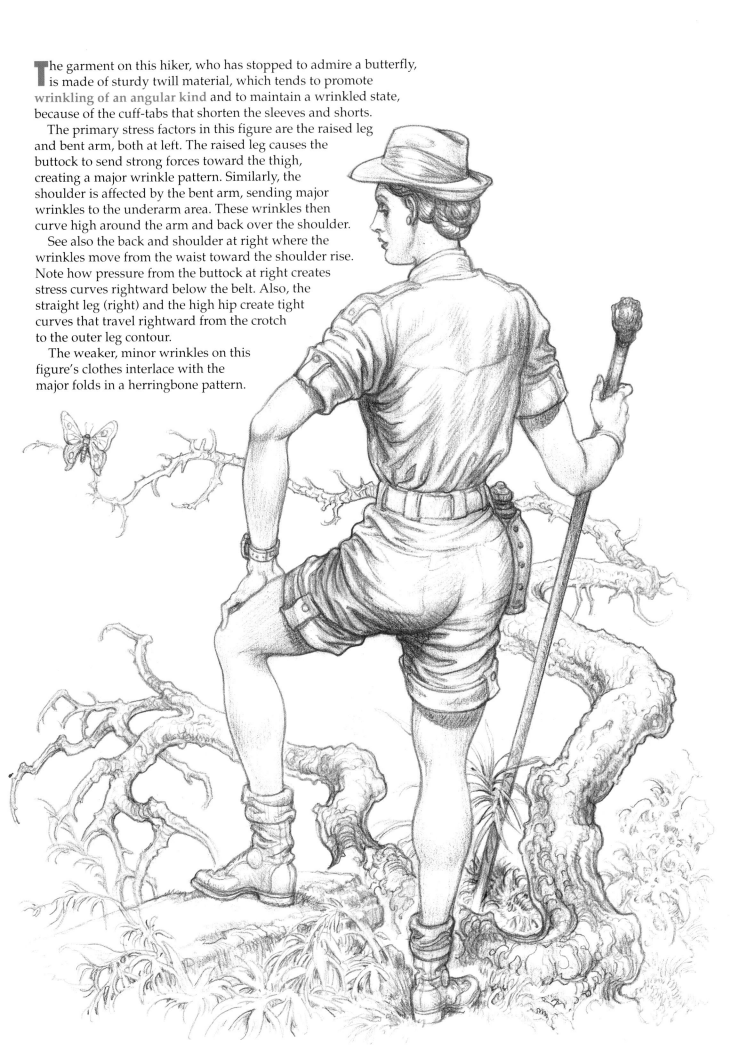

The garment on this hiker, who has stopped to admire a butterfly, is made of sturdy twill material, which tends to promote **wrinkling of an angular kind** and to maintain a wrinkled state, because of the cuff-tabs that shorten the sleeves and shorts.

The primary stress factors in this figure are the raised leg and bent arm, both at left. The raised leg causes the buttock to send strong forces toward the thigh, creating a major wrinkle pattern. Similarly, the shoulder is affected by the bent arm, sending major wrinkles to the underarm area. These wrinkles then curve high around the arm and back over the shoulder.

See also the back and shoulder at right where the wrinkles move from the waist toward the shoulder rise. Note how pressure from the buttock at right creates stress curves rightward below the belt. Also, the straight leg (right) and the high hip create tight curves that travel rightward from the crotch to the outer leg contour.

The weaker, minor wrinkles on this figure's clothes interlace with the major folds in a herringbone pattern.

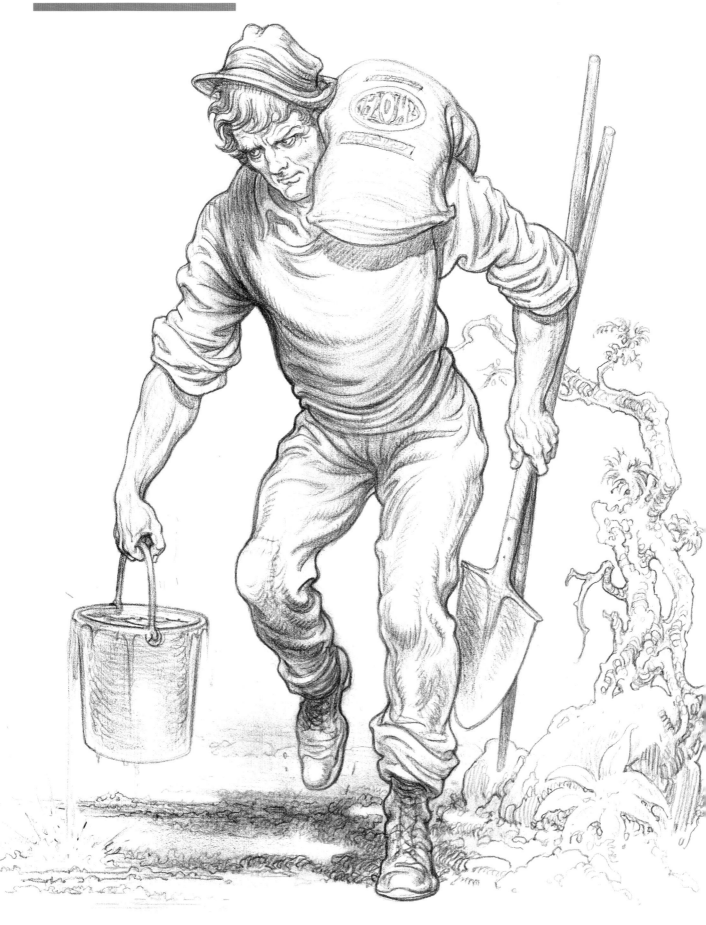

When crossing wrinkles appear on old clothes, as seen on this workman, the folds and creases seem to fall into established, **repetitive patterns**, as if the clothes were "broken in." A subtle **interior plasticity** is responsible for this "well-worn" look.

In the drawing, the figure shows certain predefined contours in the belly and chest, the sleeves, and the contours of legs. The arms, for example, show crossing wrinkles, but the major and minor wrinkles are not easy to tell apart because of wear in the clothing.

The heavy workpants also admit to past actions, especially on the trouser leg at right. The wrinkles appear in diminished patterns because of inhibited crossing forces. Only in the lower bent leg at left do we see the effects of strong body pressures that are immediate and not left over from some earlier wear.

The forward leg of this girl dancing in a loose, wide-spread skirt gives us an example of virtually **symmetrical** crossing wrinkles. This leg is central to our field of vision, and the left and right force systems are of equal tension. This creates an equal, two-sided sequence of crossing wrinkles. See how the symmetry of the force curves work out; we are hard put to decide which side is major or minor.

The forces acting on the loose, hand-held wings of the skirt, however, are not equal. The hand at left is raised higher and farther out than the one at right, creating more open, pulled-out crossing wrinkles. The hand at right is held lower and closer to the body, and a balanced zigzag pattern is immediately apparent. Despite the similarities of the two wrinkle systems that join to create crossing wrinkles, we are sure that the major force comes from the right, which is where the pull tension occurs.

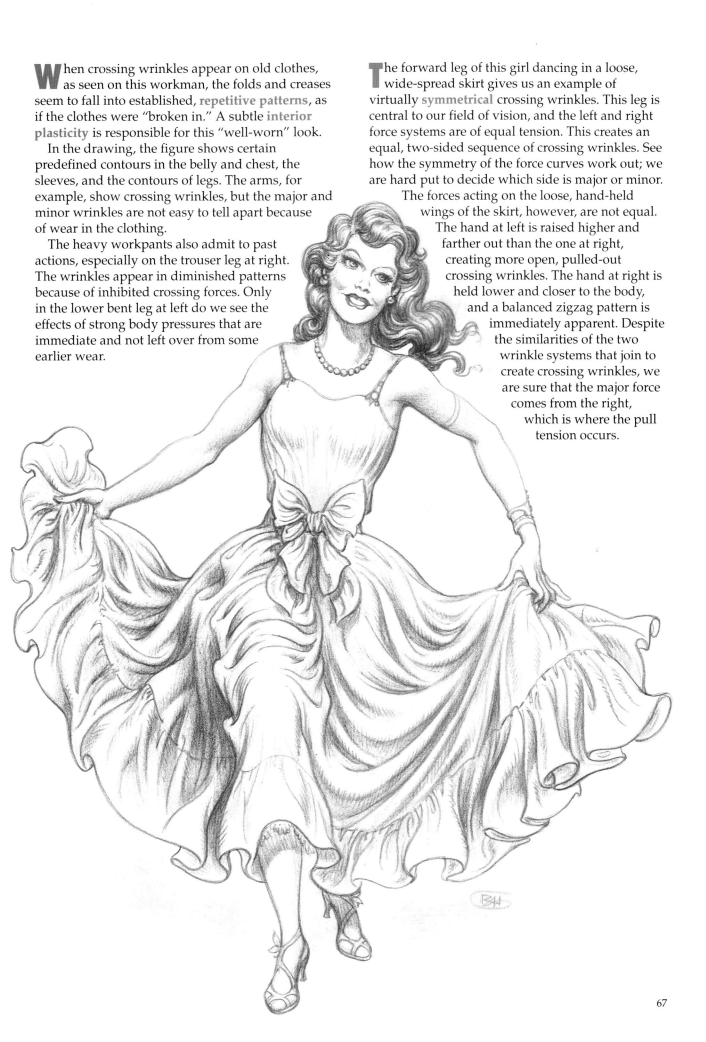

This dour-looking fellow, with legs drawn in two positions, gives us several examples of crossing wrinkles.

The arms of our figure produce crossing wrinkles based on the stress action of each bent member. The arm at left reaches forward, bends, and rotates inward, as the hand is placed on the rear leg. These moves cause a set of simple curves to emerge from the armpit anchor point. As the arm bends and turns, crossing wrinkles take over on the outside sleeve, while the inside folds tend to maintain the forward thrust.

The bend in the arm at right puts a major stress on the underarm, leaving long wrinkles on the upper inside sleeve (from the backward stress) long wrinkles on the bent underarm. In contrast to these, short minor wrinkles appear on the outer sleeve of the top of the arm and also on the inner sleeve of the bottom forearm. These all join to form typical crossing wrinkles.

Stress forces created by the torso send wrinkles curving around the figure's collar and down into the armpit at right, then out abruptly. The torso stress is downward because it is linked to the coat button anchor point; from there the tension goes rightward to the hand in the pocket. Then, see how the major force sends a long, straight wrinkle upward, ending just before the back of the coat. On the thumb edge of the hand, little fragmentary wrinkles echo the long thrust higher. Meanwhile, the hand in the pocket sets up a severe cross-barrier (running angularly downward) to stop the horizontal coat wrinkles at the pocket bulge.

Both bent leg forms (outside left and right) give us two-way thrust wrinkles. As we examine the long wrinkles, especially on the lower legs, however, note the short minor wrinkles playing alternately against the long one coming from behind. These work together to form crossing wrinkles.

The extended crossed legs (center) reveal a downward slide of the top leg. The wrinkles below the knee are taut and pulled upward because of the drag tension. But higher on the leg, where loose material is pushed together, this array tends to form a zigzag pattern. The extended lower leg is similar to the top, but its long wrinkles go downward and forward, as the trouser is pressed by the top leg. Minor wrinkles show on the contact area of two legs. The upper section of the top leg has a clear forward thrust. This creates wrinkles on the top leg that slide up and ones on the bottom leg that are forced down.

CROSSING WRINKLES

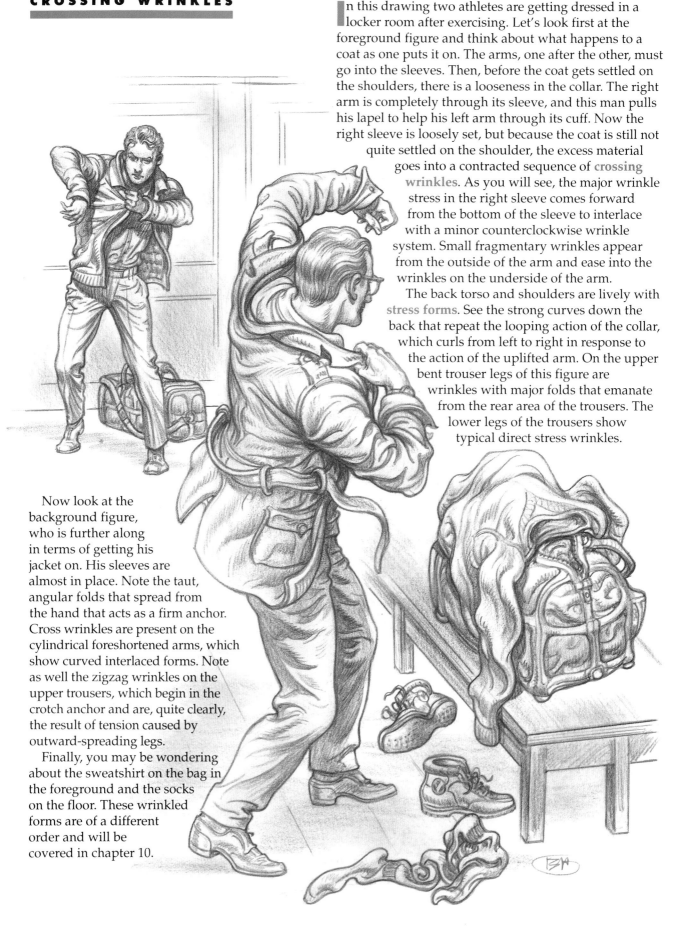

In this drawing two athletes are getting dressed in a locker room after exercising. Let's look first at the foreground figure and think about what happens to a coat as one puts it on. The arms, one after the other, must go into the sleeves. Then, before the coat gets settled on the shoulders, there is a looseness in the collar. The right arm is completely through its sleeve, and this man pulls his lapel to help his left arm through its cuff. Now the right sleeve is loosely set, but because the coat is still not quite settled on the shoulder, the excess material goes into a contracted sequence of **crossing wrinkles**. As you will see, the major wrinkle stress in the right sleeve comes forward from the bottom of the sleeve to interlace with a minor counterclockwise wrinkle system. Small fragmentary wrinkles appear from the outside of the arm and ease into the wrinkles on the underside of the arm.

The back torso and shoulders are lively with **stress forms**. See the strong curves down the back that repeat the looping action of the collar, which curls from left to right in response to the action of the uplifted arm. On the upper bent trouser legs of this figure are wrinkles with major folds that emanate from the rear area of the trousers. The lower legs of the trousers show typical direct stress wrinkles.

Now look at the background figure, who is further along in terms of getting his jacket on. His sleeves are almost in place. Note the taut, angular folds that spread from the hand that acts as a firm anchor. Cross wrinkles are present on the cylindrical foreshortened arms, which show curved interlaced forms. Note as well the zigzag wrinkles on the upper trousers, which begin in the crotch anchor and are, quite clearly, the result of tension caused by outward-spreading legs.

Finally, you may be wondering about the sweatshirt on the bag in the foreground and the socks on the floor. These wrinkled forms are of a different order and will be covered in chapter 10.

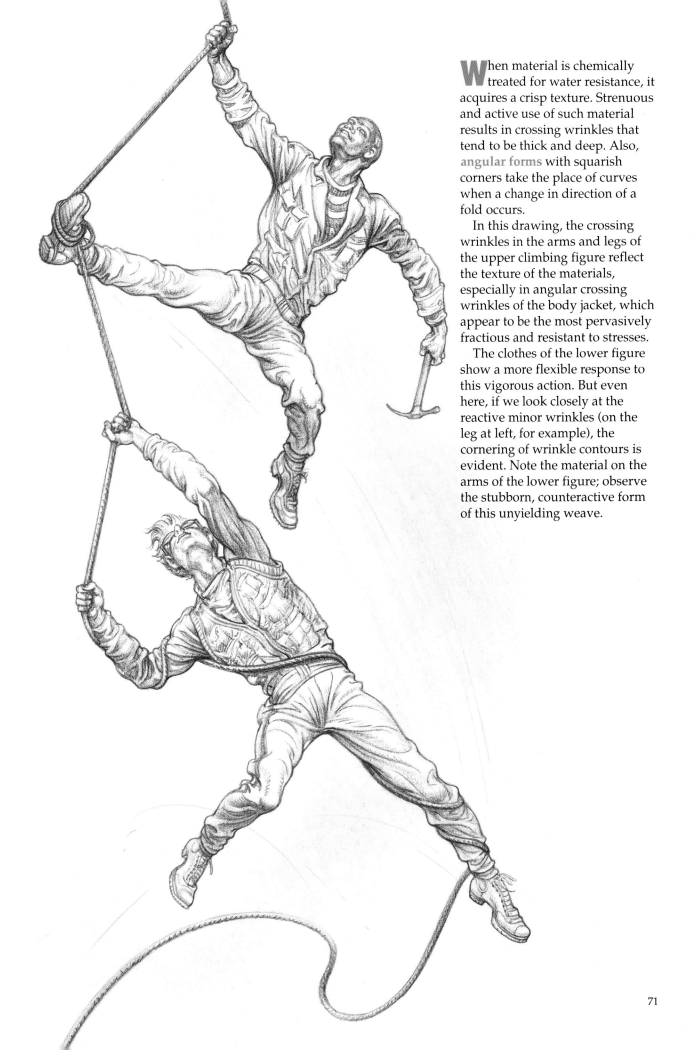

When material is chemically treated for water resistance, it acquires a crisp texture. Strenuous and active use of such material results in crossing wrinkles that tend to be thick and deep. Also, angular forms with squarish corners take the place of curves when a change in direction of a fold occurs.

In this drawing, the crossing wrinkles in the arms and legs of the upper climbing figure reflect the texture of the materials, especially in angular crossing wrinkles of the body jacket, which appear to be the most pervasively fractious and resistant to stresses.

The clothes of the lower figure show a more flexible response to this vigorous action. But even here, if we look closely at the reactive minor wrinkles (on the leg at left, for example), the cornering of wrinkle contours is evident. Note the material on the arms of the lower figure; observe the stubborn, counteractive form of this unyielding weave.

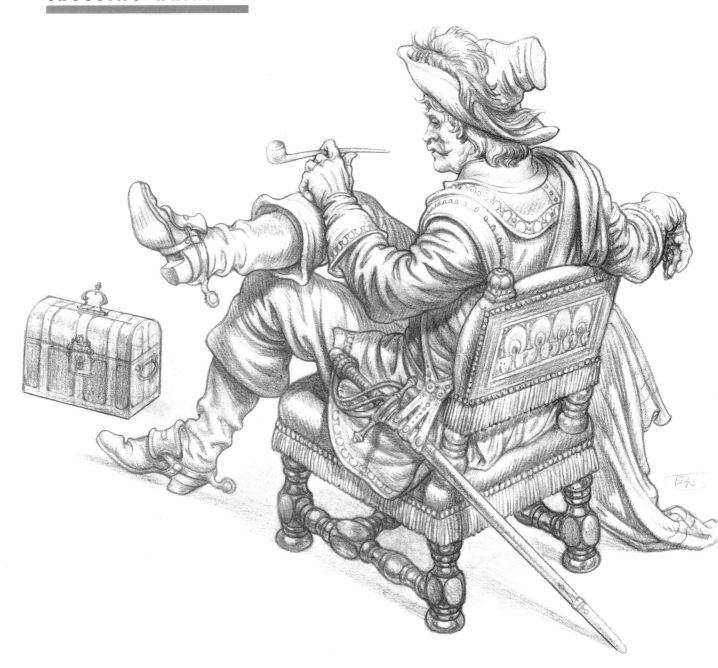

From another era, a cavalier dressed in leather, suede, and homespun gives us vivid examples of crossing wrinkles.

The jackboots of sturdy leather show thick crossing wrinkles above the spurs at the ankles and lower legs. These wrinkles are typically of a compressed character; the major wrinkles head frontward and are derived from the stress of the strong forward movement of both legs. Minor wrinkles come from the action of the rear ankles, completing the zigzag pattern.

The deep, upwardly curved folds of the pantaloon (under the top leg and gauntleted hand) reveal the major stresses coming from the lower area of the leg and knee. These are countered with short minor folds going downward. The adjacent jacket is covered with uneven crossing wrinkles because of unequal forces in material over the leg, waist, and chair. These wrinkles are responding to the weight of the heavy sword.

The bent arm above shows a more predictable crossing wrinkle system. The major wrinkles start from the underarm, while the minor wrinkles interlace from above to form the classic zigzag pattern. See also the regularity of forces on the foreshortened arm at right.

Seen in deep space, foreshortened forms (the arms on both of these duelists, for example) display crossing wrinkles that are tightly curled and circular in character. Indeed, these close-knit, hooplike ring patterns ideally represent the strong illusion of deep space. Remember that when forms shorten, elliptical patterns in clothes are replaced by circular curves.

Here are some other devices for suggesting spatial recession:

1. Form over form blocks and obstructs. In this drawing, study the overlapping legs of the duelists and the raised arm and overlapping head of the foreground figure.

2. Change of direction creates contrast. Look at the background figure and study the effect of his left arm and body as they seem to push through his flaring cape.

3. Straight, hard-edged forms played against curved forms alter spatial perception. Note the hard-edged blades crossing against the soft-edged curves of arm, body, belt, and leg.

Can you find other examples of devices used to convey the illusion of deep space?

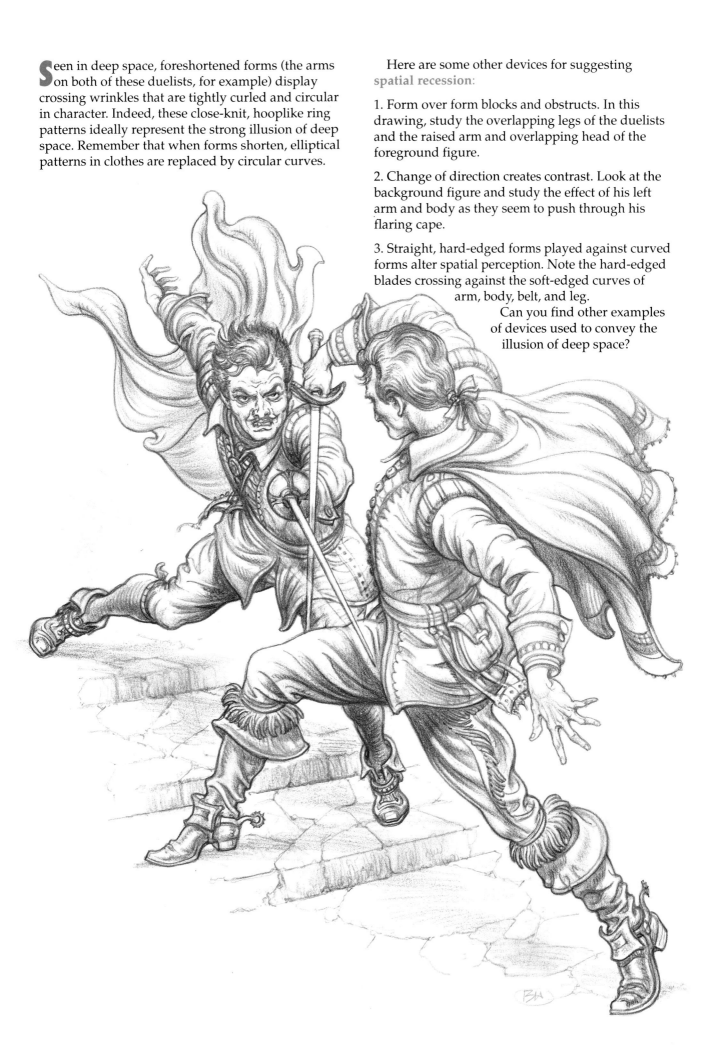

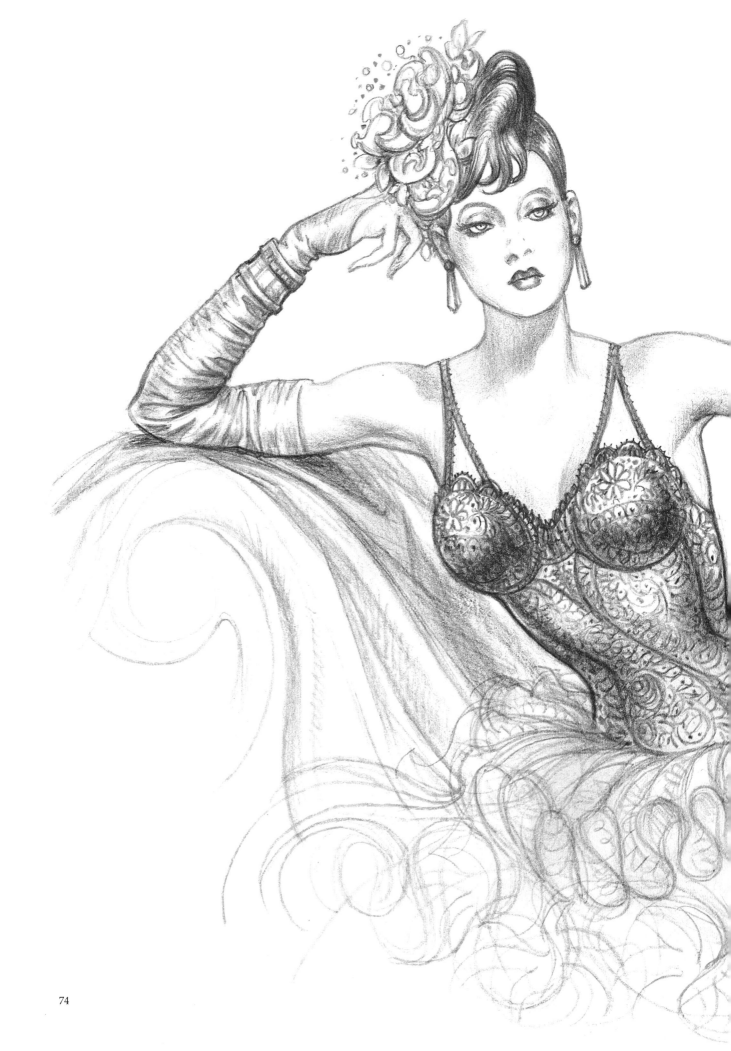

CHAPTER 5

COMPRESSION WRINKLES

The compression wrinkle is similar to the crossing wrinkle in several ways: First, the forces that activate compression emanate from two directions on a given member, moving left to right; second, compression wrinkles also interlace, forming zigzag patterns; and third, compression wrinkles are composed of both major and minor wrinkles, alternating folds created by the stresses of greater and lesser forces.

The unique aspect of compression wrinkles is their origin in the crush force, which acts on fabric like the squeeze of an accordion. The crush force creates a distinct visual quality that separates the compression wrinkle from the crossing wrinkle. The most common aspect of the crossing wrinkle is its outward pull (like the open movement of an accordion). The action of the compression wrinkle is just the opposite; it is a contracting movement that creates corrugations—not extensions or expansions.

The long gloves of an elegant woman in evening dress present a sequence of compression folds. The high style of the gleaming black satin gloves can be depended on to provide the compression wrinkles with a fluent sweep of brilliant highlights.

The folds and creases of the gloves are closely aligned, progressing with a regularity akin to symmetry, so that they become remarkably decorative.

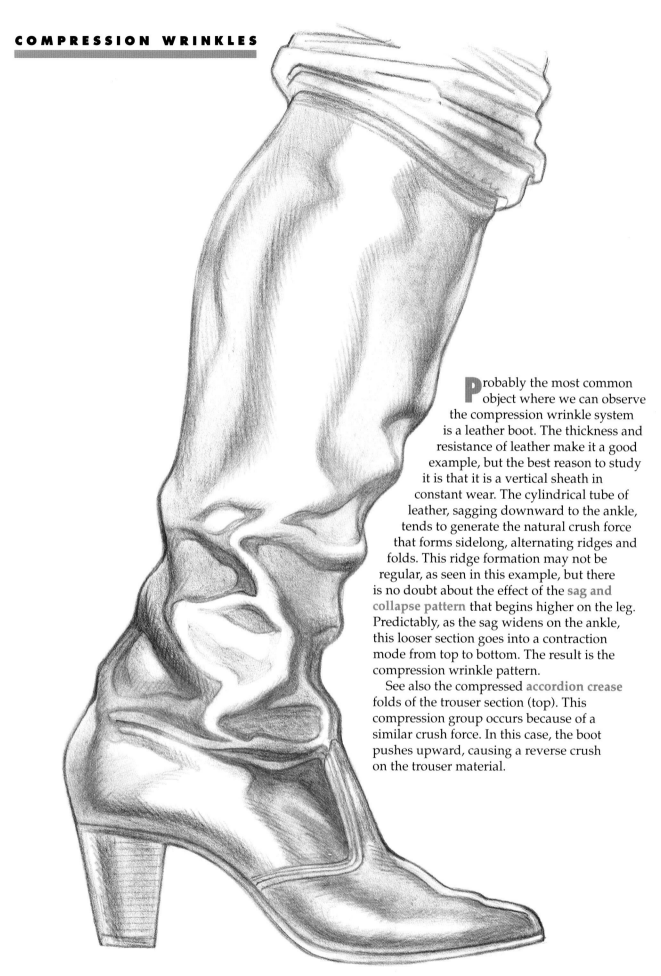

Probably the most common object where we can observe the compression wrinkle system is a leather boot. The thickness and resistance of leather make it a good example, but the best reason to study it is that it is a vertical sheath in constant wear. The cylindrical tube of leather, sagging downward to the ankle, tends to generate the natural crush force that forms sidelong, alternating ridges and folds. This ridge formation may not be regular, as seen in this example, but there is no doubt about the effect of the **sag and collapse pattern** that begins higher on the leg. Predictably, as the sag widens on the ankle, this looser section goes into a contraction mode from top to bottom. The result is the compression wrinkle pattern.

See also the compressed **accordion crease** folds of the trouser section (top). This compression group occurs because of a similar crush force. In this case, the boot pushes upward, causing a reverse crush on the trouser material.

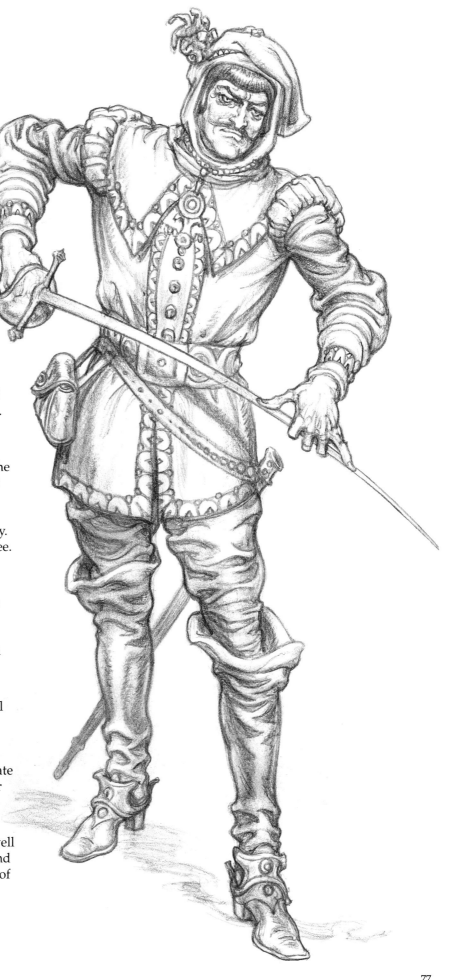

Compression wrinkles can be observed all through the gear of this armed man from an earlier era. Let's pursue these examples from the bottom up:

1. The condensed corrugations at the ankles reflect patterns seen in most boots. But observe the loose, open drop-folds of the leather thigh covers; these are induced by gravity. They sag frontward around the knee.

2. The leather breeches exhibit the classic crossing wrinkle zigzag pattern. However, the stance of the unmoving figure permits the loose thigh sections to sag and collapse downward, creating a compression wrinkle pattern similar to that of the boot forms.

3. On the sleeves, the loose material creases in the bend action of the elbows. Compression wrinkles are produced as the arms squeeze the material. This action works to initiate corrugation in the upper and lower parts of both arms.

4. The cowl headpiece shows condensed forms on the head, as well as creased folds around the neck and collar. These are all manifestations of **compression activity**, as are the fragmentary rifts on the tunic around the belted waist.

Let's look at this figure relaxing against a table. There are four compression wrinkle patterns in the man's attire:

1. The first appears as a tight series of compression zigzag folds in the lower part of the figure's arm at right. The forward crush force, stopped at the pocket, creates these folds.

2. Now shift to the midsection of the adjacent coat pocket, where you have a light squeeze in the waist area that pushes fragment folds to the coat button.

3. The forearm, receiving support from the hip at right, is pushed against the coat button, which creates compression wrinkles just under the open A-front of the jacket and down the inside of the leg at left. Note how the thigh overlaps on the leg at right; it is like an irregularly squeezed accordion—closed inward, open outward.

4. Observe how the crush force drops down the inside of the arm at left; the entire sleeve is covered with a downwardly shrinking compression wrinkle pattern, ending at the wrist.

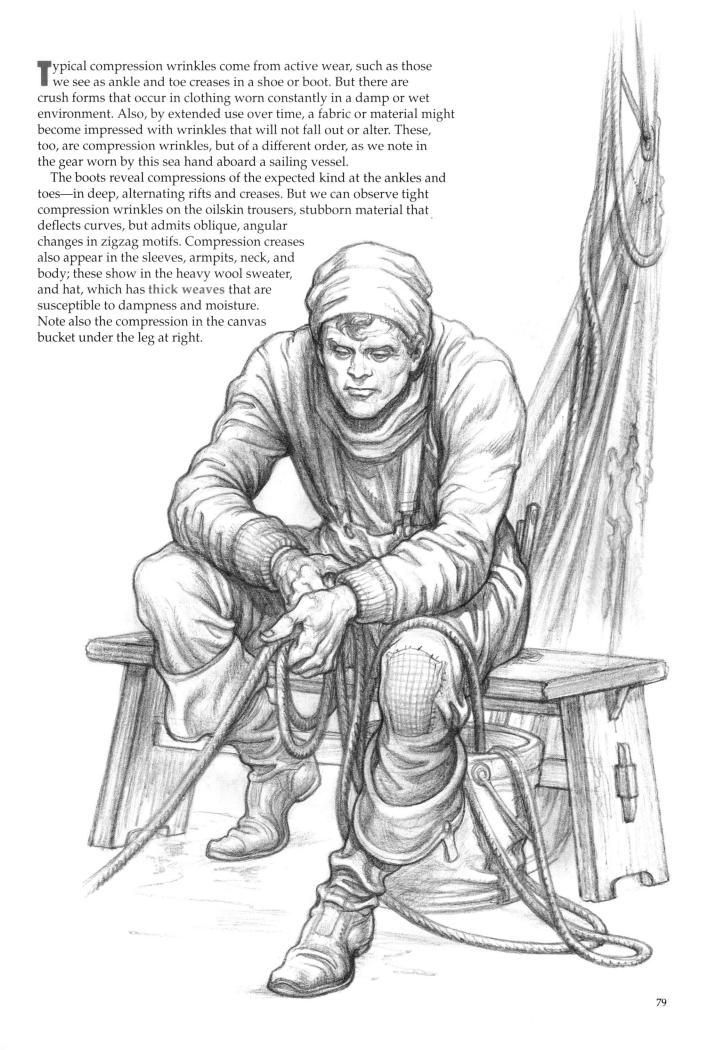

Typical compression wrinkles come from active wear, such as those we see as ankle and toe creases in a shoe or boot. But there are crush forms that occur in clothing worn constantly in a damp or wet environment. Also, by extended use over time, a fabric or material might become impressed with wrinkles that will not fall out or alter. These, too, are compression wrinkles, but of a different order, as we note in the gear worn by this sea hand aboard a sailing vessel.

The boots reveal compressions of the expected kind at the ankles and toes—in deep, alternating rifts and creases. But we can observe tight compression wrinkles on the oilskin trousers, stubborn material that deflects curves, but admits oblique, angular changes in zigzag motifs. Compression creases also appear in the sleeves, armpits, neck, and body; these show in the heavy wool sweater, and hat, which has **thick weaves** that are susceptible to dampness and moisture. Note also the compression in the canvas bucket under the leg at right.

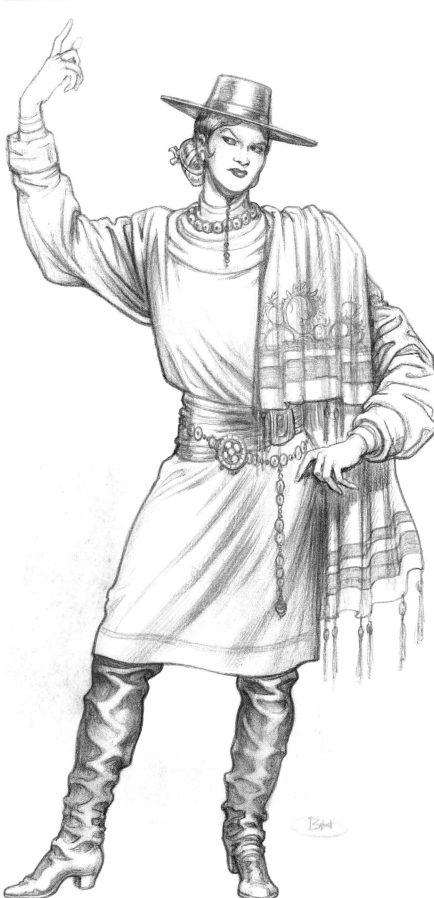

Compression wrinkles in the clothes of this Spanish dancer occur in the sag compression of the boots. The tension of gravity on the leather creates the sidewise zigzag pattern and the inevitable accordion-like corrugation.

Another set of compression forms can be seen on the shoulder at right in the narrowed folds of the serape, but not on the vertical folds lower down. This is because the lower folds are opening up; on the shoulder, the compression is inward, and the wrinkles are pushed together. The lift of the arm causes a true crush force to act on the high part of the shoulder. But lower, near the chest, the sleeve is being pulled outward in an underarm stretch; this part is not compression—it is a tension force.

Are the blouse and skirt performing compression? No! These are pulled by the active tension of leg force outward. These are pull, not compression, wrinkles.

The action of putting on a jacket or coat—or taking off a sweatshirt—gives us a rewarding look at an interesting variety of compression wrinkles. Let's observe this drawing for the varied moments of dress change.

1. The first man (front left) is putting on a zipper jacket. Note the grasp of hands on the jacket, the cramp of the material on the inside lining and outside leather panel showing the pressure of fingers. Most of the wrinkles reflect this strong pull tension. Note also the torque of the body in the sweater, and the stride acting from the crotch stress to the upper legs, forming fragmented crossing wrinkles. The sleeve on the arm at left seems to be developing compression forms; the arm action is rearward, and deep creases are turning into zigzag wrinkles.

2. The seated man, pulling a sweatshirt over his head, shows good examples of compression wrinkles. See the convincing crush as he pulls with his arm at left; there is an overlapping of deep, loose folds. The arm at right has loose compression wrinkles, while the right back is decidedly in a tight compression.

3. The man at rear left gets ready to lift a turtleneck shirt over his head. The forearm at right is being pulled into place with the arm and hand at left. Note the long wrinkles (on the forearm at right). The rear part of this arm is in a rare crush/squeeze mode.

4. Observe the man with a tie (rear right). He is in an active state, so most wrinkles are in thrust and tension forms. Against these, however, the arm sleeve at left is not fully adjusted, and therefore shows a sequence of passive compressions.

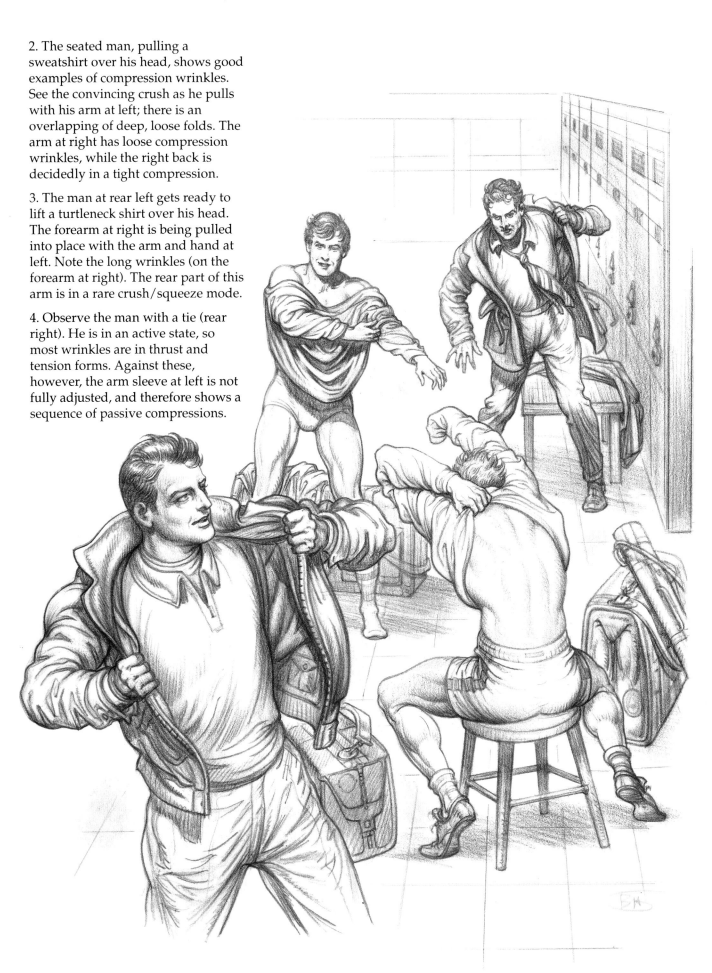

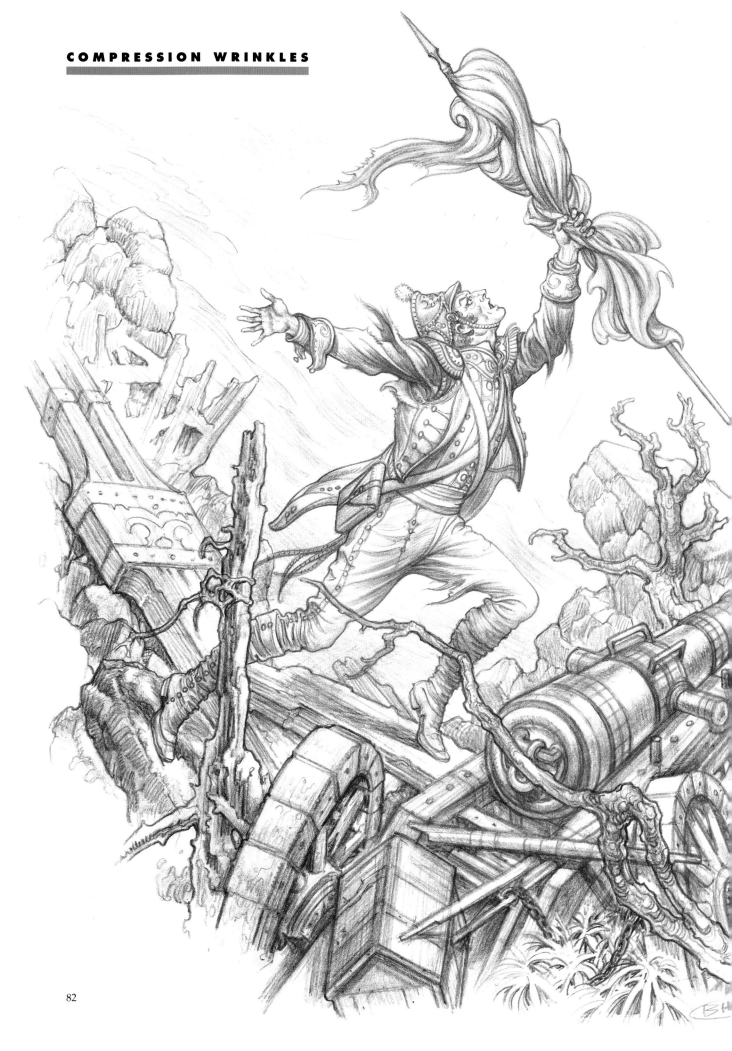

An action scene from an earlier era, where a soldier clutches a flag, provides an unusual example of compression wrinkles. The forceful compression of the flag by the enclosing fingers creates an implosion that strangles the material in crumpling inhibition, while the balance of the banner weaves and slumps in deflated malformation. The only other example of crush forces at work appears on the leggings in a long array of tight, interlacing wrinkles from the knee to the ankle.

The figure as a whole, garbed in a uniform with active, forceful stress wrinkles, is in a violent upsurge against fierce resistance, in which all forms conspire in repulsions.

This drawing shows an eighteenth-century officer wearing the top boots of the military horseman. By now we can begin to anticipate the tight squeeze forms and sidewise zigzag spread of compression wrinkles at the ankles in leather boots. The knee and calf muscles have impressed their forms on the boots above the ankles. These, however, are not compressions; these impressions only serve to show that clothing, in any texture or material, is really just another kind of body form, but with a new surface.

Note the wrist creases in the soft leather between the gloves and the cuffs of both gauntlets. These, like ankle creases on boots, tend to become **permanently impressed forms**.

The compression wrinkle patterns in the balance of the uniform appear as small crush forms in the knee and arm bend areas and at the horizontal midwaist sash, below the belt. All other wrinkles respond to some force aspect of tension, which is not that of a compression form.

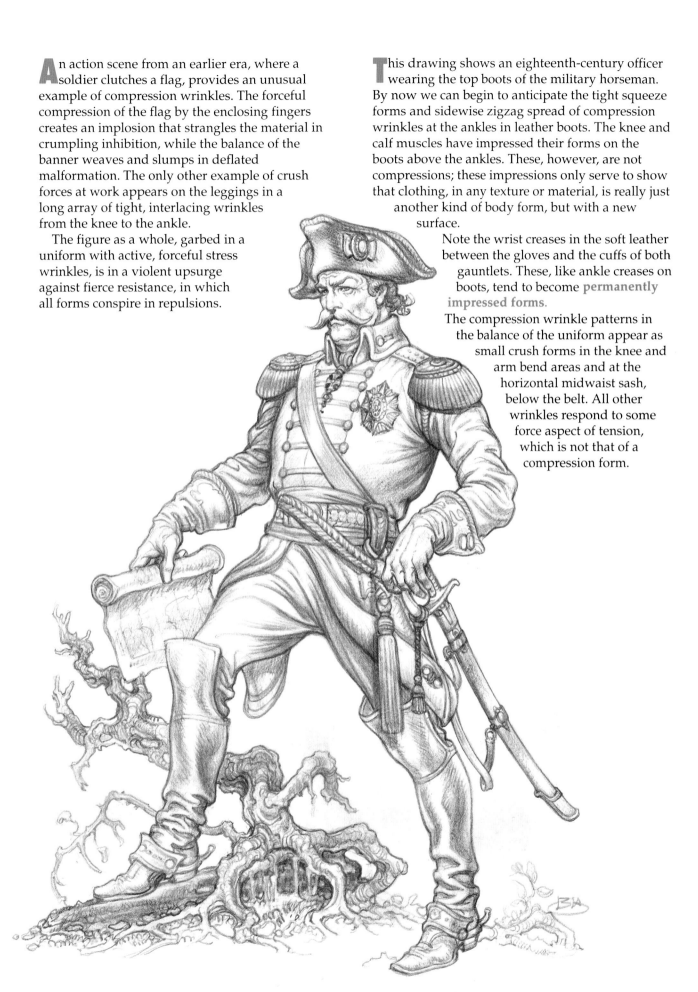

FRAGMENTATION
WRINKLES

Fragmentation wrinkles do not occur for one reason only; that is, they don't occur because of special kinetic forces alone. These wrinkles develop for several reasons.

The basic cause of a fragmentation wrinkle pattern lies in the **decay of the kinetic forces** that energize other wrinkle systems. In effect, fragmentation happens when an action is uncertain, indecisive, inconsistent, or perfunctory.

A second occasion for the development of fragmentation comes when a garment has been worn persistently for some time, allowing sweat, soil, grime, or grease to get worked into fabrics. These impurities tend to reinforce the varieties of movements that become impressed on the garment. Habitual wrinkles move with new kinetic forces and are ruptured by the **impurities in the fabric**. Incomplete forms work through the old, and incoherence builds into fractionated splinters of uncertain combinations.

When a variety of weaves, textures, fabrics, and materials are involved in clothing, we might see an effect on the wrinkles pattern that leads to fragmentation. All of these factors work together to create the indecisive forms that make up fragmentation wrinkles.

Let's look at the shirt of this blacksmith. We have here an energetic pair of actions in the arms—a drawing back of the hammer by the arm at left, and the forward thrust of the tongs and horseshoe by the arm at right. Although these are decisive movements, the shirt patterns alone seem inconclusive. The figure's sleeve at left has more effective wrinkles; the sleeve at right is somehow unsure. The shirt front has a splintered center area. This might be the result of sweat, soil, and grime in the unwashed shirt acting against certain ingrained movements.

The leather apron of the man is instructive. See how its close fit on the body has created an **impressed pattern** on the waist. The legs, thighs, knees, and shins can be read through the thick apron, which is imposed on the lower body like the shape of a hand on a glove. Further, the fragmentary pattern of wrinkles on the belly and groin are contrary to the leg actions—the stride of the figure in this scene is not present. And the wandering rifts between the legs of the man almost appear to be a series of flow wrinkles, as if he were lying on the ground.

The animal skins this man wears are not as form fitting as clothing that is measured and cut from loomed weaves. The furred skin is irregularly patterned throughout, dry and resistant in texture, and well-worn, showing body contours from constant use. This skin is a medley of forms, but it is adequate for a hunter in a "state of nature."

The belly and groin wrinkles seem to respond to compression forces. Horizontal rifts are the effects of crush and bend forces, but they are somewhat disjointed and inconsistent. A pattern of curling wrinkles winds from the thighs inward on the long, irregular triangle of coarse-grained fur. The fur has a tough, buckram-stiff group of warped curves that have not been activated by any body movement. Also, the torso covering is cut to no integral body design. The raised arm is covered for warmth; the arm with the stick at left is open and geared for action. The fur behind the thrusting straight leg is a clump of superfluous, brushlike matter. These serried, fragmentary wrinkles were formed in times past, and their stiffness is such that no action will change their shape.

Compare the brittle, warped quality of the fur skin on the hunter and the soft, pliable furry hide of the live bear cub. This will help you feel the difference. The fur on the man acts inconsistently with regard to the body action. The fur on the cub directly responds to the tight grip of the hunter.

This soldier's outfit is furrowed with a multitude of crossing wrinkles. The systems, however, are further riven through with fragmentation forms. There is a predominant wrinkle form, but the overall effect is one of repetitious small-scale creases.

This fractive tendency is not typical of wrinkle systems in most eases. But this can happen when an individual, under force of circumstances, spends a prolonged period living in his or her clothes.

Let's look at the chest area of the tunic: The figure is in a passive stance, yet the wrinkle system from the collar to the belt area is cut through with folds and wrinkles that suggest wrinkled clothing, rather than clothing expressing an immediate movement of a special kind. This figure is covered with a sequence of past-action wrinkle fragments left over from sleep, work, weather, and conflict. Wrinkles of **past-action fragmentation forms** tend to appear in clothing that molds to the body of a figure. Long-term wear impresses such clothing with the forms of the body.

Here a racing skier wearing lightweight, wind-resistant, water-repellent clothing begins a grinding, blinding, powdery downhill descent through a crystalline spray of ice and snow. During his swift, lightning sweep to the finish, he and his garments go through a swift sequence of angular, kaleidoscopic jerks, bends, wrenches, pulls, and surges. Fragmentation wrinkles (and compression creases and rifts) are bound to occur when a figure goes through fast and powerful motions of changing direction. Spontaneous deviations and aberrations in prevailing movement invariably produce eccentric impulses in fabric.

Study this figure carefully, then imagine what fragmented wrinkle patterns might occur as a result of the jolting gyrations of a broncobuster; or the shoving, jostling clash of a football scrimmage on the goal line; or the dashing urge and drive of a basketball player's dodge, break, and toss for the hoop; or a free-for-all melee of bashing players in a hockey game. Imagine the characteristic sequences of fragmentation wrinkles in these circumstances.

This baseball pitcher is about to deliver a fastball. He has taken his stance, reared back on one leg, lifted the other leg, tilting and balancing his body. He pauses momentarily; his pitching arm is drawn back, his body bent at the waist. In a moment, his eyes will shift to the batter and he'll wheel and deliver the ball downward, in a blurred fast whip. The ball will probably zip past the batter at well over 90 miles per hour.

In this arrested moment before the throw, an indecisive half-second generates a splintered wrinkle sequence up the pitcher's entire left arm. The lifted left leg is just beginning to shift downward, and the wrinkles on the thigh reflect this motion. These wrinkles are getting thin and detached, meager and indistinct.

Look at the pitching arm. You will see the suggestion of a changing wrinkle pattern that reflects, subtly, the change in the direction of the arm's motion. Again, arrested, split-second actions invariably result in fragmented patterns.

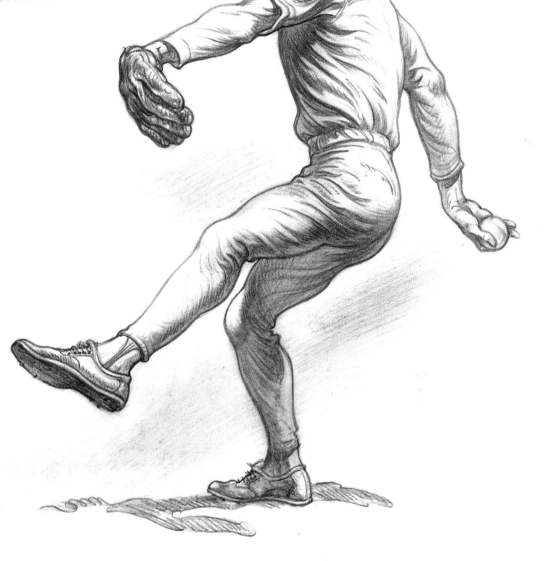

FRAGMENTATION WRINKLES

A wayfaring gypsy, roadwise and heading for shelter, gives us fragmentation wrinkles on the shoulder cape at left. The arm itself has ambiguous crossing wrinkles that dissolve into rifts and breaks. The serape, draped over the shoulders, abounds with elongated, subdivided parts, while the patched, worn trousers reveal the truncated, curved, ingrained pattern of forms that have seen extended wear over weary miles.

The total figuration of the garments reveal outwardly the impressed inner body mold of the figure, in which the contours of the clothes become the image of the inner form.

In the cold, damp climate of northwestern European lowlands, the traditional clothing of this Netherlander is abundant in size and bulk. The jacket, more form fitting than the trousers, shows crossing wrinkles in eccentric zigzag patterns on the arms and front body panel.

The loose-fitting sleeves show meandering, slack wrinkles that are staggered with thick crests and grooves that occasionally split into sectioned fragments, but these are the exception. The body of the coat, however, is covered with fragmentation wrinkles. Note an indecisive mingling of right-left wrinkles moving from the armpit area at right. This group quickly loses force as it travels lower, dissolving into segments.

The broad pantaloons show a set of large, **erratic fragmentation wrinkles**, different from any we have yet encountered. The leg at left, for example, shows a straightforward stance, but the cross-rifts from thigh to the low crotch area are strange: crossing wrinkles meander across the leg, drift downward, and terminate in faltering, oblique segments.

The staunch support leg at right is covered with slow-paced curves. At stages, they digress and break off. These trousers are, at best, misshapen.

91

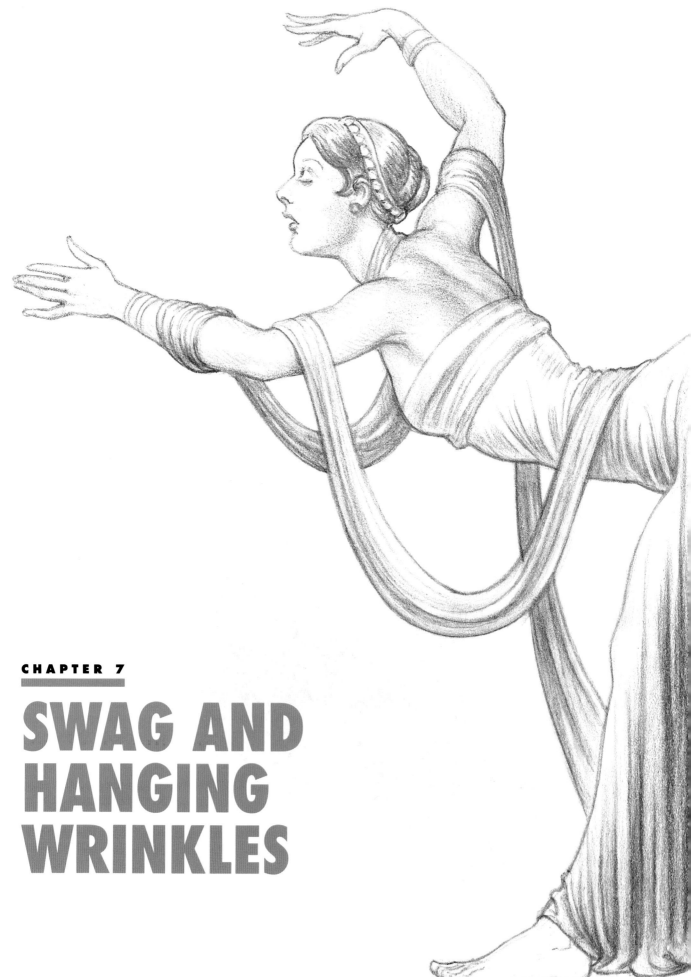

SWAG AND HANGING WRINKLES

Swag and hanging wrinkles should be considered together because both types of wrinkle systems are activated by the force of gravity and both are found in passive or stationary forms.

The swag wrinkle is made up of curved, downward-sagging loops emanating from two-point suspension anchors. Clearly, gravity pulls the cloth into an inverted arc shape as a result of such suspension.

Hanging wrinkles are usually straight forms that hang vertically from one suspension anchor. The most common pattern in the hanging wrinkle system is the organ-pipe fold, which resembles many tubes lined up in a row.

Swag and hanging wrinkles are created by the pose of this dancer. Note the stationary posture of the figure. The dancer is momentarily balanced and unmoving. The poised supporting leg gives us a sequence of straight, vertical folds. The folds classically have the organ-pipe form. Here they start out narrow around the hip-bulge anchor point and are pulled downward by gravity. Each fold spreads out slightly at the lower base of the skirt.

As the leg at right swings upward and holds, the expanding skirt forms a series of descending loops. These loops become swag wrinkles, which arch backward from hip anchor points to the lower leg and the heel anchors. Note that the deep part of each elliptical sweep develops a vertical gravity wrinkle behind the knee (see dotted arrow).

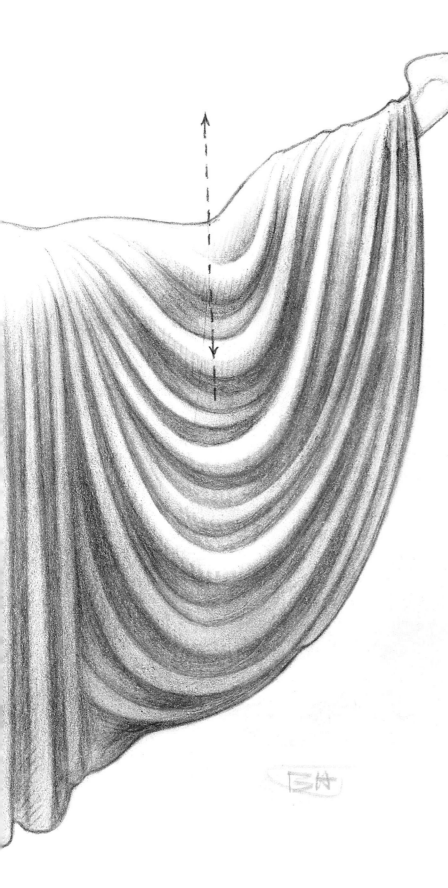

93

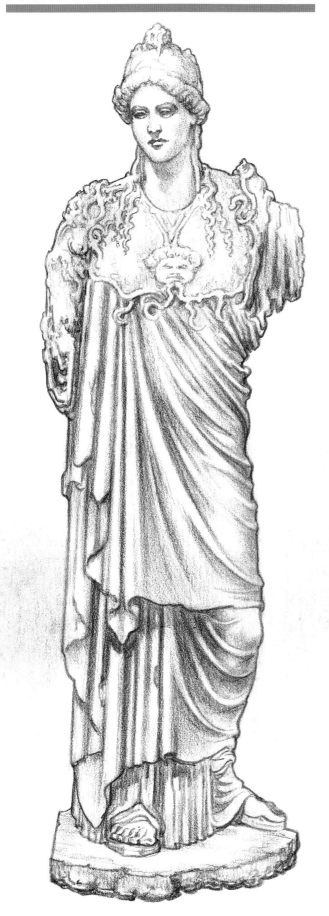

The left side of this Roman-era figure shows a straight organ-pipe fold sequence that is developing because of the force of gravity. The material coming from under the breastplate expresses the firmness of the shoulder anchor point.

The material clothing the figure works as three layers: The top layer comes down to the overfold at the knee; underneath, the middle layer drops to the ankle and slips to the foot; the bottom layer falls in narrow folds just touching the base of the carving. These are all varied examples of organ-pipe folds.

Can you spot any swag wrinkles in the curved folds on the figure's side at right? Direct tension wrinkles act on the body at right, above the knee, but swag wrinkles are lower down, curving below the knee. Here, the retracted leg allows the material to hang loose; gravity takes over, making the downward sag of the cloth form uninhibited swag wrinkles.

The walking woman (left) suspends a lightweight skirt from her hand. Her arm is set in an unmoving display gesture, while the legs move alternately. If the space between the hand and leg remains consistent during her straight walk forward, the curved swag wrinkles will maintain their pattern (give or take some minor fluctuation). It must be emphasized that these wrinkles depend on the suspension anchors remaining at a constant height.

In the figure shown from the back, swag wrinkles start high on the rear hip curve and buttock (right); this area acts as a broad suspension anchor.

Leftward, the thumb and fingers resting on the leg act as anchors in angular descent; a sequence of other anchors continue downward in traction, or drag, positions to the knee. Between these anchors, left and right, two-point swag curves emerge. Note that the skirt bottom (by the rear leg at far right) shows a final organ-pipe fold, or hanging wrinkle. Do you see the similar organ pipe forms on the skirt at far left?

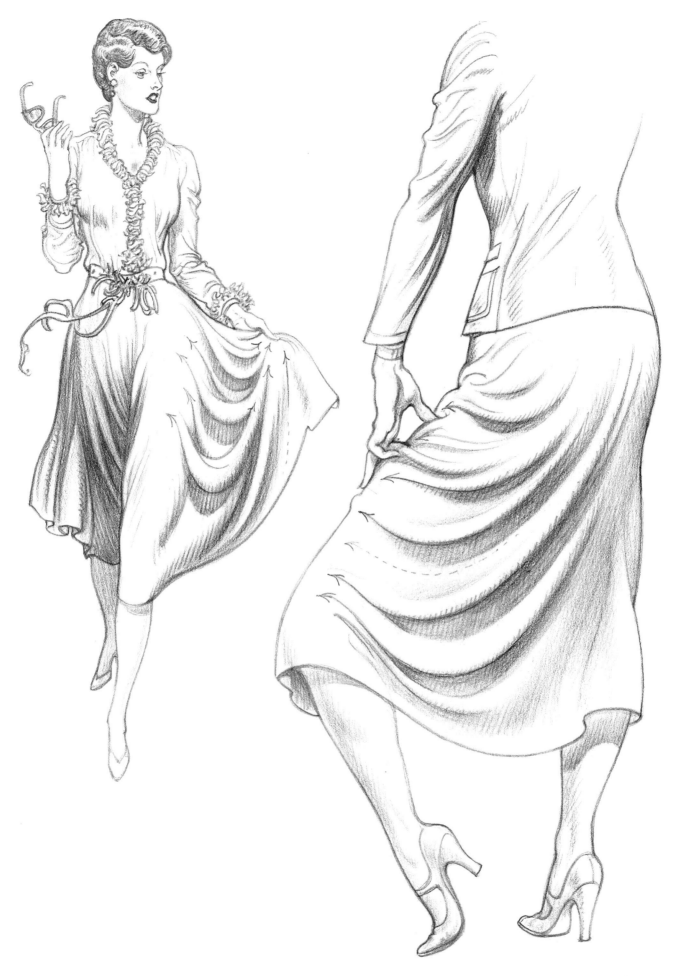

A display of drapery can appear as single, complete swag wrinkles (see first three folds at top). The wrinkles might also be incomplete swags (see the folds below the third one), which are actually crossing wrinkles.

Are all crossing wrinkles swag wrinkles? No! Crossing wrinkles cease to be swag wrinkles when forces other than gravity energize the folds. Usually this motivation comes from the action of the human form, and these strong forces violate the passive force of gravity. This is what we see here.

This nineteenth-century French gown shows a gathered section of the skirt material, tucked under a belt loop at front, that produces a wide spread of hanging wrinkles that graduate from large display size at center to narrow, modest folds at the sides of the figure, and they spread unobtrusively across the floor.

Of the gathered material below the waist, the graded bulge at right is a complex of compressed crossing wrinkles. The material opposite the bulge is not gathered, but is allowed to fall in narrow, tapered squeeze forms that descend modestly to the side.

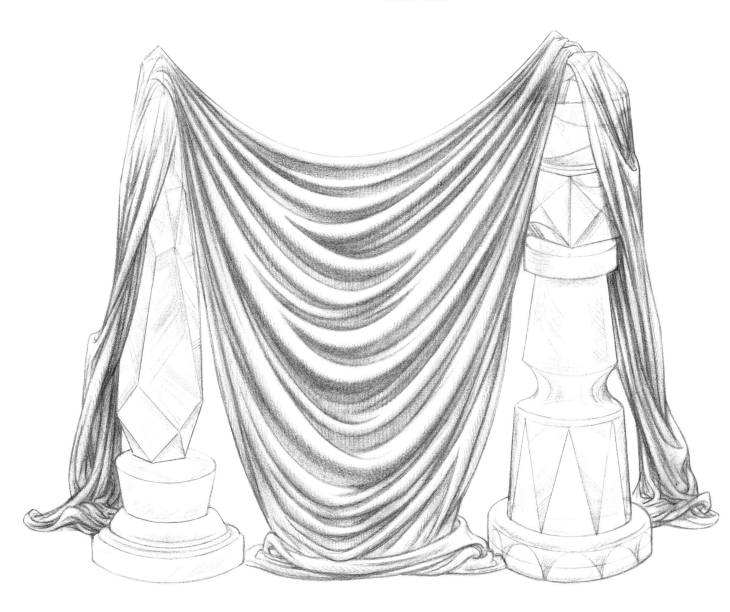

This drawing of Joan of Arc in medieval garb presents an excellent sequence of organ-pipe hanging wrinkles on the lower skirt. One of the requirements for the manifestation of these forms is an open, free space. In the rear area, for example, a functional space exists where the tube widths of wrinkles open to a wider extent than those formed closer to the leg; see how the tubes near the sword are smaller and more constrained.

The cape-flows to the rear of the body are tubelike, but the motion of the body and the raising of the arms have upset the vertical equilibrium. The forms thus cease to be hanging wrinkles. In a similar manner, the series of four thick suspension forms on the collar to the rear are also in a state of **fluctuation**. Had they been still, we would have seen them in a completely passive hanging state.

The stance of this woman in Russian attire conveys an attitude of **arrested action**.

Let's study the effect: The leg at left has halted, while the one at right is on the move. The transient leg at right has thrust wrinkles with a compelling sweep. The side motion in the skirt at right is abruptly stopped by the center drop fold in line with the inside leg at left.

At this point, the stationary leg forces a lapse into hanging wrinkles in all the folds at left but one. Follow the bottom pull of the skirt (by the leg at right) that disturbs the vertical folds at left. See how the angular swing (just left of the midline vertical break) goes upward and seems to generate unrest in the leftward folds. This phenomenon of instability tends to persist through

The courtly attire of this medieval gentlewoman shows three main sets of hanging wrinkles.

1. The center skirt produces straight, organ-pipe hanging wrinkles, shown on the inner knee bend, and long wrinkles coming from the waistline at right. The waist cinch creates these.

2. The leftward group of swag wrinkles, held waist-high by the hand at left, produces accented curves in three parts: those from behind the hip; on the upper thigh; and from below the knee.

3. The third set at right is essentially a two-part swag wrinkle sequence, held by the higher hand at right and curving to the rear waist. A close-placed group of swag forms go halfway down the leg; from there, a second group drops from the front skirt, producing long, asymmetrical swag curves.

Note the apparent asymmetry of the swag curves on both outside panels of fabric. These are not theatrical curtain sequences: This woman is in a moment of poised arrest. Her arms are held (unevenly) for her balance; and the garment shows the slight moment of pause.

Swag and hanging wrinkles can occur simultaneously in a single garment.
 In this example, a young woman going up a step is attired in a midlength spring coat, stops for a brief instant and turns—something has caught her eye. The pause is casual, but see how gracefully the force of gravity transforms this moment.

1. The torso turn at right, with the hand in the pocket, creates anchor points at the back shoulder and the front sleeve area. The force of gravity produces alternate swag wrinkles high in the rear, low in the front. These swag folds have an emphatic elliptical shape. The front curves seem be rounded—an elegant distinction caused by the support leg under the coat.

2. The shoulder at left slightly upraised creates a series of vertical organ-pipe folds in the open hang area. This is exactly where the bent knee at left is flexed under the coat—a most subtle maneuver.

The premise of this wrinkle system lies in the contrary character of trap and closure wrinkles. These wrinkles, both variations of a single type called by many names, do not act alone. A trap and closure wrinkle system has a dual quality: it acts to block, trap, or **close off** another wrinkle, in close proximity, from completion of its course. It can stop more than one wrinkle at the same time.

The trap and closure wrinkle system is called by many terms, such as: obstruction, surrounding, cinching, choking, occluding, stopping, blocking, yoking wrinkles, and so forth. We use a particular term when it best applies to the action behind the wrinkle. The variation in this wrinkle system leads to forms that are quite engaging, as they make figures remarkably exciting pictorially. The best way to make this system clear is to show some examples and conditions of trap formations.

The young woman in a sweatsuit presents another version of trap and closure wrinkles:

1. Strong wrinkles moving upward from the inside crotch reveal the power of the vertical leg stretch. Downward wrinkles from the ankle are blocked from completion by the upward pressure from below.

2. Let's drift down and backward to the bent elbow at right; a heavy overcurve wrinkle encloses inwardly the elbow bend. This is a trap in **two directions**, closing off wrinkles in the upper sleeve and choking off wrinkles from the forearm (see arrows).

3. Go to the upper inside sleeve: The lower inside armpit wrinkle thrusting to the chest area below the breast closes off a series of wrinkles from the back below. (In reverse, note the overfold pocket trapping wrinkles going inside.)

4. Now, shift to the lower bent knee at left. The bottom thigh contour is moving to the rear knee crease; this curve chokes off the lower calf wrinkles moving up from the rear.

TRAP AND CLOSURE WRINKLES

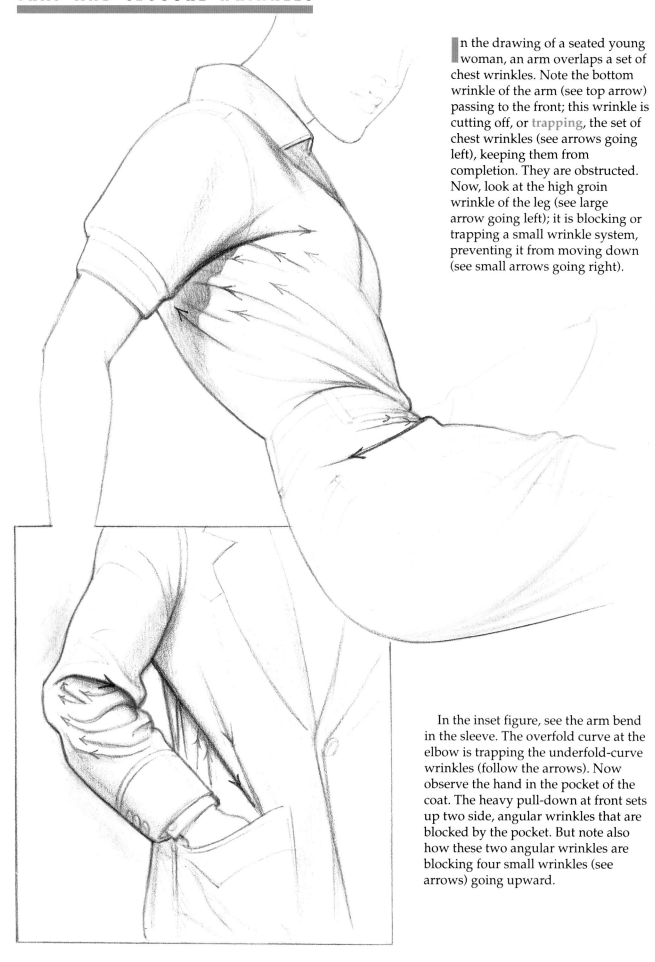

In the drawing of a seated young woman, an arm overlaps a set of chest wrinkles. Note the bottom wrinkle of the arm (see top arrow) passing to the front; this wrinkle is cutting off, or **trapping**, the set of chest wrinkles (see arrows going left), keeping them from completion. They are obstructed. Now, look at the high groin wrinkle of the leg (see large arrow going left); it is blocking or trapping a small wrinkle system, preventing it from moving down (see small arrows going right).

In the inset figure, see the arm bend in the sleeve. The overfold curve at the elbow is trapping the underfold-curve wrinkles (follow the arrows). Now observe the hand in the pocket of the coat. The heavy pull-down at front sets up two side, angular wrinkles that are blocked by the pocket. But note also how these two angular wrinkles are blocking four small wrinkles (see arrows) going upward.

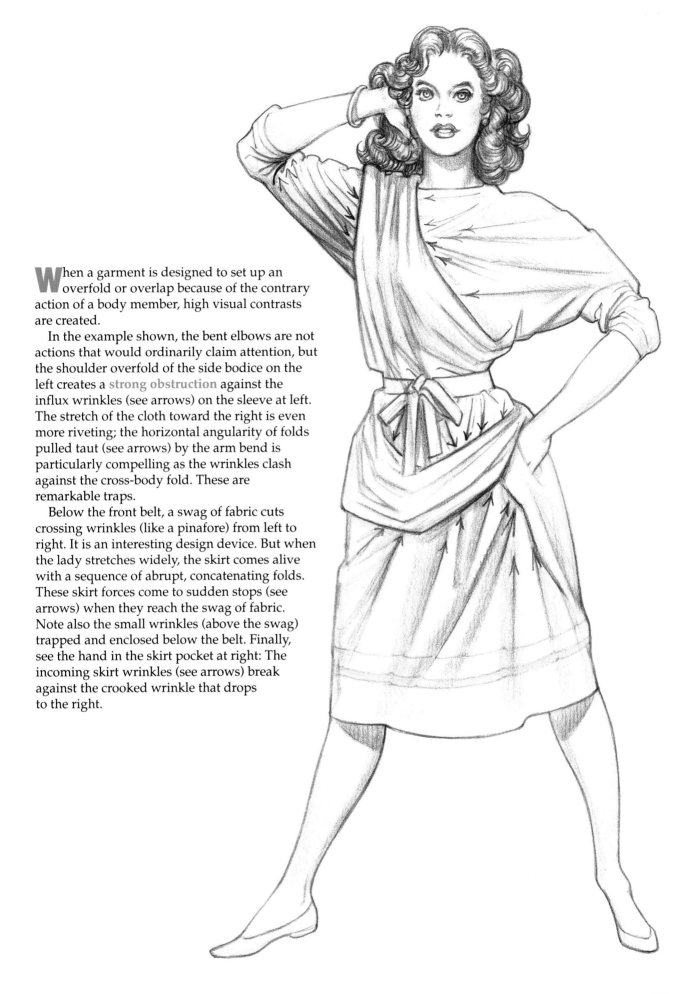

When a garment is designed to set up an overfold or overlap because of the contrary action of a body member, high visual contrasts are created.

In the example shown, the bent elbows are not actions that would ordinarily claim attention, but the shoulder overfold of the side bodice on the left creates a **strong obstruction** against the influx wrinkles (see arrows) on the sleeve at left. The stretch of the cloth toward the right is even more riveting; the horizontal angularity of folds pulled taut (see arrows) by the arm bend is particularly compelling as the wrinkles clash against the cross-body fold. These are remarkable traps.

Below the front belt, a swag of fabric cuts crossing wrinkles (like a pinafore) from left to right. It is an interesting design device. But when the lady stretches widely, the skirt comes alive with a sequence of abrupt, concatenating folds. These skirt forces come to sudden stops (see arrows) when they reach the swag of fabric. Note also the small wrinkles (above the swag) trapped and enclosed below the belt. Finally, see the hand in the skirt pocket at right: The incoming skirt wrinkles (see arrows) break against the crooked wrinkle that drops to the right.

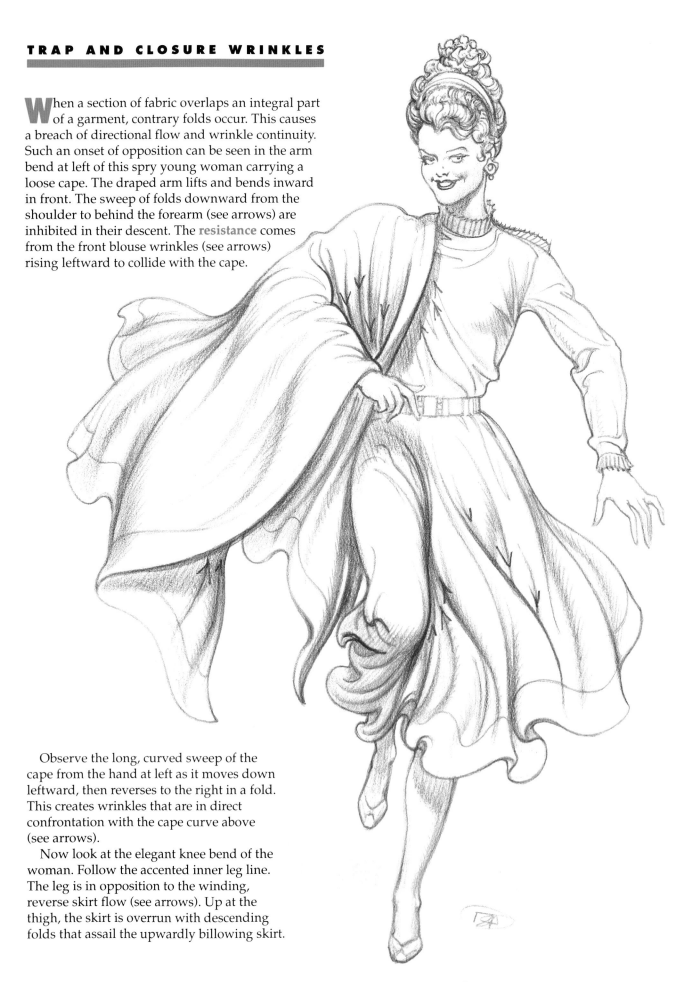

When a section of fabric overlaps an integral part of a garment, contrary folds occur. This causes a breach of directional flow and wrinkle continuity. Such an onset of opposition can be seen in the arm bend at left of this spry young woman carrying a loose cape. The draped arm lifts and bends inward in front. The sweep of folds downward from the shoulder to behind the forearm (see arrows) are inhibited in their descent. The **resistance** comes from the front blouse wrinkles (see arrows) rising leftward to collide with the cape.

Observe the long, curved sweep of the cape from the hand at left as it moves down leftward, then reverses to the right in a fold. This creates wrinkles that are in direct confrontation with the cape curve above (see arrows).

Now look at the elegant knee bend of the woman. Follow the accented inner leg line. The leg is in opposition to the winding, reverse skirt flow (see arrows). Up at the thigh, the skirt is overrun with descending folds that assail the upwardly billowing skirt.

In this example, a woman takes a dancer's posture resting on pillows. Her body can be seen as an interconnected complex of angular forms that conspire to produce trap and closure wrinkles:

1. The upper torso area by the shoulder at left has a strong vertical wrinkle at the armpit that acts as a barrier to the incoming arm wrinkles of the upper sleeve (see arrows). Now see the arm bend also at left—the firm overcurve wrinkle from under the upper arm blocks the forearm wrinkles curling into the elbow bend.

2. Observe the belt at right. Several wrinkles go upward to the breast bulge at left. The first wrinkle of this series blocks the wrinkles moving down from the right shoulder (see arrows).

3. A thick cross-fold going left to right at the belly and groin of the leg at right blocks and chokes the smaller wrinkles curving down from the belt (see arrows).

4. At the knee bend at right, the leftward thigh wrinkles (see arrows) curl to the back knee crease; two back knee creases are trapping the thigh wrinkles.

5. Now, come up to the tight knee bend at left. Here, a thick undercurve wrinkle at the rear calf is blocking off three small wrinkles (see arrows).

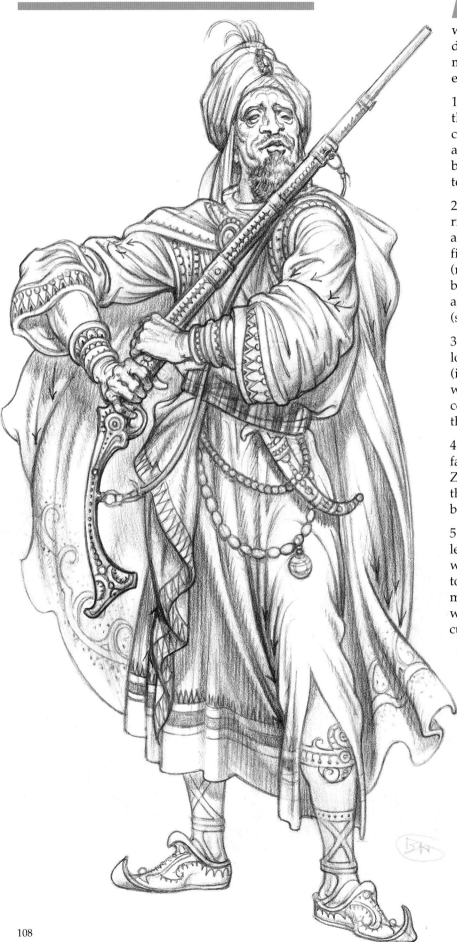

An overfold of overlapped cloth is a prime example of the trap wrinkle. This nineteenth-century desert warrior shows why manifold garments are a good example to pursue:

1. The upper arm at right, where the rifle rests, displays an array of curving wrinkles moving left (see arrows) that are trapped suddenly by an overfold crossing from left to right.

2. Adjacent to this arm, the cape at right shows a two-phase trap (see arrows) on its entire length. Note first behind the arm then lower (near the thigh) a flip of the bottom folds puts a closure stop against the downsweep wrinkles (see arrows).

3. Look now at the results of a long pull on the center skirt (inside leg at right); the tight leg wrinkles are inhibited from completion by the surging drop of the skirt (see arrows).

4. Next, look leftward to the loose fall of the body sash; the undulant Z-form folds progressively block the up-swing folds rising from below.

5. Note the cape billow at the far left; it traps the downswing of wrinkles from under the arm. As to the arm at left, see the upper member where two overcurve wrinkles are blocked by a swing curve underneath (see arrows).

An explicit example of the closure and blocking boundaries of wrinkle forces can be seen in this man's turban.

Let's start at the top and work down: In the tightly wound head cover, there are three integral sections: The first section, at top left, traps all wrinkles adjacent to the midline, a highly curved boundary edge that ends in the center forehead. The second section, from the midline to the rear, is made up of a curved set of wrinkles covering the rightward area. The wrinkles head to the midline (see arrows) and are blocked. The third section is the rest of the turban, from right bottom to the midline break. The wrinkles here go leftward and are trapped at the middle (see arrows).

Now, below the turban we have a cloth that surrounds the face. It is cut off by the turban above; hence, the edge of the turban is a closure device. The cloth around the face is divided into four parts, one on the right, three on the left. Note the smaller, triangular middle section; it is closed off by the cloth on the left and by the horizontal sequence of curves beginning at the brooch. Finally, note that the curving boundary of the cloth surrounding the face acts as a blockade to stop all wrinkles from below.

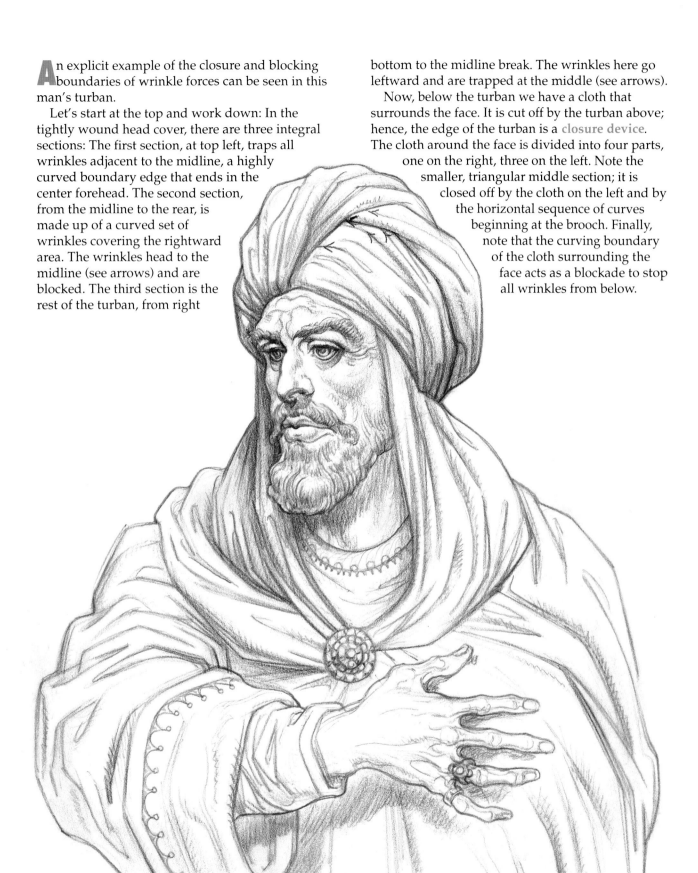

109

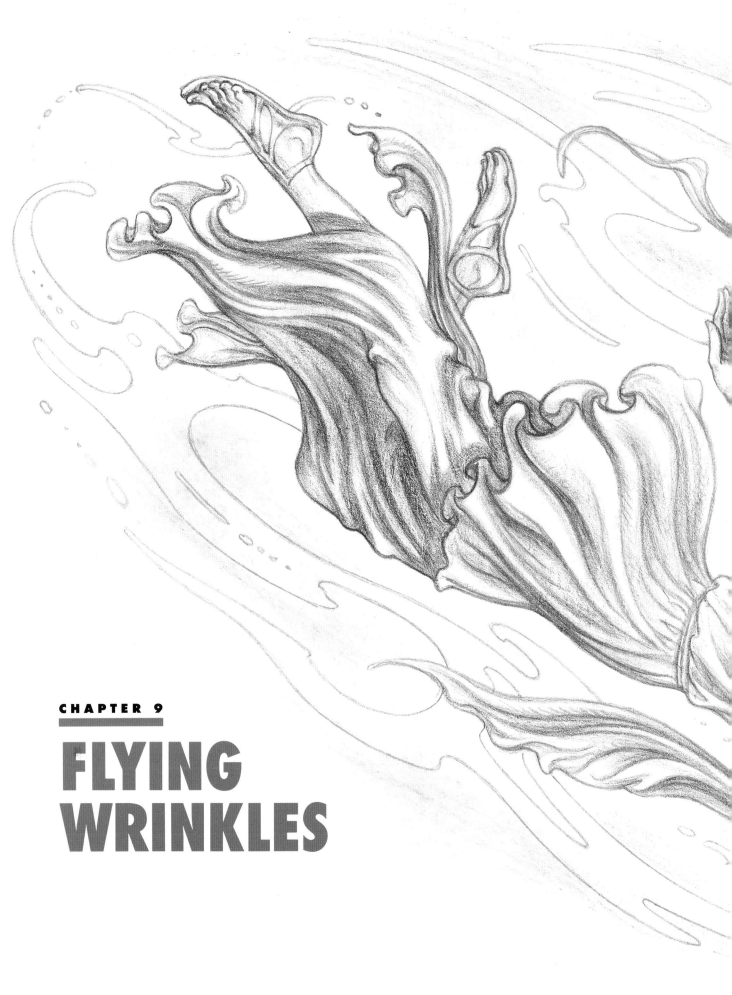

FLYING
WRINKLES

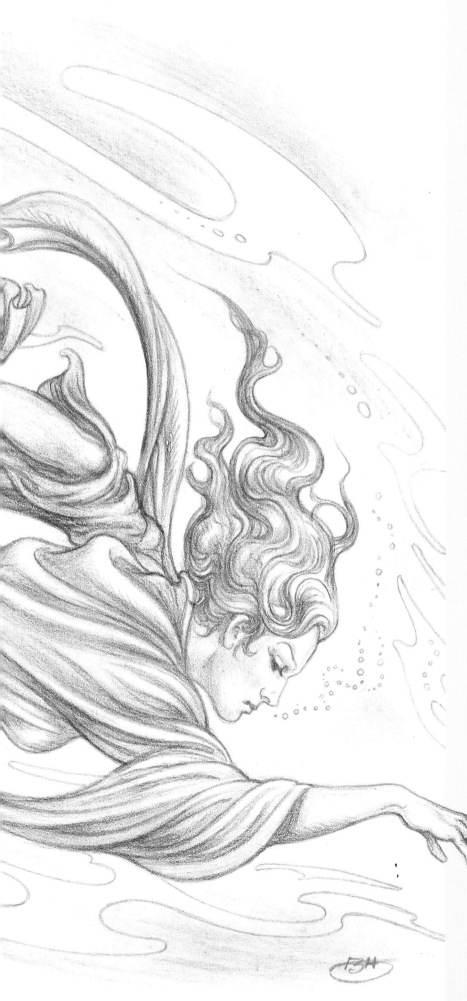

Of all the wrinkle forms and systems, the loose, open flying wrinkles are among the most exciting to observe. They come in a wide variety of exuberant, unimpeded circumlocutions, vertiginous perturbations, and buoyant agitations.

Flying wrinkles express the forces that give impetus to the fabric of a garment. The movement of air (or water) is conveyed in the material to give us a virtual "picture" of the airstream (flying movements in water appear similar to those created by air, but water is a denser medium, creating slower-acting wrinkle patterns).

In the moment of activity, complex wind forces are disclosed in the forms of weaves and materials that imitate the most delicate and suggestive motions and fluctuations of air currents. Flying wrinkles are vivid, momentary pictures of these forces in three-dimensional space.

The forces that activate water are the same as those that impart motion to air. Water, however, is a denser medium and is therefore slower to act than air. Water moves clothing material in slow, circular pathways. It proceeds in winding, spiral, corkscrews—a limitlessly interacting series of secondary twisting and turning motions.

The figure swimming against a current shows wave-like motions in her garment—this is the crest-and-trough sequence. Her hair moves in twirls and whorls. The sleeves have become elongated crescent forms, moving in backward cycloid sweeps. Now observe the wavy, organ-pipe forms of the tunic and skirt; they churn and roil like fronds of seaweed, and the folds are carried back like buoyantly drifting vegetation.

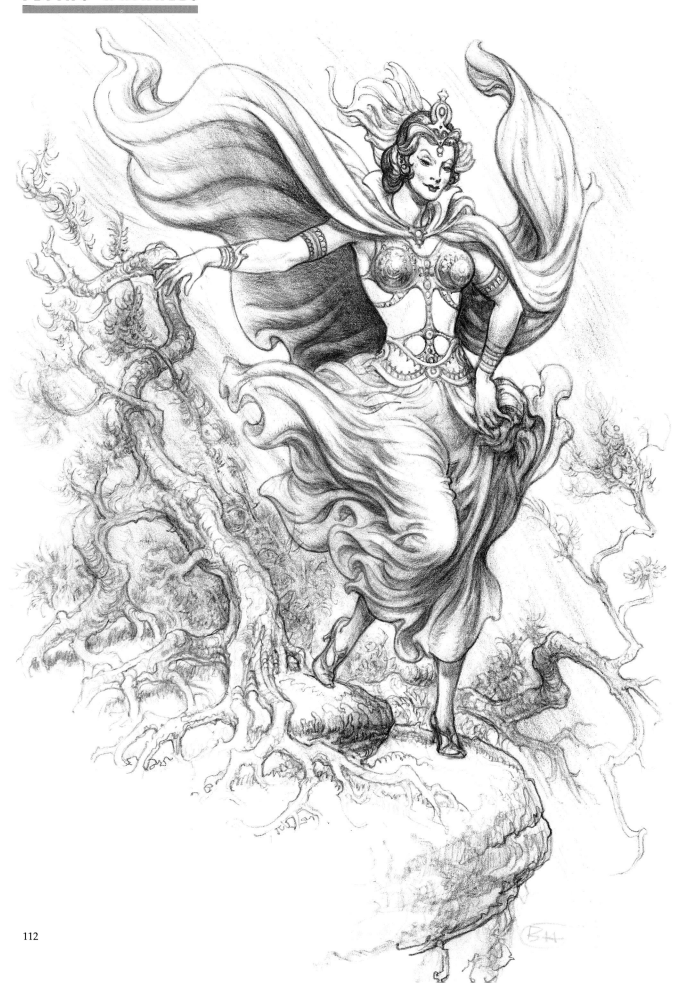

A strong ascending updraft over a cliff comes from a crosswind. Pulsating circular gusts deflect the air current that assails the garments of this woman in exotic dress. The uneven wind rotation buffets the lower garment with eddies and swirls, which causes the fabric to gyrate and flutter. Note how the skirt rises in leftward curling wave forms.

The angular airflow rises almost vertically on the right, until the air disturbance cuts across the skirt. The fabric begins to convulse higher, and the increase of wind volume and pressure reaches the cape, where the waves begin to churn the fabric. At left, above the arm, the direct force of wind has seized the voluminous cape and quickened the cresting impulse.

The figure shown here is of an adventurer in a snowbound, icy landscape. He is caught in the thrust force of a strong, churning wind that sends a wrenching turbulence against the his gear and heavy cape, which blows backward, billowing and twisting, with buffeting swirls, as he leans into the windstream.

This sequence is characterized by a release of grinding wind energy that creates quivering, jarring undulations, a surging wave pattern of gyrating flow-tubes (in the cape), and throbbing fluctuations, all of which are expressed horizontally because of the violent wind draft.

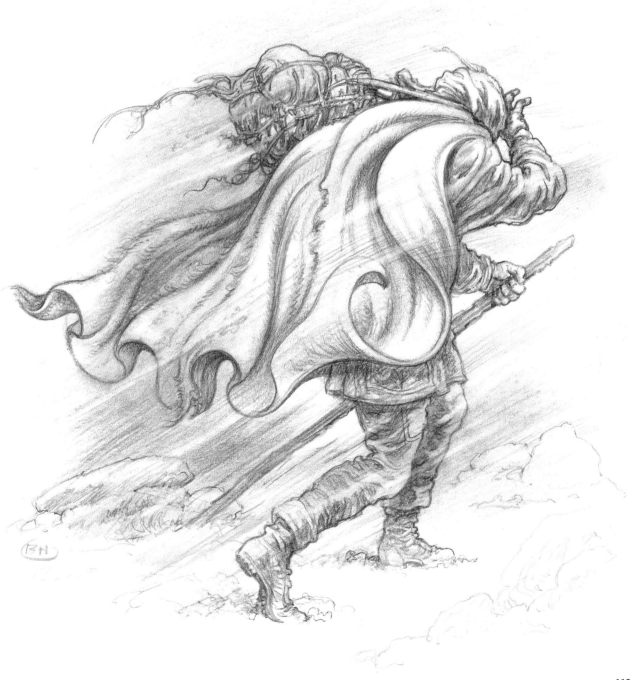

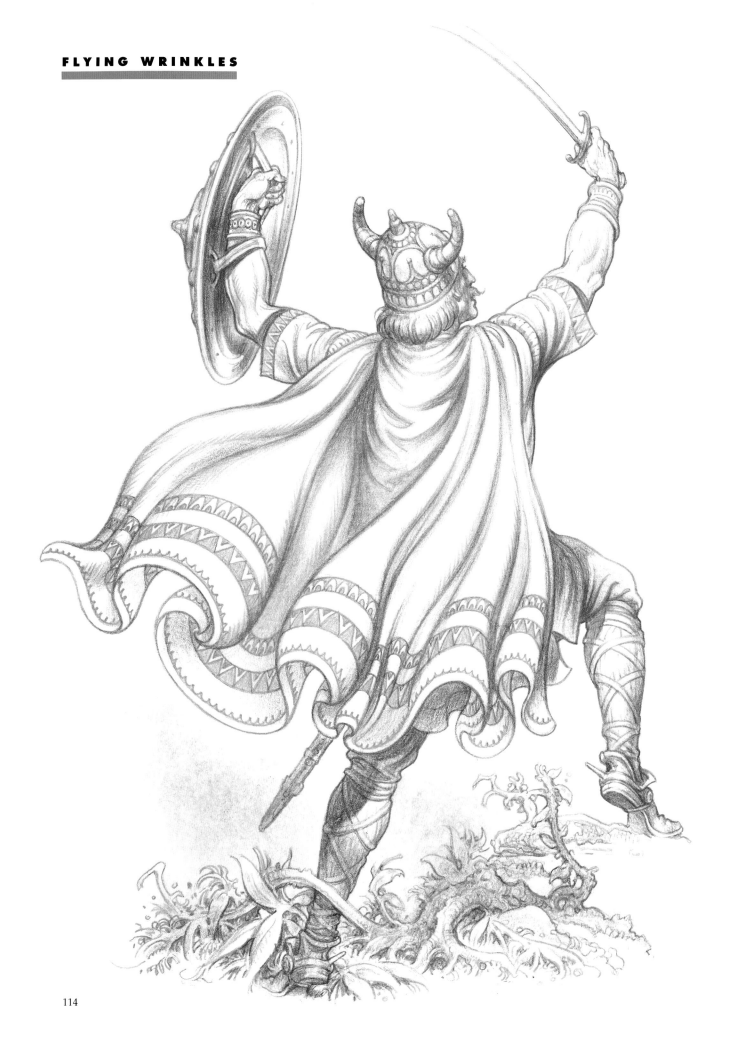

Flying wrinkles, like loose hanging wrinkles, need room to expand; otherwise, they get choked off by the body members.

In the subject at hand, an armed Viking warrior issues a challenge to an intruder; the upflung arms and the forward-moving body of the warrior causes the cape to lift into the air against a vigorous oncoming breeze. The rise of the widespread, undulant, open folds on the left cape suggests the rising **air pressure** there. The slower reaction of the narrow cape folds at right, seen above the straight leg (left), is in sharp contrast here. Note also a nimble swoop upward, followed by the sudden faltering slouch, at the cape's end. The entire process helps us to sense the uneven concussive encounter with the airstream.

Let's look at this situation in which a banner, held aloft by a victorious warrior, responds to the vigorous plunge of a rearing horse. The banner catches the wind, coiling and twisting in its embrace. A **complex motion** ensues, in which the horse, reined in, rears backward. The curling billow loses forward momentum (in part), ballooning out in round, full swirls. Momentarily, forward energy is inhibited; the flag overfolds, loses buoyancy, gets heavy, and starts a downward sag.

The cape is late in responding; the backdraft causes a primary swelling of the cape. When the rider reins in the horse, the act of rearing puts the cape in reflex; it is suddenly thrust forward, exactly opposite to the direction of the wind flow.

Note the vagaries that heavy folds are bound to undergo: air currents are deceptive and fabrics are slow to react. These reactions are quite different from the quick changes we see in wrinkles caused by body movement.

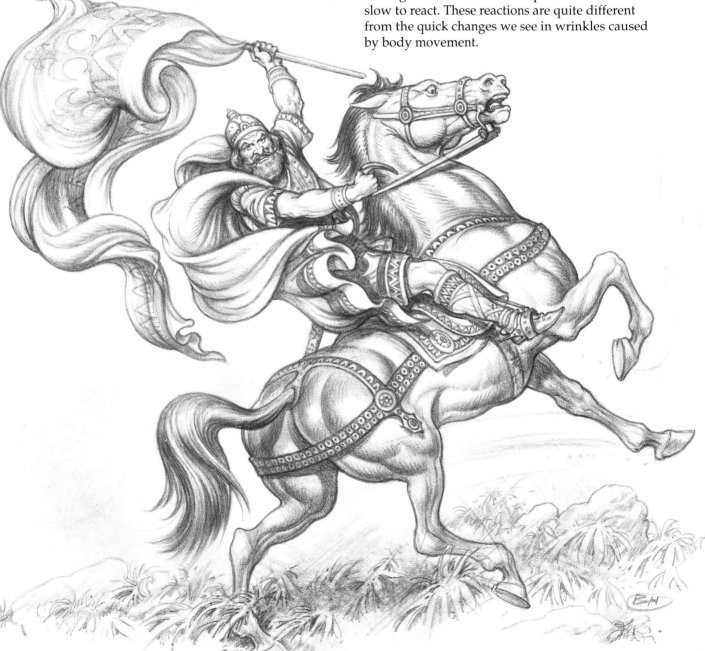

115

The meandering turbulence of air and water can be seen clearly in the **undulant spiraling** of this silk ribbon. Let's follow the passage of the ribbon in its route:

1. At middle right, going counter-clockwise, see the left-right, up-down, twist and wind, curl and coil wave forms.

2. A winding sweep left makes a reverse right looping in serpentine forms.

3. At the left mid-section, a deep swirl curves right, high, and makes a swift leftward drop, a quick overturn, and another left downsweep.

4. On the flat surface of the ribbon, the coil expresses a strong elliptic flow to the right.

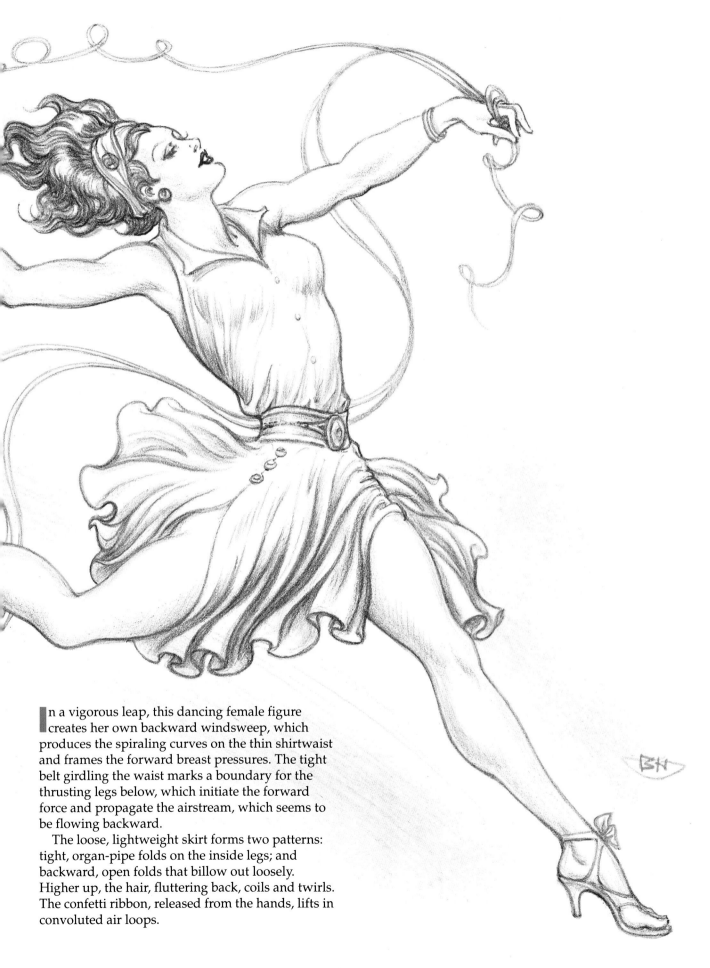

In a vigorous leap, this dancing female figure creates her own backward windsweep, which produces the spiraling curves on the thin shirtwaist and frames the forward breast pressures. The tight belt girdling the waist marks a boundary for the thrusting legs below, which initiate the forward force and propagate the airstream, which seems to be flowing backward.

The loose, lightweight skirt forms two patterns: tight, organ-pipe folds on the inside legs; and backward, open folds that billow out loosely. Higher up, the hair, fluttering back, coils and twirls. The confetti ribbon, released from the hands, lifts in convoluted air loops.

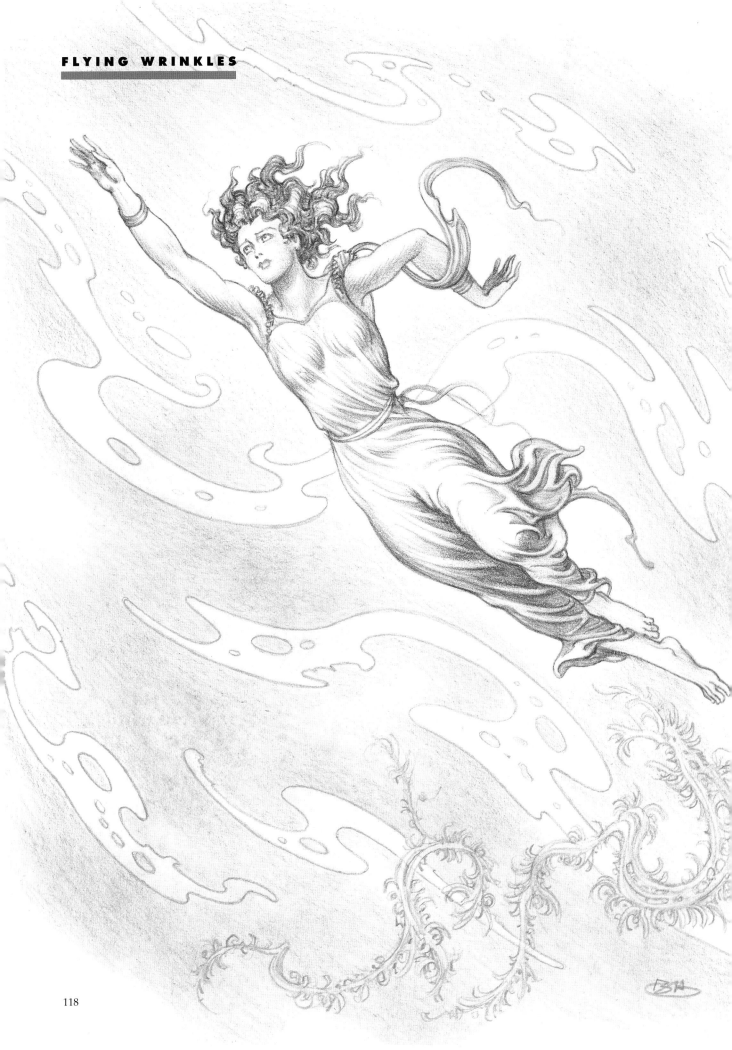

Water pressure acting on light material, as in this example of an underwater swimmer, forces a thin filmy sheath against the body and puts the figural forms in sharp relief. This effect is similar to the appearance of diaphanous drapery buffeted by the air.

Since water and air currents are both fluid, their motions produce swirling folds, backward flowing loops, and open curve forms. All of these effects show the kinetic water forces enveloping the figure. Even the hair locks curling back reflect the water rhythms passing through. Note also the swaying seaweed—its tendrils weave and coil with the water's motion.

In this stylized version of a courtly Asian woman, the figure in lavish garments tends, designwise, to respond to an unseen breeze that stirs the sleeves, and lifts the silken stole, gown, pendants, and tassels, in a delicate orchestration of undulant configurations.

The total effect of this figure is the creation of a languorous mood of a slow-motion world. Technically, these sinuous curves are devoid of gravity. The image thus created is quite tranquil.

In this illustration, a beleaguered youth throws an armed adversary off his feet. Note how several things happen at once: The kilt of the youth twists and flies back in undulant loops and waves; the heavy cape of the tossed warrior, wheeling in the air, flips about; wind driven, the cape opens and spreads in two directions; the irregular fur kilt covering the warrior's legs whips around in the air in a gyrating flutter; the warrior's horned helmet shakes loose as his hair tumbles in disarray; and, lastly, the iron sword is wrenched loose, as the heavy body pitches to the ground—it is whisked backward, twirling against the prevailing air drift. The sword is clearly not affected by the wind, but responds to the force of gravity.

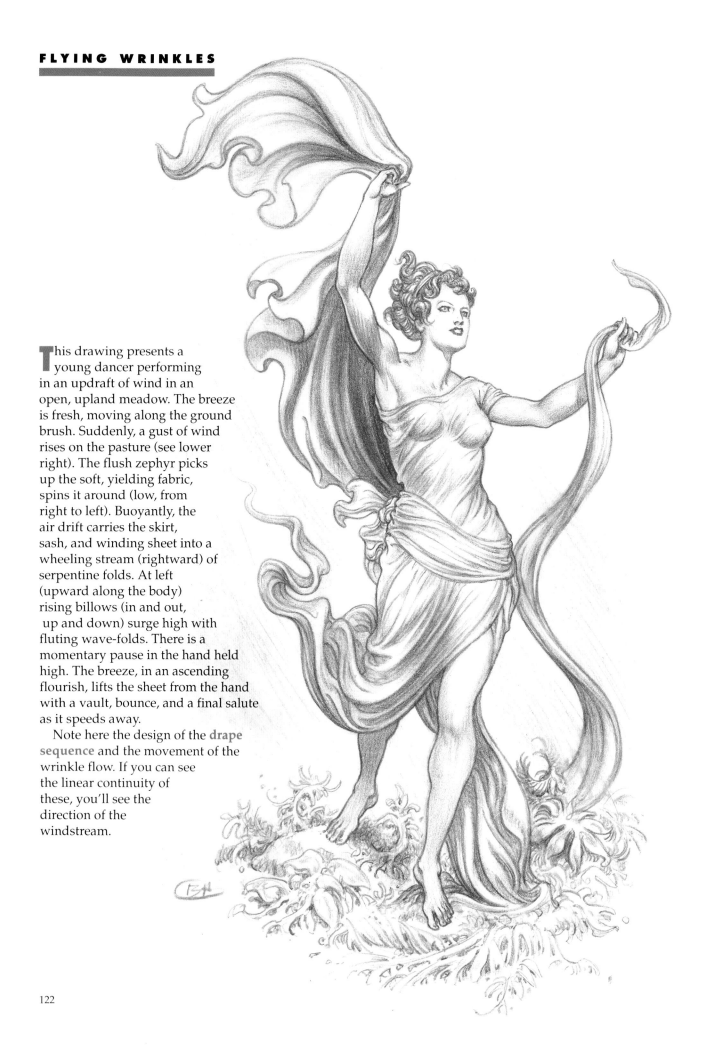

This drawing presents a young dancer performing in an updraft of wind in an open, upland meadow. The breeze is fresh, moving along the ground brush. Suddenly, a gust of wind rises on the pasture (see lower right). The flush zephyr picks up the soft, yielding fabric, spins it around (low, from right to left). Buoyantly, the air drift carries the skirt, sash, and winding sheet into a wheeling stream (rightward) of serpentine folds. At left (upward along the body) rising billows (in and out, up and down) surge high with fluting wave-folds. There is a momentary pause in the hand held high. The breeze, in an ascending flourish, lifts the sheet from the hand with a vault, bounce, and a final salute as it speeds away.

Note here the design of the **drape sequence** and the movement of the wrinkle flow. If you can see the linear continuity of these, you'll see the direction of the windstream.

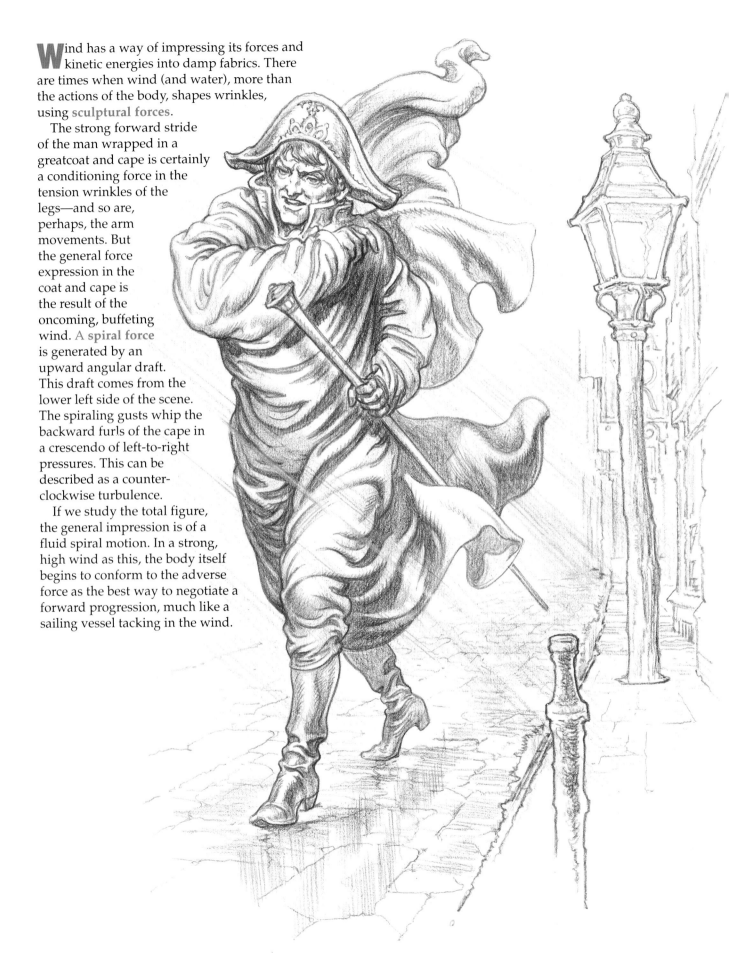

Wind has a way of impressing its forces and kinetic energies into damp fabrics. There are times when wind (and water), more than the actions of the body, shapes wrinkles, using **sculptural forces**.

The strong forward stride of the man wrapped in a greatcoat and cape is certainly a conditioning force in the tension wrinkles of the legs—and so are, perhaps, the arm movements. But the general force expression in the coat and cape is the result of the oncoming, buffeting wind. **A spiral force** is generated by an upward angular draft. This draft comes from the lower left side of the scene. The spiraling gusts whip the backward furls of the cape in a crescendo of left-to-right pressures. This can be described as a counter-clockwise turbulence.

If we study the total figure, the general impression is of a fluid spiral motion. In a strong, high wind as this, the body itself begins to conform to the adverse force as the best way to negotiate a forward progression, much like a sailing vessel tacking in the wind.

123

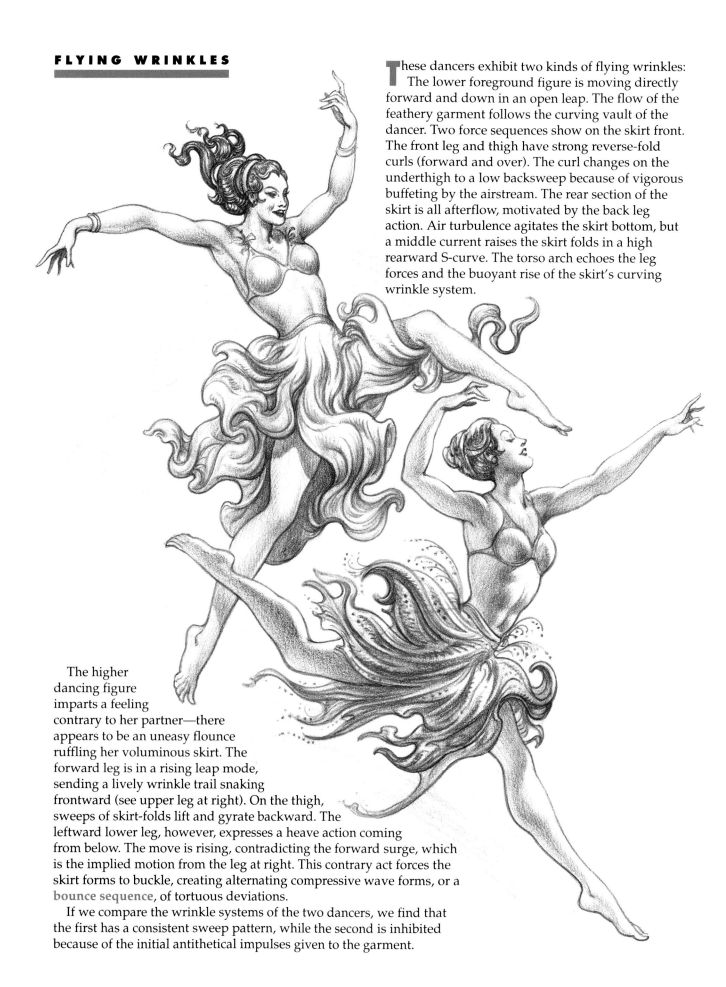

These dancers exhibit two kinds of flying wrinkles: The lower foreground figure is moving directly forward and down in an open leap. The flow of the feathery garment follows the curving vault of the dancer. Two force sequences show on the skirt front. The front leg and thigh have strong reverse-fold curls (forward and over). The curl changes on the underthigh to a low backsweep because of vigorous buffeting by the airstream. The rear section of the skirt is all afterflow, motivated by the back leg action. Air turbulence agitates the skirt bottom, but a middle current raises the skirt folds in a high rearward S-curve. The torso arch echoes the leg forces and the buoyant rise of the skirt's curving wrinkle system.

The higher dancing figure imparts a feeling contrary to her partner—there appears to be an uneasy flounce ruffling her voluminous skirt. The forward leg is in a rising leap mode, sending a lively wrinkle trail snaking frontward (see upper leg at right). On the thigh, sweeps of skirt-folds lift and gyrate backward. The leftward lower leg, however, expresses a heave action coming from below. The move is rising, contradicting the forward surge, which is the implied motion from the leg at right. This contrary act forces the skirt forms to buckle, creating alternating compressive wave forms, or a bounce sequence, of tortuous deviations.

If we compare the wrinkle systems of the two dancers, we find that the first has a consistent sweep pattern, while the second is inhibited because of the initial antithetical impulses given to the garment.

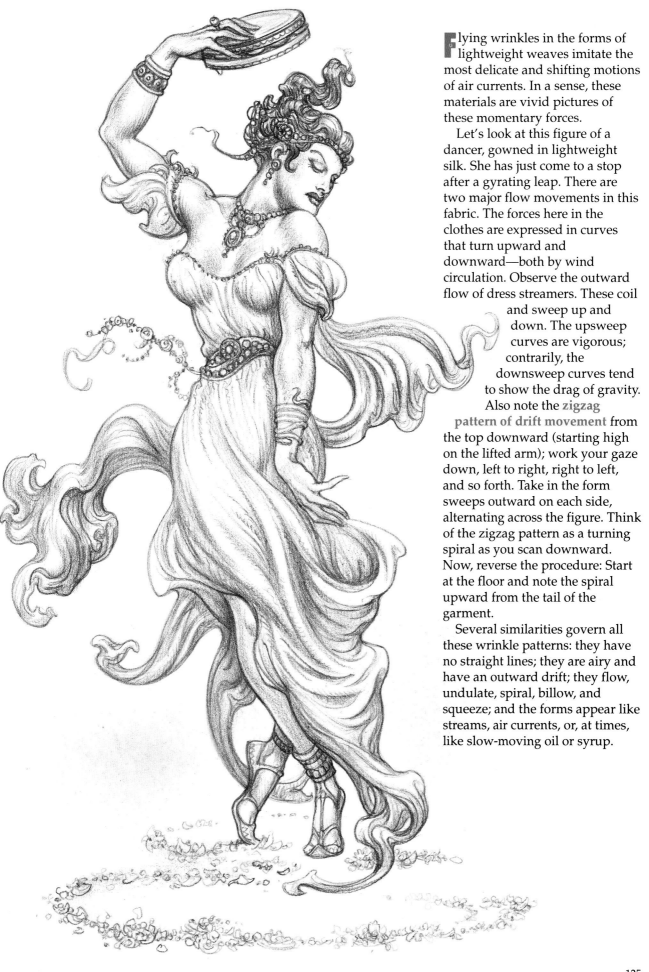

Flying wrinkles in the forms of lightweight weaves imitate the most delicate and shifting motions of air currents. In a sense, these materials are vivid pictures of these momentary forces.

Let's look at this figure of a dancer, gowned in lightweight silk. She has just come to a stop after a gyrating leap. There are two major flow movements in this fabric. The forces here in the clothes are expressed in curves that turn upward and downward—both by wind circulation. Observe the outward flow of dress streamers. These coil and sweep up and down. The upsweep curves are vigorous; contrarily, the downsweep curves tend to show the drag of gravity. Also note the **zigzag pattern of drift movement** from the top downward (starting high on the lifted arm); work your gaze down, left to right, right to left, and so forth. Take in the form sweeps outward on each side, alternating across the figure. Think of the zigzag pattern as a turning spiral as you scan downward. Now, reverse the procedure: Start at the floor and note the spiral upward from the tail of the garment.

Several similarities govern all these wrinkle patterns: they have no straight lines; they are airy and have an outward drift; they flow, undulate, spiral, billow, and squeeze; and the forms appear like streams, air currents, or, at times, like slow-moving oil or syrup.

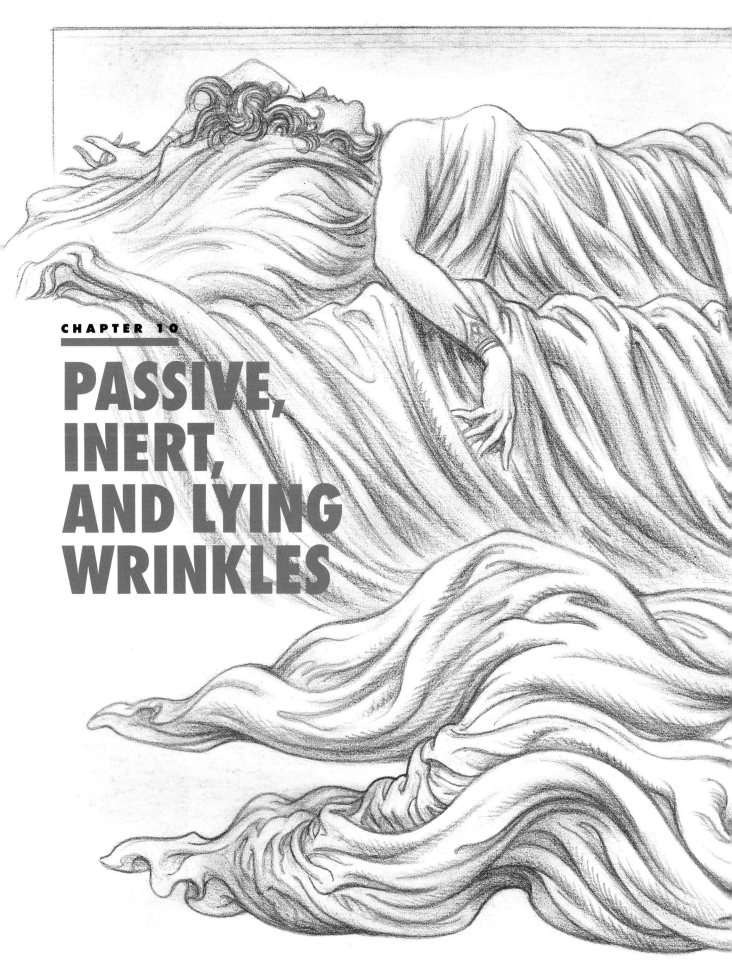

PASSIVE, INERT, AND LYING WRINKLES

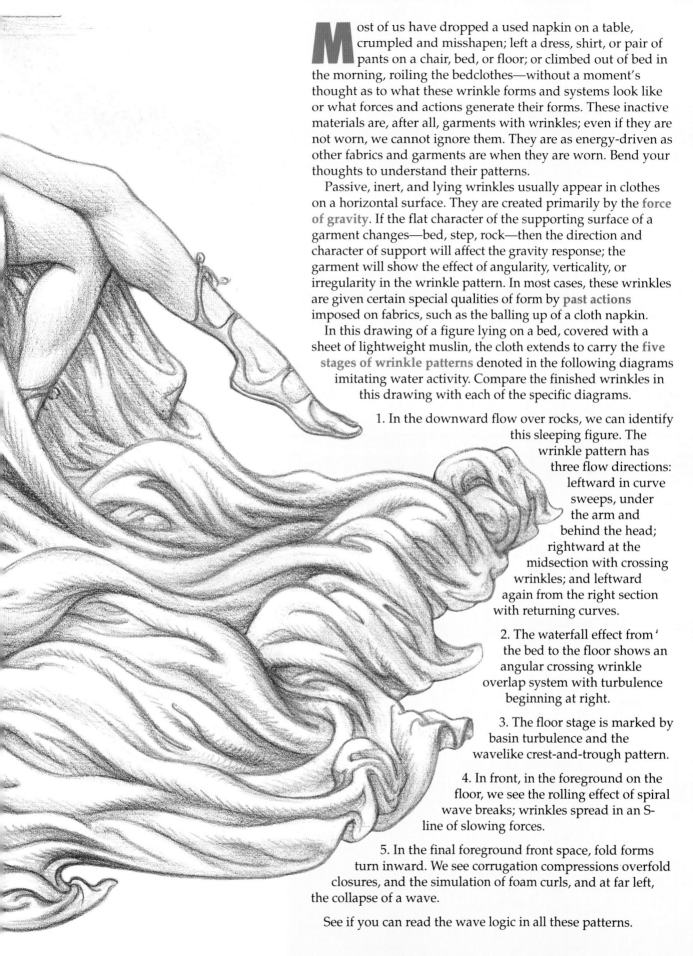

ost of us have dropped a used napkin on a table, crumpled and misshapen; left a dress, shirt, or pair of pants on a chair, bed, or floor; or climbed out of bed in the morning, roiling the bedclothes—without a moment's thought as to what these wrinkle forms and systems look like or what forces and actions generate their forms. These inactive materials are, after all, garments with wrinkles; even if they are not worn, we cannot ignore them. They are as energy-driven as other fabrics and garments are when they are worn. Bend your thoughts to understand their patterns.

Passive, inert, and lying wrinkles usually appear in clothes on a horizontal surface. They are created primarily by the **force of gravity**. If the flat character of the supporting surface of a garment changes—bed, step, rock—then the direction and character of support will affect the gravity response; the garment will show the effect of angularity, verticality, or irregularity in the wrinkle pattern. In most cases, these wrinkles are given certain special qualities of form by **past actions** imposed on fabrics, such as the balling up of a cloth napkin.

In this drawing of a figure lying on a bed, covered with a sheet of lightweight muslin, the cloth extends to carry the **five stages of wrinkle patterns** denoted in the following diagrams imitating water activity. Compare the finished wrinkles in this drawing with each of the specific diagrams.

1. In the downward flow over rocks, we can identify this sleeping figure. The wrinkle pattern has three flow directions: leftward in curve sweeps, under the arm and behind the head; rightward at the midsection with crossing wrinkles; and leftward again from the right section with returning curves.

2. The waterfall effect from the bed to the floor shows an angular crossing wrinkle overlap system with turbulence beginning at right.

3. The floor stage is marked by basin turbulence and the wavelike crest-and-trough pattern.

4. In front, in the foreground on the floor, we see the rolling effect of spiral wave breaks; wrinkles spread in an S-line of slowing forces.

5. In the final foreground front space, fold forms turn inward. We see corrugation compressions overfold closures, and the simulation of foam curls, and at far left, the collapse of a wave.

See if you can read the wave logic in all these patterns.

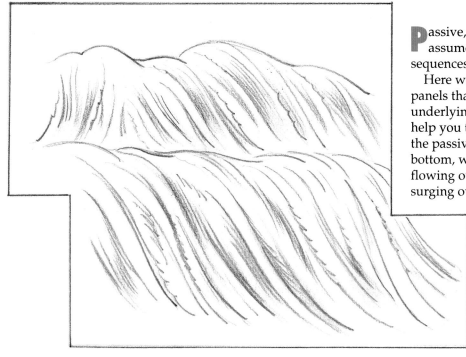

Passive, inert wrinkles frequently assume the character of water sequences in a landscape.

Here we have five diagrammatic panels that attempt to explain the underlying impulse and energy that can help you to reconstruct the images of the passive wrinkles. From top to bottom, we see what could be water flowing over rocks; a waterfall, rapidly surging over a ledge; water flowing into an extended basin; basin turbulence, with swiftly moving waves; and a wave break on shore, with rolling spirals and foam curls dying on a beach.

These examples are actually all passive wrinkles, forms without motion in still cloth. We see in them, however, the implication of the activity-states of the hydro-dynamic perception of water.

Thick and bulky fabrics, such wool blankets, or those that are heavy and resistant, such as coarse-grained sailcloth, tweed, or carpet, can take the form of a sequence of clumps if they are in a loose, disorderly state; surprisingly, these passive clumps can generate a composite aspect that has the likeness and appearance of a landscape.

With such heavy, complex fabric as your subject, how would you draw the wrinkle patterns and systems? Let's approach the solution by understanding that the varied folds and creases have similarities to the topography of mountains.

You can create these lying wrinkles by drawing a simple series of pyramidal forms ranging from flat and wide to angular and high.

Look at the wide-framed diagram at upper left in the drawing. The pyramidal forms describe the basic shapes beneath the cloth "mountain range." Now see the larger transposition of the pyramidal forms into the background of creases and folds that resemble piled-up sailcloth or heavy canvas. This is where the magical transition takes place: The pyramidal mountain range becomes a system of large-scale passive, inert wrinkles and folds.

We can gain insight into the creation of passive, inert, and lying wrinkles by relating them to the pattern of water forces and wave forms that give rise to alternating crest-and-trough motions, which seem to be in ceaseless undulation.

Large sheets of fabrics that passively assume the characteristics of waves are nylon sails, muslin and percale bedsheets, broadcloth shirting and skirting, cotton spreads and covering. These, when pulled, stretched, or drawn out in lateral, sidelong tensions produce the interesting result of alternating wave-flow patterns.

Note the framed drawing (upper left) of the wave-flow system. The crest-and-trough motion of a body of water forms the basis for a similar pattern in the inert material shown below. These motions are broad at the frontal space, and diminish as they overlap in spatial recession toward the rear.

When we translate the simple waves into cloth, we go from a linear sketch into a toned image. The replica waves and wavelets pulse in the cloth—a duplicate accord. Do you find the image of cloth sheeting in an aquatic metaphor appealing and relevant in these inert and passive wrinkles?

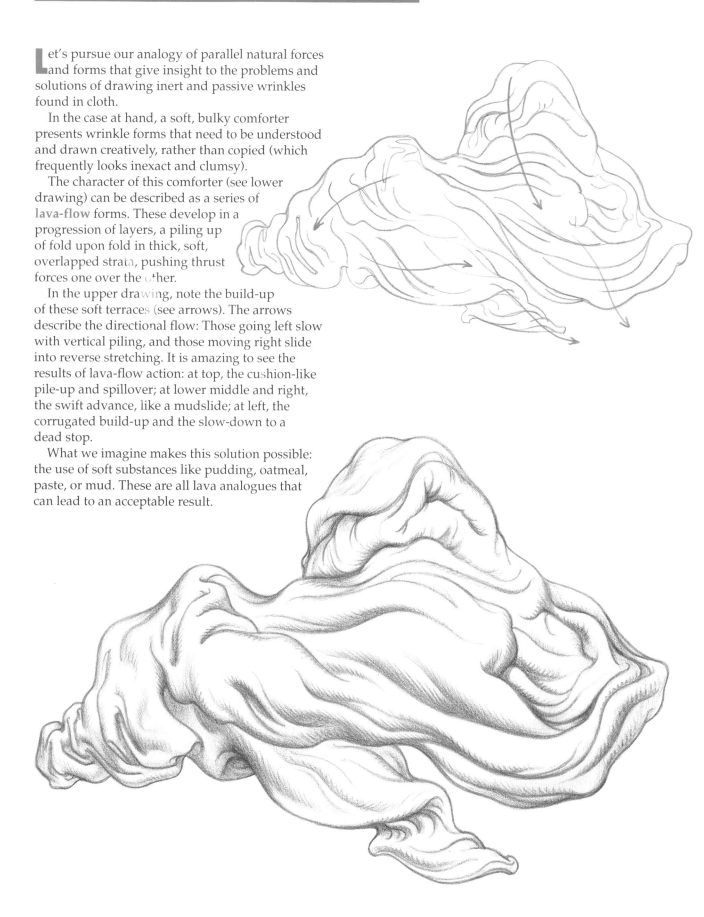

Let's pursue our analogy of parallel natural forces and forms that give insight to the problems and solutions of drawing inert and passive wrinkles found in cloth.

In the case at hand, a soft, bulky comforter presents wrinkle forms that need to be understood and drawn creatively, rather than copied (which frequently looks inexact and clumsy).

The character of this comforter (see lower drawing) can be described as a series of **lava-flow** forms. These develop in a progression of layers, a piling up of fold upon fold in thick, soft, overlapped strata, pushing thrust forces one over the other.

In the upper drawing, note the build-up of these soft terraces (see arrows). The arrows describe the directional flow: Those going left slow with vertical piling, and those moving right slide into reverse stretching. It is amazing to see the results of lava-flow action: at top, the cushion-like pile-up and spillover; at lower middle and right, the swift advance, like a mudslide; at left, the corrugated build-up and the slow-down to a dead stop.

What we imagine makes this solution possible: the use of soft substances like pudding, oatmeal, paste, or mud. These are all lava analogues that can lead to an acceptable result.

This drawing of a ship's sail, made of thick, weather-resistant canvas, shows a coarse weave layered in horizontal folds with heavy creases. The sail appears slow-moving, lumpish, and burdensome. The image to bear in mind is the resemblance of the cloth to flowing lava.

Part of the development of a convincing form is the **care in drawing** that should disclose a response to surfaces and such conditional encounters as the droop and fall-off of the canvas (at left). In another example, note the two large drops of cloth (at right), the rear squat form with two-way creased folds; at front, the longer, more vertical form shows a weaving curl with a leftward turn toward the front and across the foreground space. In the center folds over the wooden chest, we can relate the curved bank of tiered overfolds with rifted strata of hot lava. This artwork is not a copy of anything, but arises from a desire to turn the imagined form into a plausible visual image.

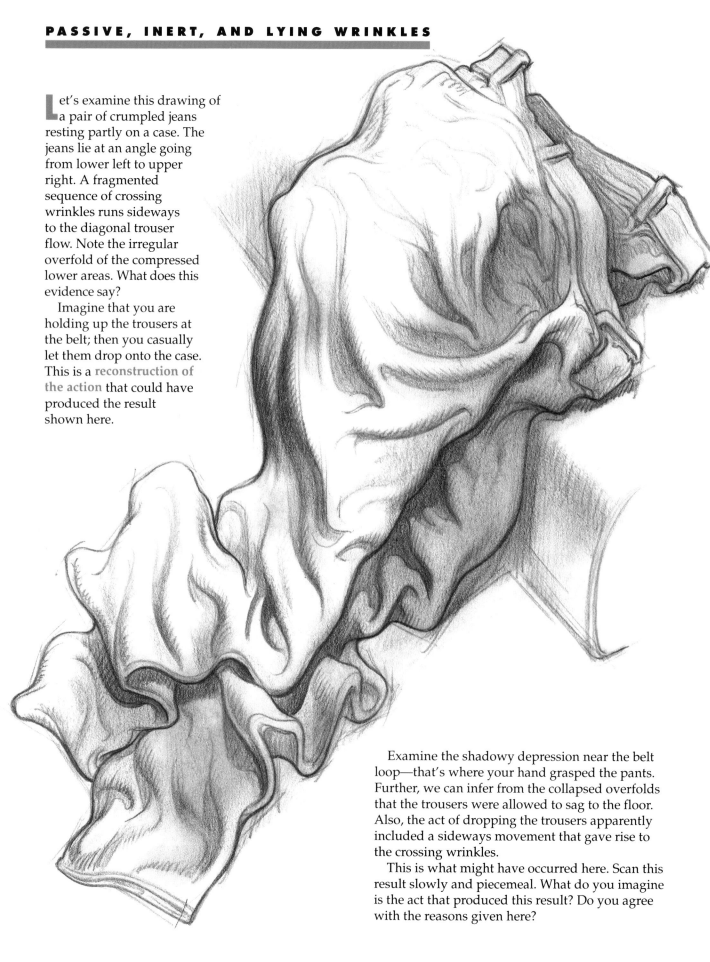

Let's examine this drawing of a pair of crumpled jeans resting partly on a case. The jeans lie at an angle going from lower left to upper right. A fragmented sequence of crossing wrinkles runs sideways to the diagonal trouser flow. Note the irregular overfold of the compressed lower areas. What does this evidence say?

Imagine that you are holding up the trousers at the belt; then you casually let them drop onto the case. This is a **reconstruction of the action** that could have produced the result shown here.

Examine the shadowy depression near the belt loop—that's where your hand grasped the pants. Further, we can infer from the collapsed overfolds that the trousers were allowed to sag to the floor. Also, the act of dropping the trousers apparently included a sideways movement that gave rise to the crossing wrinkles.

This is what might have occurred here. Scan this result slowly and piecemeal. What do you imagine is the act that produced this result? Do you agree with the reasons given here?

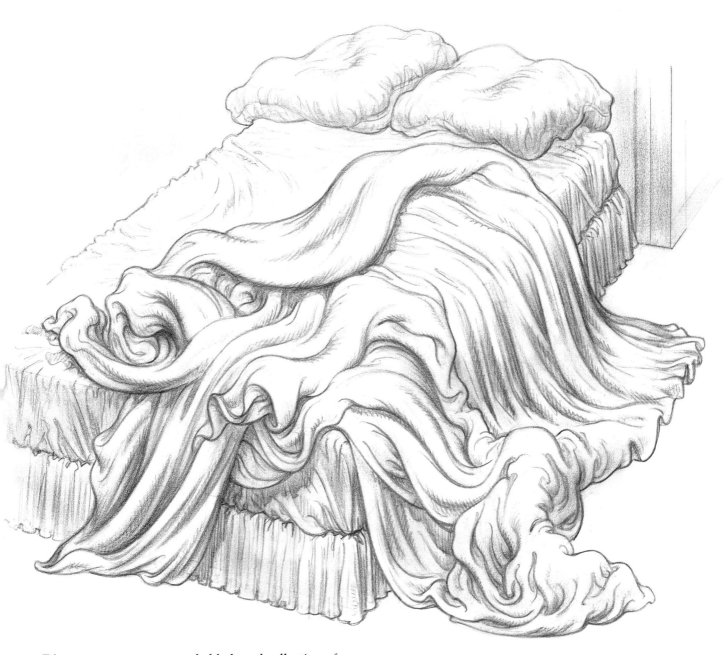

If you want to see a remarkably broad collection of wrinkle systems in one place, try looking at an unmade bed. Study and absorb the information from one of these, and you will quickly join the class of advanced artists.

This unmade bed shows several **past-action phenomena**:

1. At the left upper edge of the bed, several small half-circle rifts form a seat impression. The wrinkles move in water-ripple formations; clearly someone sat here.

2. The head impress on each pillow, centrally located, has the effect of a round weight dropped onto a soft lump of clay; the irregular impressions on the pillows' sides reflect hand thrusts and sidewise pushes from arms and shoulders.

3. The central section of the large, thick bedcover is roiled and convoluted downward like a rolling sea wave in cross-overfolds.

4. The front bedcover shows a serried slippage like a vertical waterfall drop; the front right corner section (on the bed and floor) shows a slow overlap set of undulant compression folds like a lava flow spreading fanwise on the floor.

5. Last, the bedsheet, at the rear right corner, has sidewall tucks and pulls, a tight compression sequence occurring in an irregular vertical array.

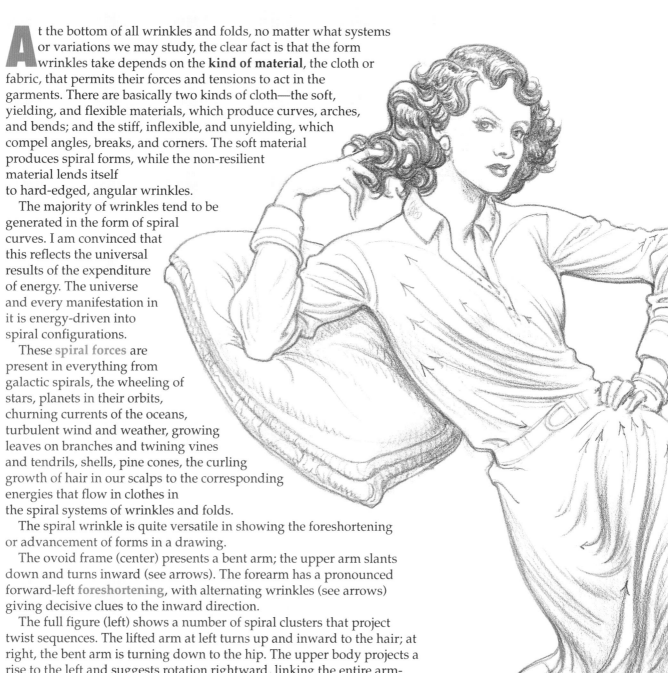

At the bottom of all wrinkles and folds, no matter what systems
or variations we may study, the clear fact is that the form
wrinkles take depends on the **kind of material**, the cloth or
fabric, that permits their forces and tensions to act in the
garments. There are basically two kinds of cloth—the soft,
yielding, and flexible materials, which produce curves, arches,
and bends; and the stiff, inflexible, and unyielding, which
compel angles, breaks, and corners. The soft material
produces spiral forms, while the non-resilient
material lends itself
to hard-edged, angular wrinkles.

The majority of wrinkles tend to be
generated in the form of spiral
curves. I am convinced that
this reflects the universal
results of the expenditure
of energy. The universe
and every manifestation in
it is energy-driven into
spiral configurations.

These **spiral forces** are
present in everything from
galactic spirals, the wheeling of
stars, planets in their orbits,
churning currents of the oceans,
turbulent wind and weather, growing
leaves on branches and twining vines
and tendrils, shells, pine cones, the curling
growth of hair in our scalps to the corresponding
energies that flow in clothes in
the spiral systems of wrinkles and folds.

The spiral wrinkle is quite versatile in showing the foreshortening
or advancement of forms in a drawing.

The ovoid frame (center) presents a bent arm; the upper arm slants
down and turns inward (see arrows). The forearm has a pronounced
forward-left **foreshortening**, with alternating wrinkles (see arrows)
giving decisive clues to the inward direction.

The full figure (left) shows a number of spiral clusters that project
twist sequences. The lifted arm at left turns up and inward to the hair; at
right, the bent arm is turning down to the hip. The upper body projects a
rise to the left and suggests rotation rightward, linking the entire arm-
body system to the bent arm and hip at right. This is the main drive of
the figure's action.

Note that the real force of the figure is in the extended leg at right
performing a dominant override action against the subordinate leg at
left. See the strong, assertive spiral swinging left to the curling skirt base.
These spirals effectively abort the swings of the under leg passage (by
trap and closure forms) and give energy to the extended leg with its
curve repetitions.

In the frame at far right we see a review of the flying wrinkle: There
is virtually no flying wrinkle other than the spiral form. Angularity
has no place here. A corresponding element in these forms is the open,
off-the-body fold. In the drawing, note the narrow spirals in the body
of the dress; compare these with the flaring wind-driven undulations
of the skirt.

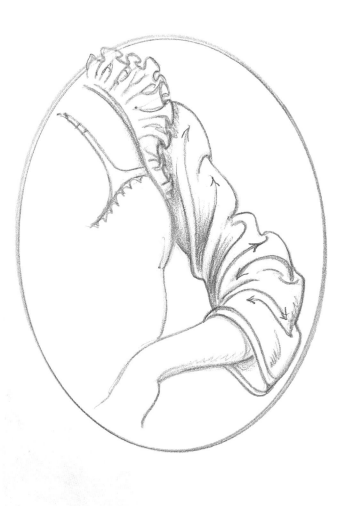

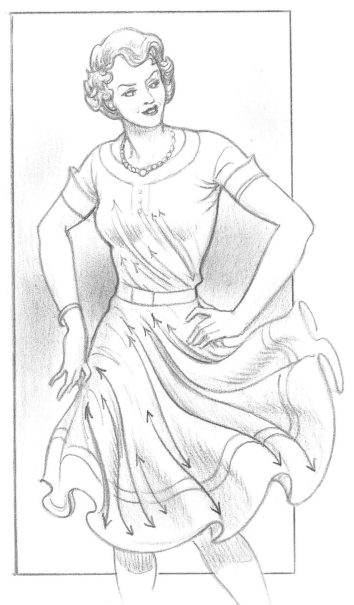

WRINKLE PATTERNS, TEXTURES, AND MATERIALS

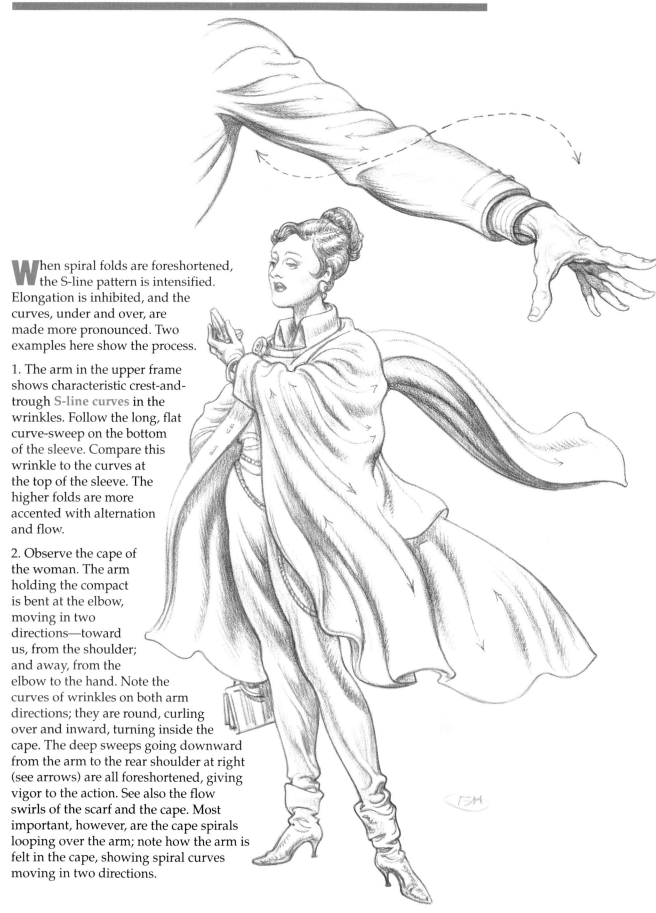

When spiral folds are foreshortened, the S-line pattern is intensified. Elongation is inhibited, and the curves, under and over, are made more pronounced. Two examples here show the process.

1. The arm in the upper frame shows characteristic crest-and-trough S-line curves in the wrinkles. Follow the long, flat curve-sweep on the bottom of the sleeve. Compare this wrinkle to the curves at the top of the sleeve. The higher folds are more accented with alternation and flow.

2. Observe the cape of the woman. The arm holding the compact is bent at the elbow, moving in two directions—toward us, from the shoulder; and away, from the elbow to the hand. Note the curves of wrinkles on both arm directions; they are round, curling over and inward, turning inside the cape. The deep sweeps going downward from the arm to the rear shoulder at right (see arrows) are all foreshortened, giving vigor to the action. See also the flow swirls of the scarf and the cape. Most important, however, are the cape spirals looping over the arm; note how the arm is felt in the cape, showing spiral curves moving in two directions.

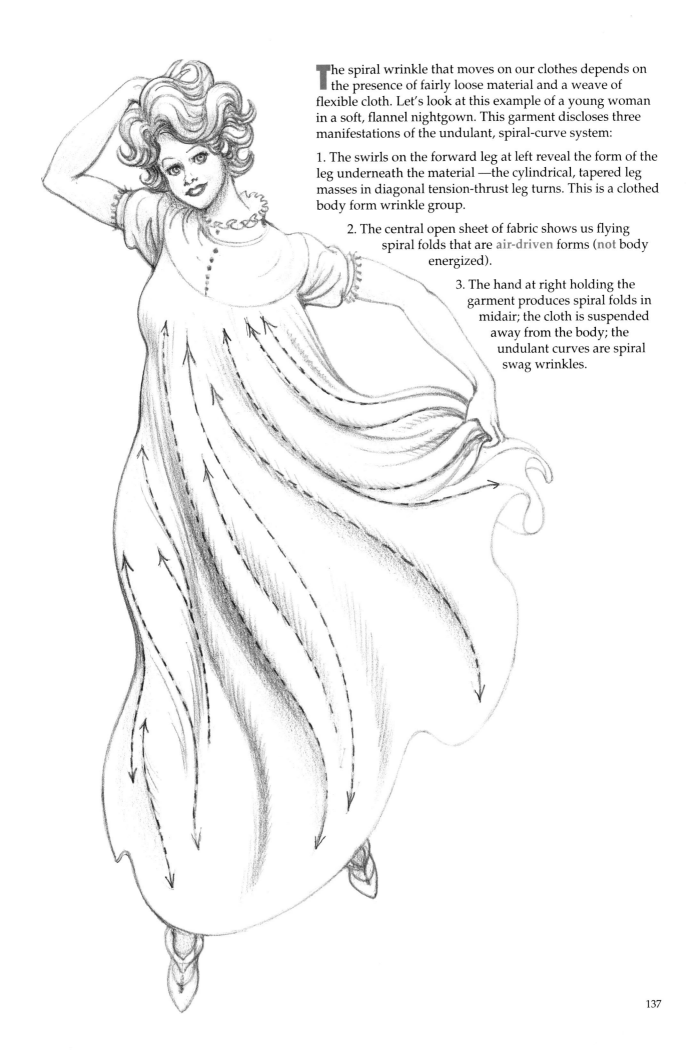

The spiral wrinkle that moves on our clothes depends on the presence of fairly loose material and a weave of flexible cloth. Let's look at this example of a young woman in a soft, flannel nightgown. This garment discloses three manifestations of the undulant, spiral-curve system:

1. The swirls on the forward leg at left reveal the form of the leg underneath the material —the cylindrical, tapered leg masses in diagonal tension-thrust leg turns. This is a clothed body form wrinkle group.

2. The central open sheet of fabric shows us flying spiral folds that are **air-driven** forms (**not** body energized).

3. The hand at right holding the garment produces spiral folds in midair; the cloth is suspended away from the body; the undulant curves are spiral swag wrinkles.

We have looked at loose, flexible fabrics and garments that show curves, spirals, and convolute forms. Now, let's look at a garment that shows **hard-edged, angular wrinkles**.

Here we see a raincoat made of unyielding material of the kind that includes synthetic fabrics infused with water-resistant substances. This loose-fitting garment exposes wedge-shaped, angular, crossing wrinkles. They appear in an alternating, sectioned order. The arms, for example, convey consistent compressions from virtually every angle of view—front, side, or back. The action of forces in the body of the coat and the anchor points describe subdivided, prismatic elements. These are characteristics that we associate with starched cloth, crumpled paper, or crinkled tinfoil.

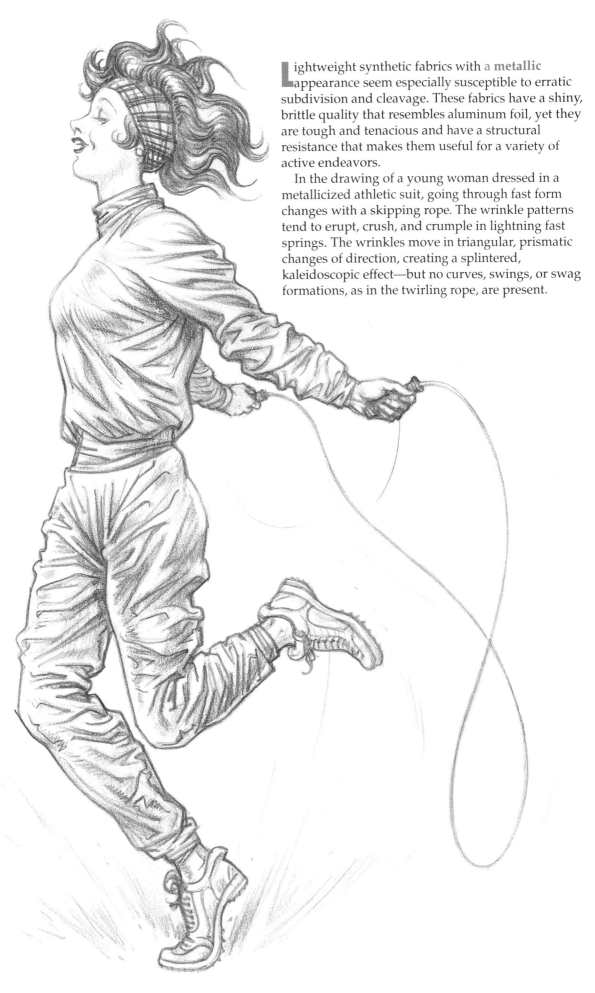

Lightweight synthetic fabrics with a **metallic** appearance seem especially susceptible to erratic subdivision and cleavage. These fabrics have a shiny, brittle quality that resembles aluminum foil, yet they are tough and tenacious and have a structural resistance that makes them useful for a variety of active endeavors.

In the drawing of a young woman dressed in a metallicized athletic suit, going through fast form changes with a skipping rope. The wrinkle patterns tend to erupt, crush, and crumple in lightning fast springs. The wrinkles move in triangular, prismatic changes of direction, creating a splintered, kaleidoscopic effect—but no curves, swings, or swag formations, as in the twirling rope, are present.

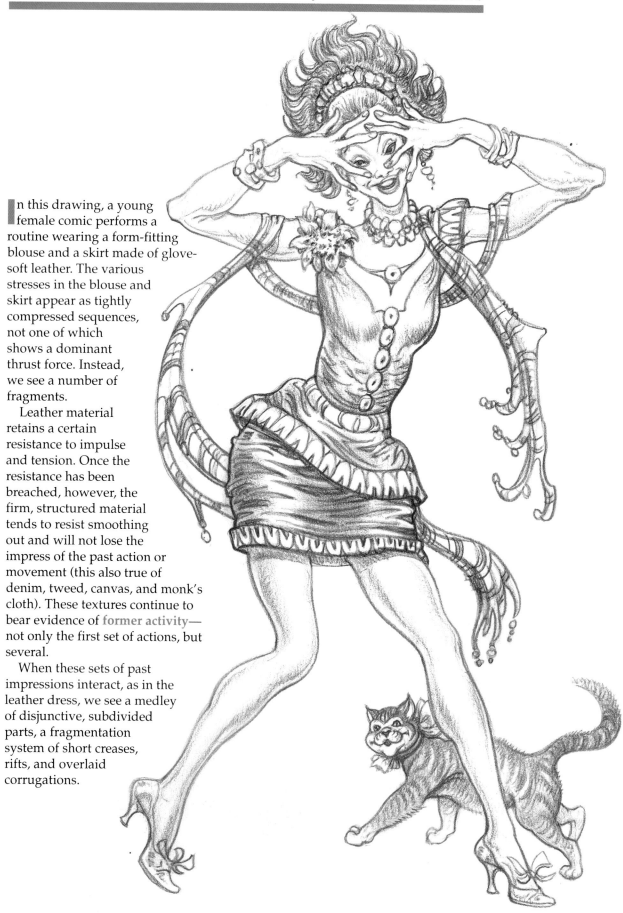

In this drawing, a young female comic performs a routine wearing a form-fitting blouse and a skirt made of glove-soft leather. The various stresses in the blouse and skirt appear as tightly compressed sequences, not one of which shows a dominant thrust force. Instead, we see a number of fragments.

Leather material retains a certain resistance to impulse and tension. Once the resistance has been breached, however, the firm, structured material tends to resist smoothing out and will not lose the impress of the past action or movement (this also true of denim, tweed, canvas, and monk's cloth). These textures continue to bear evidence of former activity—not only the first set of actions, but several.

When these sets of past impressions interact, as in the leather dress, we see a medley of disjunctive, subdivided parts, a fragmentation system of short creases, rifts, and overlaid corrugations.

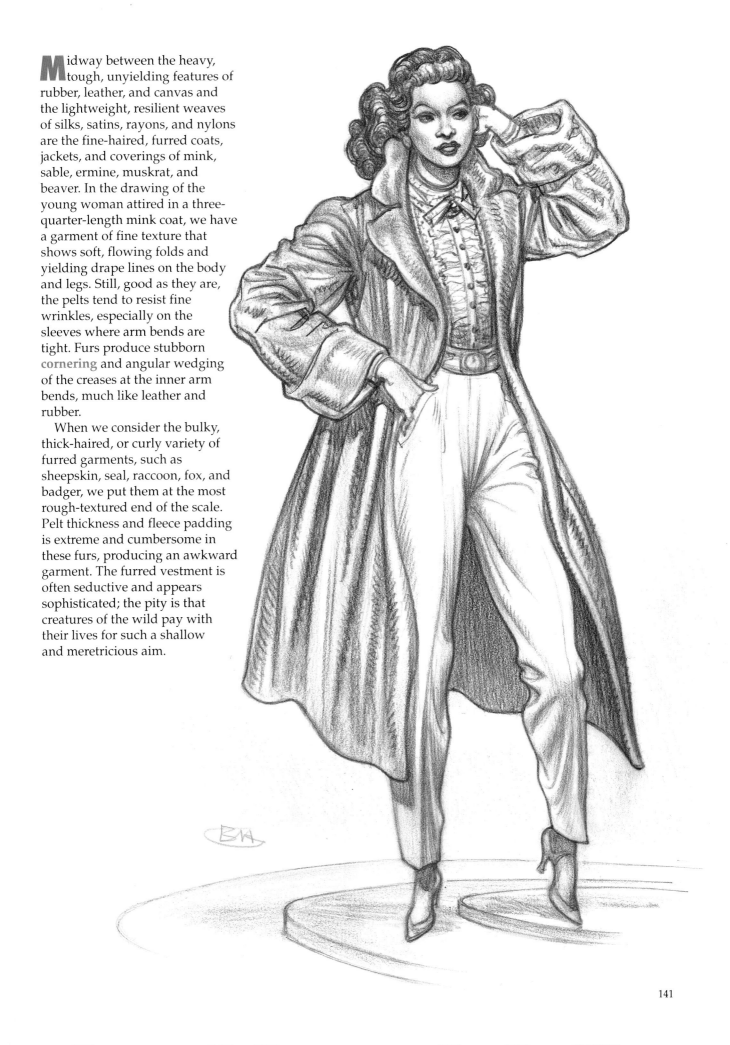

Midway between the heavy, tough, unyielding features of rubber, leather, and canvas and the lightweight, resilient weaves of silks, satins, rayons, and nylons are the fine-haired, furred coats, jackets, and coverings of mink, sable, ermine, muskrat, and beaver. In the drawing of the young woman attired in a three-quarter-length mink coat, we have a garment of fine texture that shows soft, flowing folds and yielding drape lines on the body and legs. Still, good as they are, the pelts tend to resist fine wrinkles, especially on the sleeves where arm bends are tight. Furs produce stubborn **cornering** and angular wedging of the creases at the inner arm bends, much like leather and rubber.

When we consider the bulky, thick-haired, or curly variety of furred garments, such as sheepskin, seal, raccoon, fox, and badger, we put them at the most rough-textured end of the scale. Pelt thickness and fleece padding is extreme and cumbersome in these furs, producing an awkward garment. The furred vestment is often seductive and appears sophisticated; the pity is that creatures of the wild pay with their lives for such a shallow and meretricious aim.

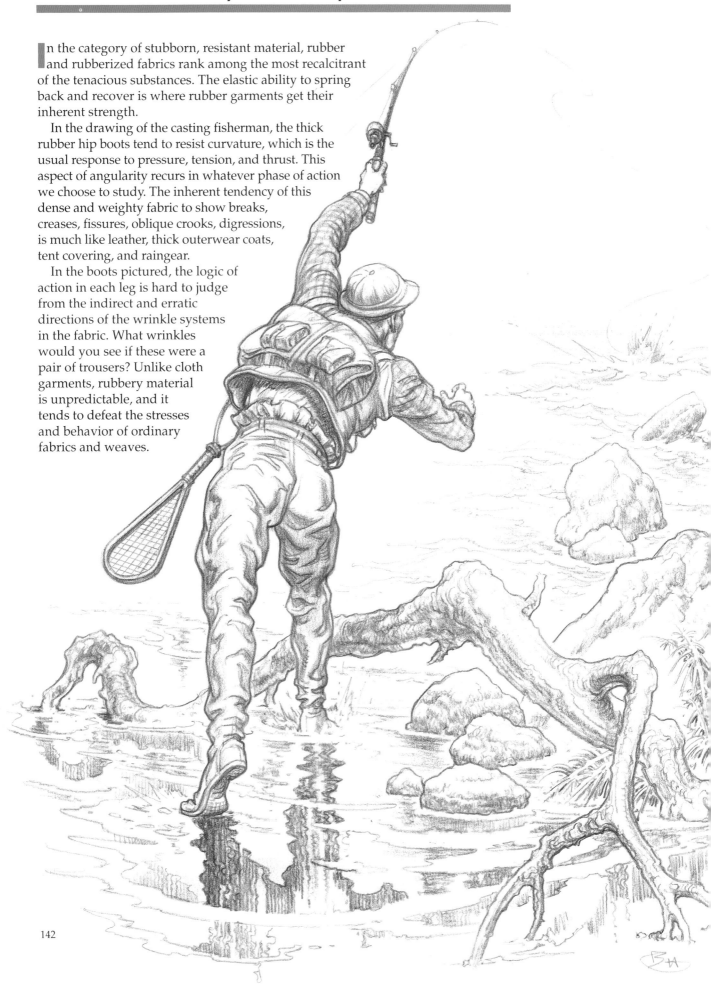

In the category of stubborn, resistant material, rubber and rubberized fabrics rank among the most recalcitrant of the tenacious substances. The elastic ability to spring back and recover is where rubber garments get their inherent strength.

In the drawing of the casting fisherman, the thick rubber hip boots tend to resist curvature, which is the usual response to pressure, tension, and thrust. This aspect of angularity recurs in whatever phase of action we choose to study. The inherent tendency of this dense and weighty fabric to show breaks, creases, fissures, oblique crooks, digressions, is much like leather, thick outerwear coats, tent covering, and raingear.

In the boots pictured, the logic of action in each leg is hard to judge from the indirect and erratic directions of the wrinkle systems in the fabric. What wrinkles would you see if these were a pair of trousers? Unlike cloth garments, rubbery material is unpredictable, and it tends to defeat the stresses and behavior of ordinary fabrics and weaves.

INDEX